OIL PAINTING TECHNIQUES

OIL PAINTING TECHNIQUES

EDITED BY DAVID LEWIS

INTRODUCTION BY WENDON BLAKE

WATSON-GUPTILL PUBLICATIONS, NEW YORK

Copyright © 1983 by Watson-Guptill Publications

First published 1983 in New York by Watson-Guptill Publications,
a division of Billboard Publications, Inc.,
1515 Broadway, New York, N.Y. 10036

Library of Congress Cataloging in Publication Data
Oil painting techniques.

 Includes index.
 1. Painting—Technique. I. Lewis, David.
ND1500.037 1983 751.45 83-14614
ISBN 0-8230-3261-2

Distributed in the United Kingdom by Phaidon Press Ltd., Littlegate
House, St. Ebbe's St., Oxford

Manufactured in U.S.A.

 4 5 6 7 8 9 / 88 87 86

There are many people who deserve thanks for helping me while I worked on this book, especially, Don Holden, Robin Goode, Betty Vera, and Jay Anning. Without their help, creating *Oil Painting Techniques* would have been impossible. With their help, it has not only been possible, but a pleasure.
David Lewis

Contents

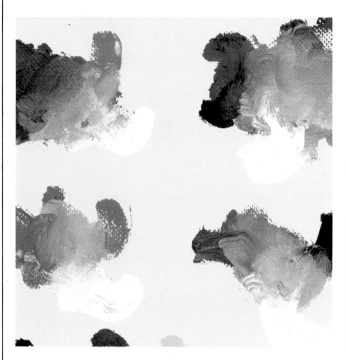

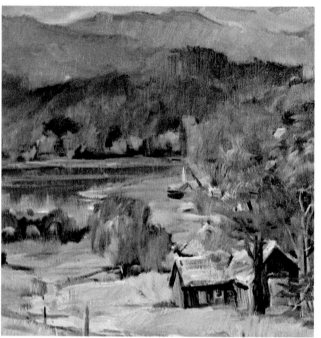

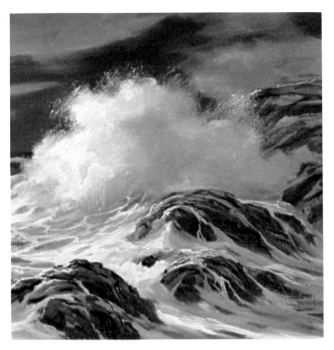

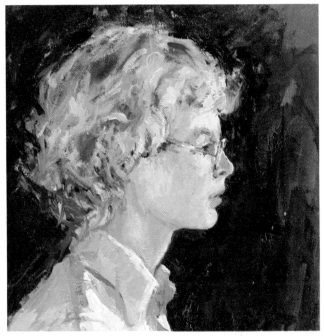

Introduction

When the editors of Watson-Guptill Publications asked me to write the introduction to this book, I walked over to the shelf where I keep my how-to-paint books and started thumbing through them. I was astonished to see how many I'd accumulated over the years. Many of the best artists in America and Britain had committed their methods to paper and created what's often called an "open university"—a university without a campus or classrooms, just books.

But after going through all those books on my shelves, I was struck by the fact that nearly every good art instruction book represents just *one* artist's viewpoint, techniques, and teaching methods. There were few books in which a *group* of artists joined forces so that the reader could see different kinds of paintings and absorb different teaching methods.

So I was especially pleased when I saw the proofs of the book you're now reading. This is something rare among art instruction books: a volume that presents the work and the teachings of ten different painters of real stature. It's a refreshing, innovative kind of book, like a mini-version of an art school in which there are lots of good teachers, each one contributing a fresh and individual viewpoint.

To create this stimulating survey of oil painting techniques, the editors of Watson-Guptill have dipped into a dozen outstanding how-to-paint books by these ten different artists, each of whom is a master of the craft.

Let me tell you a bit about each artist and the books on which this lively volume is based.

Foster Caddell is a versatile portrait and landscape painter who's particularly good at spotting the common problems that every student encounters—and coming up with solutions that produce dramatic advances in the student's work. In this volume, you'll find excerpts from two of his books that deal with these problems: *Keys to Successful Color* and *Keys to Successful Landscape Painting*. And I should also mention one other excellent book, *Keys to Painting Better Portraits*.

George Cherepov has won acclaim for a delightfully fresh, spontaneous approach to painting landscapes, portraits, and still lifes. You'll be reading an excerpt from *Complete Guide to Landscape Painting in Oil*, for which Cherepov painted the pictures to accompany my own text. He also wrote an excellent book called *Discovering Oil Painting*.

Jane Corsellis is a British painter who now lives in Canada, where she pursues her fascination with figure painting in oil. You'll enjoy an excerpt from her book, *Painting Figures in Light*, which does an exceptional job of explaining how to paint the figure in a highly creative way that combines the effects of light, atmosphere, and the environment in which the model is posed.

Ken Davies has become famous for his mastery of sharp focused still lifes, as shown in his widely-read book *Ken Davies: Artist At Work*, excerpted here. This is a particularly important book for anyone who wants to learn the precision technique that's often called "magic realism."

Charles Pfahl, one of America's most respected figure painters, is featured in *Charles Pfahl: Artist at Work* by Joe Singer, from which the editors have chosen some striking parts.

Charles Reid seems to be good at everything—portraits, figures, landscapes, still life in oil and watercolor—and has written five books that have won extraordinary popularity. You'll find excerpts from two of them: *Flower Painting in Oil* and *Painting What You Want to See*. But you should certainly know about the other three: *Flower Painting in Watercolor*, *Portrait Painting in Watercolor*, and *Figure Painting in Watercolor*.

E. John Robinson is a renowned seascape painter whose *Marine Painting in Oil* is excerpted here. He's written three other books that artists value highly: *Master Class in Seascape Painting*, *The Seascape Painter's Problem Book*, and *How to Paint Seascapes in Watercolor*.

John Howard Sanden is a celebrated portrait painter whose books and seminars have made him the mentor of thousands of artists. You'll find an excerpt from *Painting the Head in Oil*, written with Joe Singer. You should also know about the companion volume, *Successful Portrait Painting*, written with his wife, Elizabeth Sanden, who's also an excellent painter.

Richard Schmid has won a nationwide following for his bravura painting technique. He brings dazzling virtuosity to portraits, figures, landscapes, and still life. This book contains excerpts from *Richard Schmid Paints Landscapes*, which is a companion volume to another superb book, *Richard Schmid Paints the Figure*.

Paul Strisik is a noted landscape painter who paints New England scenery and the far West with equal power. His inspiring thoughts on landscape painting are distilled from *The Art of Landscape Painting*, which he wrote with Charles Movalli.

By the time you reach the end of this book, you'll have absorbed some of the best thoughts of ten of the top artists in North America. And you'll have sampled a dozen inspiring books that should encourage you to dig more deeply into the writings of these ten artists. You'll find that one good book leads to another.

WENDON BLAKE

MATERIALS AND EQUIPMENT

What do you need to paint an oil painting? While it's impossible to cover all the colors, mediums, varnishes, and types of canvas available, this section will serve as a broad outline to get you started. Read it carefully, but be sure to explore the subject further on your own. (Books devoted to the craft of painting, such as Ralph Mayer's *The Artist's Handbook of Materials and Techniques*, are excellent guides to what you need to know about painting materials.) If you already have some favorite brushes, colors, or other materials, that's fine—don't throw them out just because they are not among the basic materials mentioned here.

Brushes

Always buy the best brush you can afford. You can buy cheaper paints or work on inexpensive canvas, but painting with cheap brushes is like trying to model a figure in clay with mittens on. Good oil painting brushes are made out of bristle or red sable in two forms, flats and rounds. Don't use a synthetic brush with plastic bristles —these are meant for acrylic painting rather than oil.

BRISTLES

Bristle brushes are generally made from hog's hair and are fairly stiff. They come in sizes ranging from no. 1 to no. 10 (even larger sizes are available in some brands). In your flats, you should have a no. 4, a no. 6, and a no. 10. Always use the largest bristle brushes for the broadest areas. These brushes aren't that expensive, and so you should have at least these four. Again, buy good ones. If you're buying long flats, make sure that the bristles curve in at the corners. This is very important! Never buy long flats that are square-tipped, or they'll splay out and cause you trouble. But round bristles are excellent if you want to buy those.

Since bristle brushes are stiffer than sables, you can put much more paint on the canvas with them, covering broader areas more easily. Because of this, some artists feel it is a good idea to use bristle brushes for *alla prima* painting. (*Alla prima* means aiming for the final result from the very first stroke.)

SABLES

Sable brushes are soft and pliable. If you like the feeling of a sable brush, buy the smaller size, no larger than a no. 6 or no. 8. After this, the cost is so high you really have to be in love with sable to want it.

You may come up with a rather slick, slippery-looking result when painting *all prima* with sable flats. Sable flats seem to be best for glazing, and also they're much more expensive than hog's hair. Use the round sable, though, especially for delicate, fine detail work.

In fact, have several round sables— sizes no. 3 to no. 6. They wear out fast and aren't very expensive. The size here isn't that important; however, anything smaller than a no. 3 is small for the needs of most artists and above no. 6, you might just as well use a small bristle brush.

Painting Surfaces and Easels

Oil painting can be done on a variety of surfaces, each of which has its own distinct characteristics. Artist Charles Reid evaluates several of the most commonly used oil painting surfaces below.

CANVAS

Canvas is made of two materials, cotton and linen.

Cotton. Cotton canvas is difficult to stretch. The surface tends to be smooth and gets clogged with paint quickly, making overpainting a very difficult and unpleasant business. In a word, cotton is not recommended for anything other than quick sketches and exercises.

Linen. Linen is by far the superior material. It comes in various weights and textures. The weight depends on the number of threads per square inch. The texture depends on the size of the weave. If you buy prepared canvas, you won't have to worry about this, since most prepared canvas seems to come in a standard medium texture. However, buying prestretched, preprimed canvas is a costly luxury. If you plan to do much painting, buy your linen in rolls and stretch your own canvases. It's not only much cheaper but also will give you a choice of textures.

An even better choice, but more of a bother, is "raw" linen. This means that the linen comes without the white priming—it's simply linen cloth—and you must prime it yourself. (Gesso for priming painting surfaces is discussed on page 13.) Some artists buy their canvas this way. It's the least expensive, and it is also more reliable, as the priming on the preprimed canvas isn't always what it should be. You can get the widest possible choice of textures when you buy unprimed linen. It's best to start with a medium texture. You can always experiment with other textures later. You can send for an illustrated catalog of art supplies from Utrecht Linens, Inc. (33 Thirty-Fifth Street, Brooklyn, N.Y. 11232). They have a wide range of linens from which to choose, they're very pleasant to deal with, and they're prompt in their delivery.

PANELS

Masonite panels are much better than canvas ones. They're inexpensive and make an excellent surface when given a couple of coats of Liquitex acrylic gesso. Always get the untempered panels. Tempered Masonite contains oil that doesn't form a good surface for the gesso. Remember, you can't put plastic paint over an oil surface such as an old oil painting. The gesso will flake right off. You can only put oil paint over plastic paint.

PAPER

Many artists have used paper and cardboard for oil painting. Others feel that oil attacks paper and eventually the paper will break down. Toulouse-Lautrec did many paintings on cardboard, and they're still holding up. Cardboard isn't what it used to be, however, and so it can't be recommended as a painting surface. Your best bet is vellum—vellum has oil in it already, and so it's compatible with oil paint.

EASELS

The type of easel you choose depends on where you plan to do most of your painting. If you're going to work in your house or outside, you should have a portable easel. There are aluminum ones that work fairly well. But portable easels just aren't as satisfactory as studio easels made to stay in one place. If you have a permanent studio space set up and can afford the cost, a sturdy studio easel is ideal. But while it's important to use an easel that's fairly steady, it's even more important to concentrate on spending your painting money on good brushes. You can manage with a cheaper easel, but you can't manage with cheaper brushes.

Paint Boxes, Palettes, and Paints

Paint boxes aren't essential to painting—they're convenient tools for carrying around your real painting necessities. But palettes and paints are important—the effect of either can vary considerably depending on what you use. Charles Reid comments on these three painting tools below.

PAINT BOXES
An official paint box isn't necessary, but it's handy. You can carry your paint tubes, brushes, and palette in one container. This type of box even allows you to carry a palette with paints squeezed out, which saves you from having to scrape your palette each time you want to move. If you don't want to invest in a paintbox, any container will do. Art students use an assortment of paint boxes, cartons, canvas bags, briefcases, and toolboxes. A paint box is one item that doesn't matter, as long as it carries what you want.

A French easel makes a splendid paint box. This is a folding easel and paint box combined. It's a marvelous invention, but very expensive. It's wiser to spend your money on more critical materials instead. In the studio, a baby's bassinet is excellent for holding your equipment.

PALETTES
It's not a good idea to use paper palettes, although many students insist that they're easier. This is true if you only paint occasionally—you can tear off your paper and discard it. But this wastes paint, and it's very hard to mix paint properly on a paper palette.

If you paint often, use a regular wooden or Masonite palette. If you work mostly in a studio, a glass palette is excellent. Never use a plastic palette for oil paint. Turpentine melts the plastic. (The only exception would be Plexiglas, which seems to work better.) Glass palettes are not handy to carry, but they're good for a studio because they're easy to clean. A razor blade in a holder from your hardware store does the job. But you can't use it on wooden or Masonite palettes because it will tear up the surface. Instead, a painting knife and tissues, or a paint rag and some turpentine will clean a wooden or Masonite palette nicely.

PAINTS
Artists seem to vary as to their favorite brands of oil paint. Winsor & Newton paints are fine, but costly. Grumbacher, Shiva, and Bocour also make excellent paints. You'll probably find at least one of these brands in your art supply store. Each company's paints vary slightly in hue. For example, a Winsor & Newton cadmium yellow pale is warmer than a Grumbacher cadmium yellow pale. You'll find many colors the same, but do be prepared for some differences. Before you buy a selection of oil paints, review the basic palette of colors discussed on pages 22–23.

Manufacturers often add filler to their paints. Filler is a substance that is added to the pure pigment and oil when a color is tubed in order to extend the paint's shelf life and add to its workability. It doesn't hurt the pigment, but, obviously, the more filler there is in a tube, the less pigment (and therefore less tinting power) will be in that tube. This doesn't mean you can't get as brilliant a color. It just means that you'll have to use a bit more paint when using colors with a lot of fillers. Some manufacturers also use more oil than others in their paints. This has nothing to do with the quality of the pigment itself, and since some people like more fluid paint, they may actually prefer this. But it might be better to add oil (or other mediums) to your paint yourself, so you can control the amount added.

Mediums, Gesso, and Accessories

MEDIUMS

Artists use painting mediums to make oil paint more fluid and "buttery." Unfortunately, some mediums also can cause many permanency difficulties.

Liquid Mediums. The safest mediums are prepared combinations such as Taubes' copal painting medium and Winton, a painting medium made by Winsor & Newton. You also can make your own medium using one-third linseed oil, one-third turpentine, and one-third damar varnish. This home-made medium is just as good as the prepared ones. Turpentine alone is not a good binder, and so it is not recommended for use as a medium all by itself. Linseed oil alone tends to yellow. It, too, must be used in combination with other mediums.

Gel Mediums. Several companies put out gel mediums which work well and seem to be safe in terms of permanency. Each brand is a bit different in consistency, and so you'll have to experiment with several to find the one you like best.

GESSO

Artists always used to prepare their own gesso for priming canvases, and many still do. There are several synthetic gessos available today, however, that are all equally good. But, as with paint, you'll find the consistency of the gesso differs with each manufacturer. You'll probably have to add some water to the gesso before applying it to your canvas or panel. It's better to put on two or three thin coats rather than a single thick one. Buy a nice wide nylon or bristle brush—a 3-inch or 4-inch (8 to 10 cm) house-painter's brush will do nicely—to apply your gesso to the canvas. After each coat has dried, give it a light sanding with fine sandpaper to smooth the surface of any deep brush grooves.

MISCELLANEOUS ACCESSORIES

Besides the materials discussed, there are a few other items:

Rags, Tissues, etc. First of all, you'll need something with which to wipe your brushes. Most rags are unsatisfactory, since they're not absorbent enough. Cloth diapers are great, but difficult to come by. Facial tissues, toilet paper, and paper towels are excellent.

Palette Knives. You'll also need a palette knife to clean your palette. You may prefer what is usually called a painting knife, which has a blade that is small and flexible.

Turpentine, Brush Cleaner, and Mineral Spirits. These are necessary for cleaning your brushes. You can buy a special cleaning jar at your art store, or make your own out of two cans.

To make your own brush cleaner, Charles Reid recommends using a coffee can and a smaller can that fits inside it. Cut out the top of the smaller can and turn it upside down. Then drive a nail into its bottom to make holes. Place the smaller can with the holes upside down in the larger coffee can and fill it with turpentine or brush cleaner. When you clean your brush, the sludge will drop to the bottom, and you'll always have fairly clean turpentine or brush cleaner.

To hold your medium, you can use small oil cups from the art store or, cheaper still, try cat-food cans. After each painting session, clean your brushes in turpentine, brush cleaner, or mineral spirits, and then scrub them well with soap and water. Clean brushes are a joy to work with, but just as important, cleaning them in mild soap and water will assure a long life.

BRUSHWORK

How you hold your brush depends on what kind of brush stroke you're going to make. Broad areas and detailed areas demand different treatments. As you paint more and become accustomed to holding your brush in various ways, you'll develop your own favorite brushwork. Some artists use dry, smudging brush strokes, while others use fluid, flowing strokes. Some even paint pictures with thousands of little dots of color instead of actual strokes. Your brushwork is your handwriting in paint. You should practice using the brush in a variety of ways, but try not to worry too much about it. Concentrate on the subject of your painting, and your brushwork will practically take care of itself.

Using the Brush

Many students dab at paintings with little strokes. Only once in a while are little dabs necessary. Usually what's needed is a bolder stroke executed with a bigger brush held back toward the end of the handle, and some courage. Don't be afraid you'll abuse your brushes when you're painting vigorously. You must use your brushes as needed to get the effect you're after.

The main thing to remember when holding your brush is that it's a friend, not an enemy. Don't strangle it in a vicelike grip. The brush should be a natural extension of your hand, wrist, and arm. If you're working on detailed areas where control is important, hold your brush down by the ferrule. If you're working on a broad area with freedom and verve, hold your brush back toward the end of the handle. *Never* hold the brush only one way. This section illustrates six types of brush strokes and the methods of holding the brush in each case.

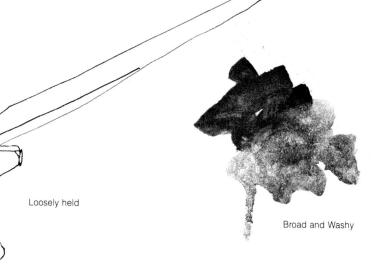

Loosely held

Broad and Washy

Broad and Washy. With an ox-hair brush, apply the paint almost as if it were watercolor. Use lots of turpentine or painting medium with a small amount of pigment. (Keep your turpentine and your painting medium in separate containers.) Never brush extremely diluted pigment over an old painting or try to work it into areas you've just painted. Only use this approach when starting a new canvas. Naturally, you'll do most of your mixing on the palette, but if some pigment starts to build up, a brush dipped in turpentine can be worked directly into the paint on the canvas. Finally, don't use opaque white pigment to lighten your wash-in areas. The turpentine will act as your lightener. Just as water is used to lighten watercolor, the more turpentine you use, the lighter and more transparent your wash will be on the canvas. This method is excellent for your early lay-in stage, when you want to cover large areas of your canvas quickly. When various colors are mixed and worked together on the canvas, lovely effects result. Some contemporary artists use this method from beginning to end, never using impasto.

For your broad, washy strokes, hold the brush back toward the end of the handle. Control isn't the object here; the aim is spontaneity. If you're just beginning a painting, this is the time to have fun and get some color going. You're all set, as long as you don't let the paint build up too soon. Allow some outrageous color to happen in your washes; swirl and scrub with your brush.

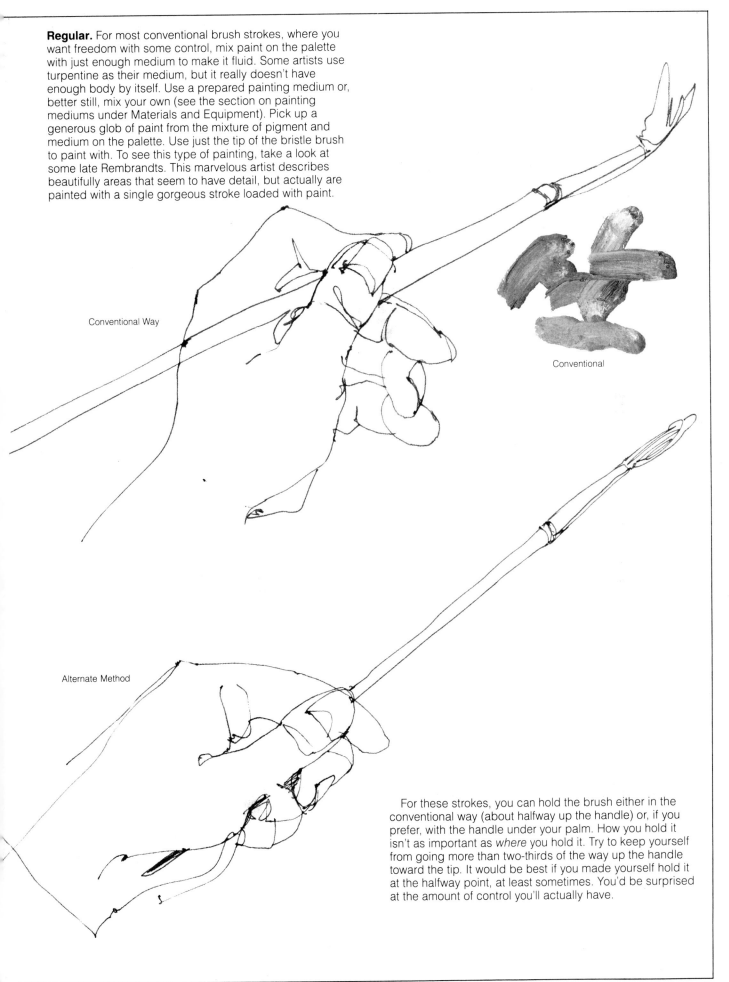

Regular. For most conventional brush strokes, where you want freedom with some control, mix paint on the palette with just enough medium to make it fluid. Some artists use turpentine as their medium, but it really doesn't have enough body by itself. Use a prepared painting medium or, better still, mix your own (see the section on painting mediums under Materials and Equipment). Pick up a generous glob of paint from the mixture of pigment and medium on the palette. Use just the tip of the bristle brush to paint with. To see this type of painting, take a look at some late Rembrandts. This marvelous artist describes beautifully areas that seem to have detail, but actually are painted with a single gorgeous stroke loaded with paint.

Conventional Way

Conventional

Alternate Method

For these strokes, you can hold the brush either in the conventional way (about halfway up the handle) or, if you prefer, with the handle under your palm. How you hold it isn't as important as *where* you hold it. Try to keep yourself from going more than two-thirds of the way up the handle toward the tip. It would be best if you made yourself hold it at the halfway point, at least sometimes. You'd be surprised at the amount of control you'll actually have.

Broken Color. This is called broken color in oil painting and drybrush in watercolor. Actually, *drybrush* seems to describe it best: little, if any, medium is used, and very dry pigment is dragged across the textured surface of the canvas. Use an ox-hair brush here. The limp sable brush is really too soft for this technique. As also mentioned in the Materials section, the amount of oil mixed into the pigment varies with each brand of paint. However, most colors without medium added will be dry enough to use for drybrush.

This approach is excellent for painting one color over another that's already dry. It's possible to suggest detail and texture as well as light without laboring over the passage. The Russian painter Nicholi Fechin used this very dry paint beautifully. He apparently found the commercial colors that American artists use too moist, and so he squeezed his paint onto paper towels in order to remove excess oil.

About the same amount of control is needed to produce drybrush strokes as conventional strokes. Use the side of the brush rather than the tip, and hold the brush with the handle under your palm or projecting out between thumb and forefinger, again about halfway up the handle. Since you're using the side of the bristles, the brush handle is almost parallel to the canvas as you make your stroke.

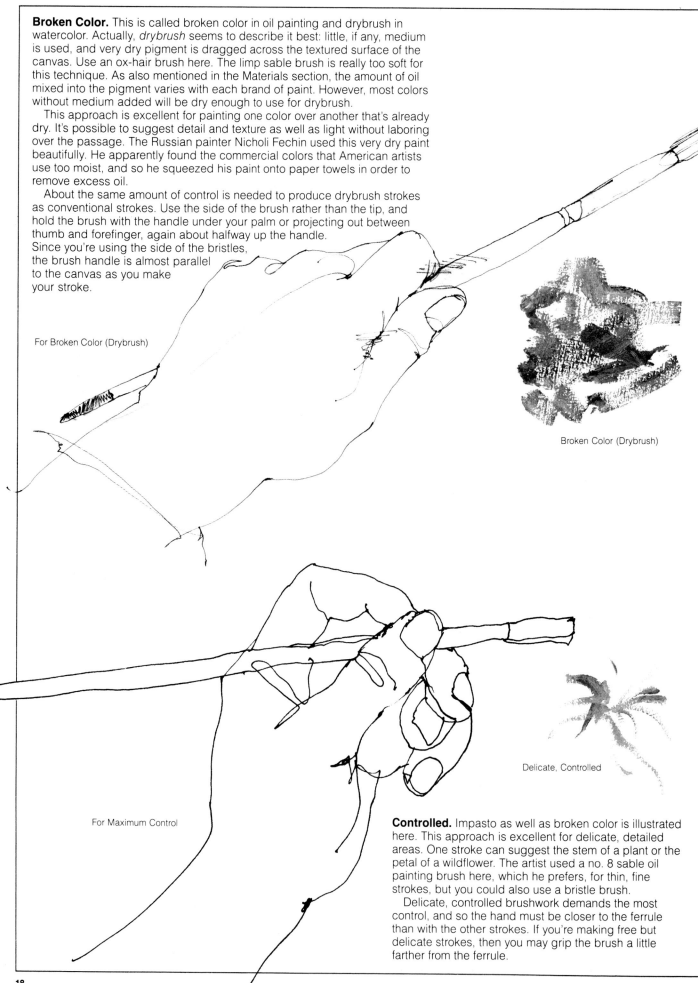

For Broken Color (Drybrush)

Broken Color (Drybrush)

Delicate, Controlled

For Maximum Control

Controlled. Impasto as well as broken color is illustrated here. This approach is excellent for delicate, detailed areas. One stroke can suggest the stem of a plant or the petal of a wildflower. The artist used a no. 8 sable oil painting brush here, which he prefers, for thin, fine strokes, but you could also use a bristle brush.

Delicate, controlled brushwork demands the most control, and so the hand must be closer to the ferrule than with the other strokes. If you're making free but delicate strokes, then you may grip the brush a little farther from the ferrule.

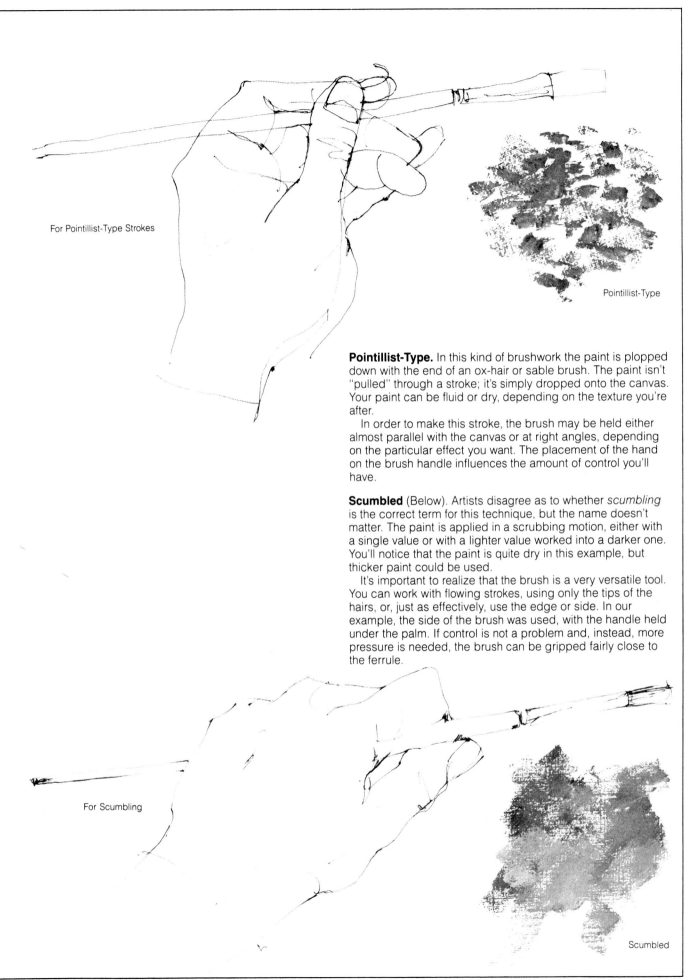

For Pointillist-Type Strokes

Pointillist-Type

Pointillist-Type. In this kind of brushwork the paint is plopped down with the end of an ox-hair or sable brush. The paint isn't "pulled" through a stroke; it's simply dropped onto the canvas. Your paint can be fluid or dry, depending on the texture you're after.

In order to make this stroke, the brush may be held either almost parallel with the canvas or at right angles, depending on the particular effect you want. The placement of the hand on the brush handle influences the amount of control you'll have.

Scumbled (Below). Artists disagree as to whether *scumbling* is the correct term for this technique, but the name doesn't matter. The paint is applied in a scrubbing motion, either with a single value or with a lighter value worked into a darker one. You'll notice that the paint is quite dry in this example, but thicker paint could be used.

It's important to realize that the brush is a very versatile tool. You can work with flowing strokes, using only the tips of the hairs, or, just as effectively, use the edge or side. In our example, the side of the brush was used, with the handle held under the palm. If control is not a problem and, instead, more pressure is needed, the brush can be gripped fairly close to the ferrule.

For Scumbling

Scumbled

HANDLING COLOR

Children often see objects in terms of color rather than just value or form, and this is one of the reasons why their art has a strength, directness, and simplicity that many adults envy and wish they could manage in their oil paintings. Most older people are afraid of using strong colors, and in their effort to make things look "real," they overmix their color so it gets gray where it shouldn't and the values become muddy and confused.

The purpose of this section is to help you learn to mix color that is fresh and exciting. Besides acquainting you with a basic palette of useful colors for oil painting, it will explain how to see colors in terms of values and to mix colors that present special problems: getting lights and darks to look colorful, putting enough variety into summer greens, making grays interesting, and mixing good flesh tones.

Basic Palette

For painting in oil, you need to have a selection of colors that will allow you to mix a wide variety of hues, of every value and intensity. Every painter should find his or her own favorites. If you find that you like exotic colors— hues that are a bit unusual—check a book like Mayer's on their permanency.

THE BASIC OIL PALETTE

To start with, here is a list of some colors which are fairly basic. This should not be considered a definitive list, however. Try these colors, but experiment with others, too. The palettes of many artists change constantly.

Alizarin Crimson. This color is necessary and considered permanent. It's a slow drier and a very strong dye. (You'll realize this if you ever get some on a clean dress or shirt.) Alizarin is wonderful for mixing those purples, lavenders, and pinks so necessary in painting flowers. You'll need it also for darkening reds and for mixing other rich darks. Artist Charles Reid often mixes it with ultramarine blue or viridian to make his darkest darks, or with cerulean or phthalo blues for making purple.

Cadmium Red Light. This color is a good basic red that should probably be a permanent part of your palette. It doesn't have as much tinting power as alizarin, but it's still very strong. Some artists find it much more useful than either cadmium red medium or cadmium red dark. The darker cadmiums can be used for particular mixtures, but cadmium red light seems the most versatile of the reds, and one that you should at least start with on your palette.

Vermilion. This is a slightly cooler version of cadmium red light. The difference between these two reds is so slight you could find yourself interchanging them without even noticing.

Cadmium Orange. While you can mix yellow and red to make an orange, the orange you mix won't be as nice as cadmium orange. Many artists consider this a necessary color, and you should have it on your palette. Remember, cadmiums are strong, and so always start with a little, especially if you are mixing it with a light color or a white. A touch of cadmium orange can be added to a white to give it warmth and strength.

Cadmium Yellow Pale. This is a color that varies in hue considerably from one manufacturer to another. Also try lemon yellow and cadmium yellow light. You'll find these three yellows similar in value, but varying in warmth and coolness.

Viridian. This is the most useful green, and if you are going to have just one, this should be it. It does not look like a "natural" green when used straight from the tube, but it is wonderful in mixtures.

Phthalo Green. The only other green that comes out of the tube as dark as viridian is phthalo green. Phthalo (short for phthalocyanine) green can be a fine color, but because it's strong and tends to be dominant, use it sparingly.

Permanent Green Light. This is a good light green, a bit warmer than viridian. This color would never knock your eye out, but it's wonderful for subtle areas.

Ultramarine Blue. This is an old standby. It has good tinting power without being as strong as phthalo blue. Ultramarine is very dark out of the tube and is a good mixer.

Phthalo Blue. You may prefer phthalo blue to ultramarine, although phthalo is very strong and tends to dominate any mixture. It makes beautiful dark purples when mixed with alizarin crimson.

Cobalt Blue. This is a lovely color, much more gentle and subtle than the ultramarine and phthalo blues. It's a middle-value blue, a bit darker and richer than cerulean blue.

Cerulean Blue. This is a soft light blue, useful for mixing subtle grays. If you can have only two blues, choose cerulean and ultramarine.

Yellow Ochre. This is a subtle, unobtrusive earth color, and therein lies its advantage. When you want a soft, quiet yellow, this color is excellent. You can get a soft yellow using a small amount of one of the cadmiums, but you have to be careful, since the cadmiums are much stronger in tinting power than yellow ochre. Yellow ochre, however, can be a bit chalky when used in mixing greens.

Raw Sienna. This earth color is a darker version of yellow ochre. For mixing greens, the raw sienna works beautifully. Because it's lower in value (darker), it tends to make richer and deeper greens.

Burnt Sienna. This is one of those colors (like viridian) which is necessary on your palette, but not a good color when used alone. It needs company. Many students overuse burnt sienna, and the results are often raw and harsh. Try using burnt sienna as a substitute for red when mixing. Use a bit in your green mixtures, and try mixing it with ultramarine, phthalo blue, or viridian to make rich darks.

Burnt Umber. This is your darkest brown. It's warmer and more reddish than raw umber. Burnt umber is good for dark darks when you don't wish to use black. But don't rely on burnt umber alone. Mixtures seem to be better than any single color right out of a tube—some artists prefer to make darks with a mixture of burnt sienna and blue or green. Also, burnt umber makes a fine gray when mixed with blue and a bit of white.

Raw Umber. This color is cooler than burnt umber and tends more toward the green. Eventually you may decide you want to leave it off your palette, but try using both raw and burnt umber at first. You might well find both necessary.

Black. Many teachers discourage the use of black because students overuse it. It's not always the best way to darken a color, and you can often get richer, more varied results by using mixtures of other dark hues. However, black is a fine color and can be used with yellows to make beautiful greens.

White. Permalba white (made by Weber) is good, or any titanium white will do.

GENERAL ADVICE ON MIXING OILS

When you mix your oil colors, use a brush and blend them on the palette. Use only small amounts of each color until you get the right mixture. (Of course, you'll have larger amounts of fresh colors around the edges of the palette, but you'll only take small dabs of them for mixing.) Be sure to clean your brush in turpentine or mineral spirits before touching another color or you will dirty it. Also, never squeeze your tubed colors into the middle of the palette. Arrange them in an orderly fashion around the edges. And put *all* your colors out—not just the ones you think you'll use.

A lot of paint seems to get wasted when it's mixed with a knife rather than a brush. But if you like working in broad areas of flat color, you may find mixing with a knife preferable. It's up to you.

Seeing Pure Color as Value

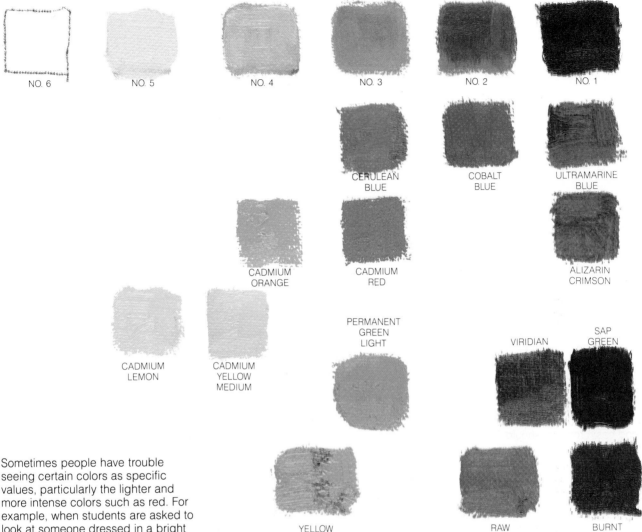

NO. 6 NO. 5 NO. 4 NO. 3 NO. 2 NO. 1

CERULEAN BLUE COBALT BLUE ULTRAMARINE BLUE

CADMIUM ORANGE CADMIUM RED ALIZARIN CRIMSON

CADMIUM LEMON CADMIUM YELLOW MEDIUM PERMANENT GREEN LIGHT VIRIDIAN SAP GREEN

YELLOW OCHRE RAW SIENNA BURNT UMBER

Sometimes people have trouble seeing certain colors as specific values, particularly the lighter and more intense colors such as red. For example, when students are asked to look at someone dressed in a bright red shirt and dark blue slacks and identify the values they see, very often they'll say "dark" for the slacks, but "red" for the shirt!

When you're painting a scene, it's important to be able to identify each color you use as a specific value. Bright, strong colors often suggest a light value to people, while grayed, less intense color may suggest a darker value. But they are confusing value with intensity. Remember, each color has a specific hue, value, and intensity as it comes from the tube. Try to keep them separate.

LEARNING THE VALUES OF YOUR COLORS

The value chart above shows a good way to chart your colors. Of course, individual perceptions may vary slightly, and you may disagree with some of the values, but as long as you get the idea, you shouldn't have too much of a problem charting your colors.

MAKING YOUR OWN VALUE CHART

Use a canvas panel 8″ × 10″ (20 × 25 cm) or larger, depending on the number of colors you have.

1. Paint a black–and–white value scale across the top—five values plus white. You may find it easier to start at the left with ivory black and then add more and more white to it as you work to the right, or you can start with white and work toward black, whatever is most comfortable.

2. Now, put the colors you normally use—you don't have to use the ones shown in the chart above—in their usual order around the edges of your palette. Then match each color with one of the black–and–white values. Don't adjust the tubed color by mixing

it with another color or with black and white, but use it just as it is when you squeeze it out of the tube. It might be hard to judge the values at first, and you may mess up several panels in the process, but in the long run the practice is worth it.

Notice that several colors on the chart fall between two values. Cadmium yellow, for instance, seems to be between 4 and 5 on the scale, yellow ochre between 3 and 4, and viridian between 1 and 2. This is fine. For now, just place such colors between two of the values, as it's done here. Once you have learned to discern subtle value differences, you may want to make a value scale that contains nine or more values plus black and white.

Mixing Darks

If a good, rich dark is a value or two lighter than a monochromatic dark (a neutral dark of no particular color), the slightly lighter but more colorful dark will appear deeper and richer. Darks need to have a feeling of luminosity and atmosphere, and getting some color into them is the best way to achieve this.

MAKING DARK COLOR MIXTURES

When you want a "color" dark, try using one of the basic combinations shown on this page. The colors used to mix them are listed below. Many of these colors can be interchanged, and so you should try these mixtures first and then experiment by switching the individual colors around.

A. Burnt sienna and
 ultramarine blue
 or phthalo blue.
B. Burnt sienna,
 viridian, and
 burnt umber.
C. Alizarin crimson and
 ultramarine blue
 or phthalo blue.
D. Ivory black,
 burnt or raw umber,
 burnt sienna, and
 raw sienna.
 (You can also mix phthalo blue,
 ultramarine blue, or viridian with the
 ivory black.)
E. Cadmium red and
 permanent green or
 permanent green light. (These
 colors make lighter, brighter darks.)
F. Cadmium red and
 viridian.

When you want a dark dark but *don't* want a color, use ivory black. It might be necessary to do this, for example, when a painting is filled with color and you need a dark—and a pure black (rather than a mixed black) can be just the right touch.

LIGHTENING DARKS

You may want to try lightening your darks with a warm color, not white. Actually, try to use white as little as possible to lighten middle and dark values because it makes them look muddy and heavy. Naturally, use white for light values, but even then try to make sure each light area contains a "color idea"—a slant toward a particular color. White is necessary for lightening colors—it just shouldn't be the *only* way to lighten them.

A

B

C

D

E

F

Mixing Lights

Pure white or a cool white often appears less white than white paint with a touch of warmth. So if a white looks dead, a touch of cadmium orange will give it life. Even if the area is cool, if you really need a light light, add a touch of warmth to the white.

Look at these swatches and note the large proportion of white pigment compared to the small amounts of strong colors such as cadmium orange, cadmium red, and alizarin.

MIXING WARM LIGHTS

To mix warm lights, always start with white and then add the smallest touch of color to it. If you add too much of a strong color like cadmium orange, for example, you'll just end up wasting a lot of white paint to get the white you want. If this should happen, rather than try to add more white to the mixture, just start a fresh pile of color—but this time, take less cadmium orange, or add a touch of the first mixture instead of the pure color to the white paint.

Swatches G through J are just examples of the warm colors you can add to white and still have it read as "white." Interchange the colors in your own swatches and try adding other pigments that might work better for you than these do. The following colors were used in the swatches shown:

G. Titanium white,
 cadmium lemon, and
 cadmium orange.
H. Titanium white,
 cadmium yellow light,
 cadmium lemon, and
 alizarin crimson.
I. Titanium white,
 cadmium lemon,
 cadmium yellow light, and
 cadmium red.
J. Titanium white,
 cadmium lemon,
 alizarin crimson,
 cadmium orange, and
 cerulean blue.

Sometimes adding only one warm color to white is enough. You don't have to add several colors—it all depends on what you want. On the other hand, the last swatch is a nice combination of colors that suggest both warm and cool tones. Try this one without orange, too.

MIXING COOL LIGHTS

Here are some ideas for mixing cool lights, as shown in swatches K through N:

K. Titanium white, cerulean blue, and alizarin crimson.
L. Titanium white, ultramarine blue, and alizarin crimson.
M. Titanium white, phthalo blue, alizarin crimson, and cadmium lemon.
N. Titanium white, cerulean blue, alizarin crimson, and cadmium orange.

Try the last two examples without the respective complements, yellow and orange. These colors add a nice mellow quality to the white, but they also neutralize the color. (For example, swatch K is the same as swatch N, but without the orange.)

In making your swatches, try not to overmix your colors. Keep the color identity of individual hues visible in some areas of the swatches, along with a small area of completely blended color.

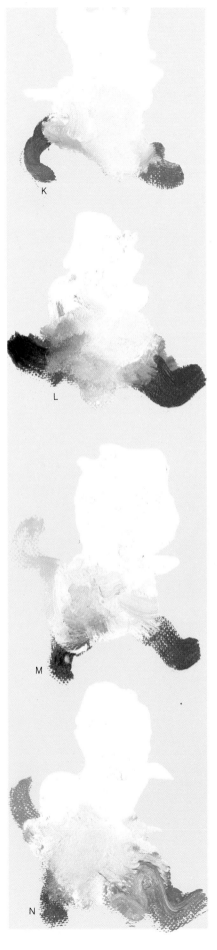

Mixing Greens

Experimentation is essential in capturing color. This is especially true in landscape painting, since you often have to mix the predominant colors in landscapes—greens—with a variety of pigments to get just the colors you want. If you were to look at a single leaf in a large bush, for example, green is the initial color you'd see. But if you wanted to capture that scene on canvas, painting the entire bush "green" certainly would not be the answer. If you looked at the scene more closely, you'd probably see other colors—purple-blue grays in the distant trees, and cool, milky grays and

even yellows in the bush itself—that you'd want to include in your painting. If you've done a good deal of landscape work you may be familiar with some of these mixtures.

When you make your swatches, you can experiment by substituting several yellows for the one suggested here. Don't worry too much about what they're called. Just notice whether they're warm or cool, and whether they appear to blend well or dominate a mixture. Naturally, this applies to all colors, not only yellow. Every company has different formulas for colors, just

as they have different numbers for their brushes. So one company's cadmium red might look almost like an orange, while another company's might look more like the cooler vermilion red. Yellows especially seem to vary a lot. As for blues, Grumbacher's cerulean blue is very opaque, while Winsor & Newton's cerulean is much more transparent.

MIXING WARM AND COOL GREENS
When you mix greens, you must be aware of which of your tubed colors are warm and which ones are cool. Naturally, it would make sense in

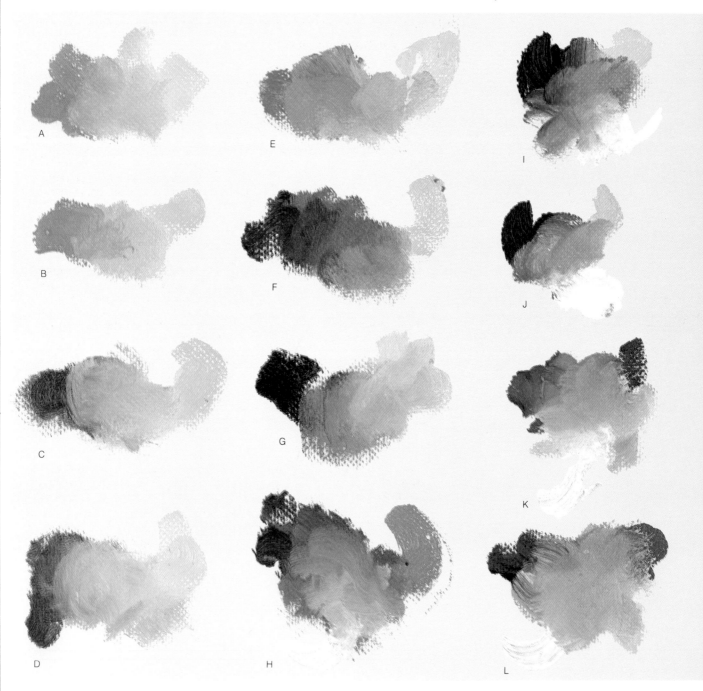

mixing warm greens, for example, to start with cool colors. Look at the swatches.

Swatches A through D were mixed only with warm and cool versions of green and yellow. Swatches E through H were mixed with warm and cool blues and yellows. (Of course, all blues are cool, but some are relatively warmer than others.) Swatches I and J were mixed with ivory black and yellow. White was deliberately omitted from all these mixtures, since white cuts the intensity of the color. Also, you should first see how the mixtures look with pure color before lightening or otherwise changing the mixture.

The rest of the mixtures, swatches K through O, consisted of three colors plus white. This final grouping makes the most interesting color combinations. Notice that within each of the three-color mixtures there are possibilities for both warm and cool greens, depending on the amount of yellow. The white lightens the mixture as well as making it more neutral. Of course, these mixtures represent only a few of the possibilities. You can find many more by interchanging the colors or trying other colors and combinations that might work even better for you. So don't look at these swatches as "rules for painting greens." See them as tools to help you start experimenting. Never feel you must always use a certain yellow or a certain green or blue.

As in any mixing situation, you must get to know which colors dominate in a mixture and which colors are weak. A little bit of cadmium yellow, for instance, goes a long way. And since cerulean blue is a comparatively weak color, when you mix the two, you'll need to add more cerulean blue and only a little bit of cadmium yellow to make a green.

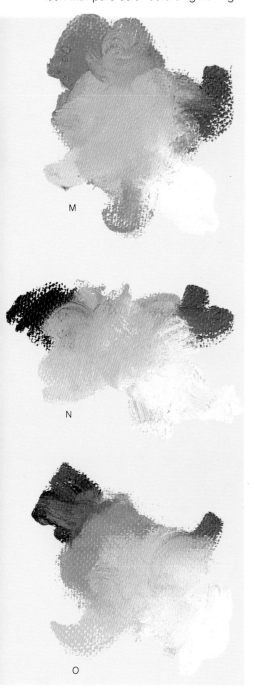

M

N

O

MIXING A VARIETY OF GREENS
The swatches below show mixtures that make some of the many greens found in nature. They range from the most obvious green-yellow blends, through blue-yellow mixtures, to more complicated combinations involving the addition of a complement with white. These are the colors used in the mixtures:

A. Permanent green light and cadmium lemon (cool).
B. Permanent green light and cadmium yellow light (warmer).
C. Sap green and cadmium yellow (still warmer).
D. Viridian and cadmium lemon (cooler).
E. Cerulean blue and cadmium lemon (cool).
F. Ultramarine blue and cadmium yellow light (warmer).
G. Phthalo blue and cadmium lemon (cool).
H. Ultramarine blue and yellow ochre (warm and neutral).
I. Ivory black and cadmium lemon (cool and neutral).
J. Ivory black and cadmium yellow light (warm and neutral).
K. Cobalt blue, alizarin crimson, cadmium lemon, and titanium white (mellow, somewhat cool).

L. Ultramarine blue, cadmium red, and cadmium yellow light. (Warmer and a bit harsh. Cadmium red seems more difficult to mix than alizarin crimson for darks. And phthalo blue seems easier to use in mixtures than ultramarine blue—it seems cleaner. The reason is probably that phthalo blue and alizarin crimson are both transparent colors).
M. Cerulean blue, alizarin crimson, cadmium lemon, and yellow ochre. (The ochre is suggested primarily for experimentation. You may want to leave it out as a rule, since it adds an opaque heaviness to an otherwise nice combination.)
N. Phthalo blue, alizarin crimson, cadmium lemon, and titanium white. (These colors are good, clean mixers, though you might try a cadmium yellow in place of the cadmium lemon.)
O. Ultramarine blue, alizarin crimson, and cadmium yellow light. (Because of the warmer yellow and blue, this combination tends toward a warmer green.)

Mixing Grays

Grays should never be just gray. A good gray should be a color that's rich even though it's subdued.

MIXING INTERESTING GRAYS

Paint swatches like the ones on this page sometimes look lovely in themselves. Perhaps it's the pure color seen next to the partially blended color, together with the resulting gray—all in one miniature "color-field" painting. These color swatches should teach you not only how to mix grays, but also how to use them in your oil paintings. A combination of pure color against more neutral color suggests a richness that wouldn't be possible with a combination of colors of equal intensity. The second lesson is that partially mixed colors are often more interesting than thoroughly mixed colors. When you mix grays, try not blending them completely—make sure you can see the individual colors that have gone into a particular mixture.

Train your eye to see proportions, too. The color you'll end up with is as much the result of the *proportions* of colors in the mixture as the specific colors you use.

Mixing complementary colors is the usual way to make grays. The following color mixtures were used to make the paint swatches shown:

A. Sap green,
 cadmium red light, and
 titanium white.
B. Viridian,
 alizarin crimson, and
 titanium white.
C. Sap green,
 burnt sienna, and
 titanium white.
D. Ultramarine blue,
 cadmium orange, and
 titanium white.
E. Cerulean blue,
 cadmium orange, and
 titanium white.
F. Phthalo blue,
 alizarin crimson, and
 cadmium yellow.
G. Ultramarine blue,
 alizarin crimson, and
 yellow ochre.
H. Cobalt blue, and
 burnt umber.
I. Ultramarine blue,
 raw umber, and
 titanium white.

These are only some of the combinations you can use.

MIXING WARM AND COOL GRAYS

Try mixing cool complements like viridian or phthalo blue and alizarin crimson along with a cool cadmium lemon for cool colors, and use warm complements like sap green or ultramarine blue and cadmium orange for warm mixtures. You must begin to become aware of the relative warmth and coolness of colors within the same color family. For example, all blues are cool, but phthalo and cerulean blues tend to be cool blues, while ultramarine blue is warmer. Alizarin crimson is a cool member of the red family, and cadmium lemon is cooler than cadmium yellow light. Of course, you don't have to mix only cool complements. You can intermix warm and cool complements, too. For example, swatch C is a cool cerulean blue and a warm cadmium orange.

Look at the swatches and see which combinations tend to be warm and which ones are cool. Notice that within each swatch there are warm areas as well as cool ones, depending upon the color that dominates the mixture there.

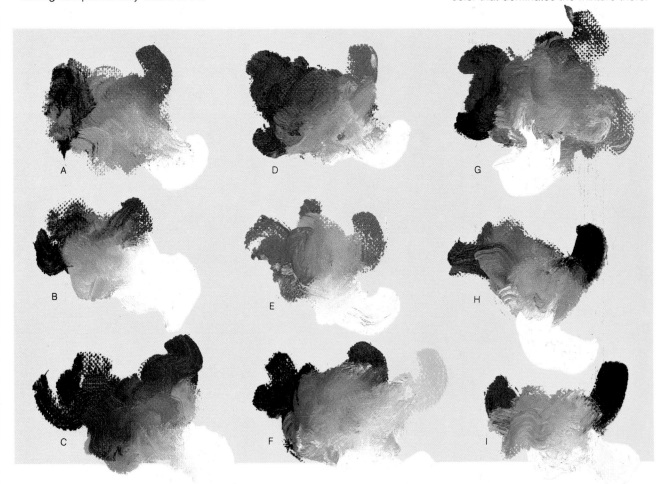

Mixing Flesh Tones

The colors you use for flesh tones have very little to do with getting a good skin color. What does matter is the quantity and proportions of the colors in the mixture, where you place them on the figure, and how you mix and relate them to the rest of the picture.

MIXING BASIC FLESH TONES

The swatches on this page illustrate variations of the basic mixtures Charles Reid uses for flesh tones. They usually consist of a red (cadmium red) and a yellow (cadmium yellow, cadmium yellow light, yellow ochre, raw sienna) for the warm areas. To cool them, he uses cerulean blue for the light areas and viridian green for the darks.

There aren't any set proportions you should use, though you may tend to use more cadmium red in the mixture than cadmium yellow because the yellow is a stronger color. Use the same colors in both the light and shadow areas. The only difference might be substituting raw sienna for yellow ochre in the shadow.

The following colors were used to make the paint swatches shown:

J. Titanium white,
cadmium red, and
cadmium yellow.
Try this basic combination first before adding a complement such as blue or green.

K. Titanium white,
cadmium red light,
cadmium yellow pale
(or cadmium lemon, or cadmium yellow,
or any other yellow you'd like to try), and
cerulean blue or permanent green light.
This is a basic light flesh tone to try. Mix all of the above as a single complexion color, or use only the red and one of the yellows with a complementary color. Don't look for a formula. You must experiment!

L. Titanium white,
yellow ochre,
cadmium red,
any one of the cadmium yellows, and

cerulean blue or
permanent green light.
This makes a more subtle flesh tone. It's less vibrant than the others because the yellow ochre is so quiet, but it's included here because some students have trouble with yellow. They tend to add too much, and their mixtures get orange.

M. Titanium white,
raw sienna or
yellow ochre,
cadmium yellow, and
viridian or
cobalt blue or
ultramarine blue.
This is a darker mixture than the others—try it for shadows or darker complexions.

PAINTING DIFFERENT SKIN COLORS

There are no unique colors for painting the flesh of blacks, Hispanics, or any other racial groups. You can always use the same colors. The difference is in the proportions of certain colors and how dark you'll make your "light" wash. For example, you'd use the same colors for the *shadow* of a white person that you would use in the *light* areas of a black person. It's true that on a dark-skinned person the colors would generally be darker and certain hues might seem more apparent—you might, for example, be more aware of the blues. But blue tones are on white skin, too. In fact, the mixture for a person with fair skin would have more blue and less red-yellow than, say, a person with olive skin. That's why there are no set formulas for painting flesh tones—because the proportions of the colors are as varied as the colors of each individual.

The proportion of warm to cool color also depends on the clothing the person is wearing, since the clothing reflects its colors onto the skin. It is also influenced by the colors of the surroundings and the color idea of the painting. You can never separate the flesh tones from the rest of the picture. You must harmonize and relate all your colors. Thus, a warm complexion surrounded by cool color might look "off" unless both areas are integrated.

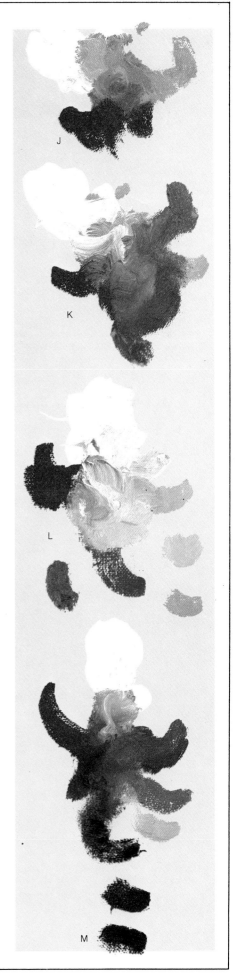

PAINTING LANDSCAPES

Landscape painters are fascinated with the
beauty of the great outdoors. Whether it is
a sunlit meadow flanked by gnarled moody
trees, or a winding road with a distant view
of mountains and a clouded gray-blue sky,
the many possibilities of the natural
outdoors challange and stir the landscape
painter.
The purpose of this section
is to help you learn how top professional
landscape painters develop their paintings
through step-by-step demonstrations. This
section shows the various mixtures these
artists have used to achieve different effects,
how they've started with strong colors
(subduing them later if necessary), focused
on shapes, used warm and cool colors or
light and heavy colors, used slight strokes
or scumbling to suggest branches or
intricate bushes.

Mountainous View in Perspective

1. After making a quick brush drawing in cool tones (blue softened with a touch of brown) that reflect the general color of the landscape, the artist blocked in the planes of the mountains in mixtures of a warm, subdued blue (such as ultramarine or cobalt), yellow ochre, and alizarin crimson. Notice that each shape gradates from dark at the top to light at the bottom, making the divisions between planes more distinct. The cloud forms were begun with mixtures of these same three primaries softened with more white.

2. Next, the artist brushed in the brighter tones of the foreground. Brilliant yellow-greens such as these, with a hint of ruddy warmth, can be made from yellow-blue mixtures (cadmium yellow light and ultramarine or phthalocyanine for greater intensity) or yellow-green combinations (such as cadmium yellow light and viridian or phthalocyanine green for greater intensity), warmed with a hint of cadmium red light or burnt sienna. The darker greens of the trees were blue-brown combinations (such as phthalocyanine or Prussian blue and burnt sienna) or green-brown combinations (such as viridian and burnt sienna). The dark shadows beneath the trees were painted with a similar mixture.

3. (Opposite page, top) Brighter greens were introduced into the trees in the right and left foreground. Like the grass, these greens can be made with yellow-blue combinations or yellow-green combinations: cadmium yellow light; ultramarine for a more delicate green; phthalo blue or Prussian blue for a stronger green; viridian or the more brilliant phthalocyanine green. The warm hues in the trees are a red-brown earth color such as burnt sienna or Venetian red, though the latter is so powerful that it must be used sparingly. The artist warmed the sky with more yellow ochre and darkened the nearest mountain range with more blue to make a more distinct separation from the distant ranges.

The artist warmed the grass with more hot color (cadmium red light or burnt sienna) and added a warm reflection (alizarin crimson) in the lake. The shape of the road was sharpened; fence posts were added for perspective; and he blocked in the house, along with the shadows to the right. The house is a blue-brown mixture and the hot tone in the road contains cadmium red light. Notice that at this stage, the artist was still experimenting with the shapes of the distant moun-

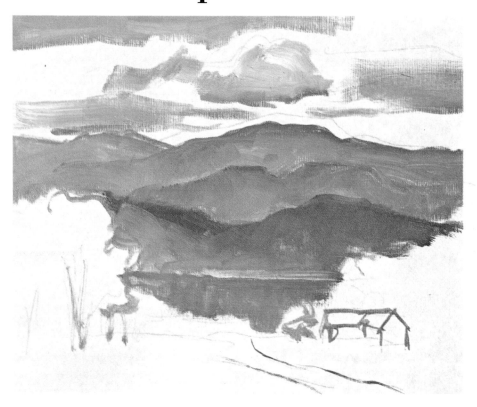

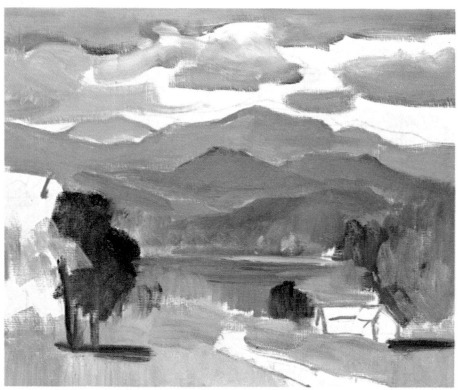

tains. The lake was painted with the same blue-crimson-yellow-white mixtures used in the clouds.

4. (Opposite page, bottom) The multiple planes of the mountains were now clearly defined, and the artist

worked on final details (sunlit foliage, foreground grass, tree trunks and branches) and began to subdue his colors. It's a good idea to start with strong colors and then subdue them, rather than start with muted colors and struggle to heighten them later on. The

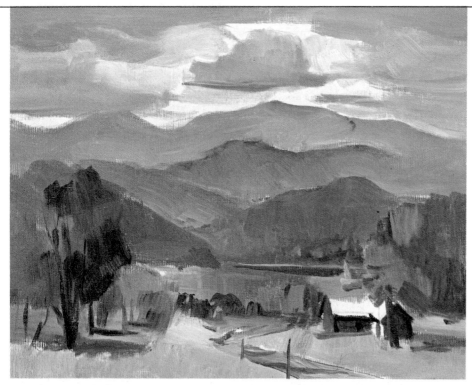

artist now began to introduce many more cool colors in the sky—more blue, a hint of yellow ochre, and white. The nearest mountains were darkened with more blue, and the reflections in the lake were defined more clearly. The darks of the trees were strengthened. In choosing a palette for this type of landscape, remember that ultramarine blue will give you more delicate greens, while phthalo blue or Prussian blue will give you bright greens (and phthalocyanine green will make them brighter still). Cadmium yellow light is essential, and cadmium red light, alizarin crimson, and either burnt sienna or Venetian red are important for the warm tones. In the sky, you may prefer cobalt blue to ultramarine.

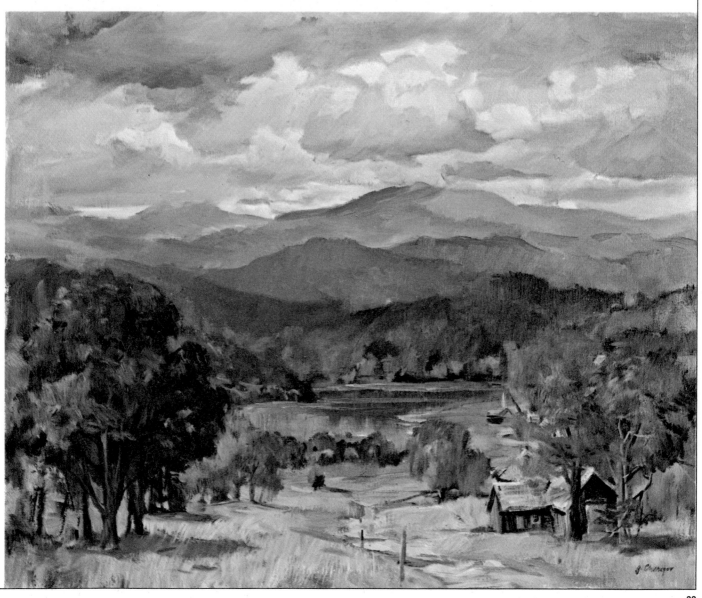

Reflecting Autumn's Colors in Water

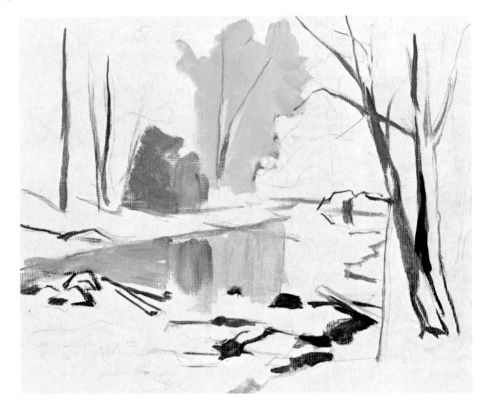

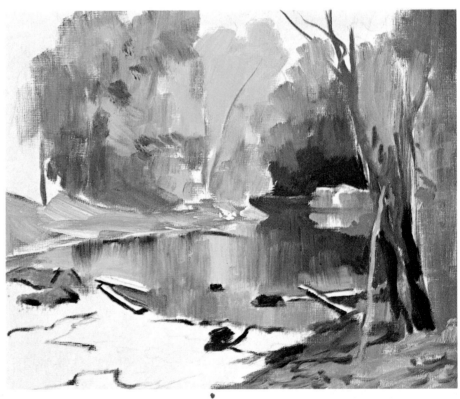

1. The artist's preliminary brush drawing focused on the shape of the stream—the shore lines were carefully drawn—and indicated a few other details such as floating logs, rocks, and the more important tree trunks on either side of the water. The leafy edge of the brilliant central tree upstream was drawn, since this tree will be the brightest reflection in the water. The artist blocked in both the tree and its reflection in cadmium yellow light, with just a hint of cadmium red light. The orange reflection and the small tree above it are also a blend of cadmium red light and cadmium yellow light, but with a greater proportion of red. The bit of cool green—cadmium yellow light and ultramarine blue or viridian—would provide relief from all this hot color. At this stage, it was obvious that most of the "water colors" would actually be the hot colors of the landscape surrounding the stream; very little of the water would be cool.

2. Because water always takes its color from its surroundings, the artist painted the woodland colors and their reflections at the same time. Mixtures of cadmium yellow light and cadmium red light were modified by burnt sienna and a touch of ultramarine blue for the darker colors. The strong violet was made with ultramarine blue and alizarin crimson. The grays of the rocks and tree trunks are blue-brown mixtures of ultramarine blue and burnt sienna or burnt umber.

3. (Opposite page, top) Now the artist concentrated on the blue sky, which was reflected in the rapids in the foreground. He painted the sky and rapids with his favorite combination of cobalt blue, alizarin crimson, yellow ochre, and white. In the rapids, the same combination was intertwined with the hot reflections of the forest; the darks were painted with a blue-brown combination such as ultramarine or phthalo blue and burnt sienna or Venetian red. The artist began to use dark strokes of this same type of mixture to define tree trunks, fallen logs, and rocks. The trees in the upper left were carried to the edge of the canvas, and the artist began to suggest foliage and fallen leaves with smaller strokes.

4. (Opposite page, bottom) The entire canvas was now covered with wet color, and the artist could concentrate on refinements and details. To strengthen the contrast between the rapids in the foreground and the tranquil reflections beyond, he intro-

duced more cool color—blue and white mixtures—in the lower left. He also added "sky holes" of cool color at the top of the canvas. More delicate yellows and yellow-oranges were introduced among the trees, and the single patch of green was subdued to a mere

hint of cool color reflected in the water. The hot tone at the far end of the stream was made lighter and more atmospheric. The nearby tree trunks on the right contain many more subtle grays, which are blue-brown combinations. Finally, the artist picked out

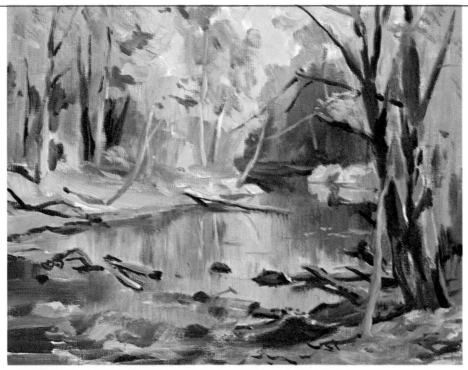

details of sunlit leaves, trunks, branches, floating leaves in the water, and fallen leaves in the foreground with slender brush strokes. Notice how many cool colors now appear among the warm passages. For this type of landscape, the most important colors on the palette would be cadmium yellow light and cadmium red light; a subdued blue such as cobalt or ultramarine, with some help from a stronger, cooler blue such as phthalo blue or Prussian blue in the water mixtures; alizarin crimson, burnt sienna, and perhaps Venetian red for some of the hotter passages; with some help from yellow ochre and burnt umber in the quiet areas.

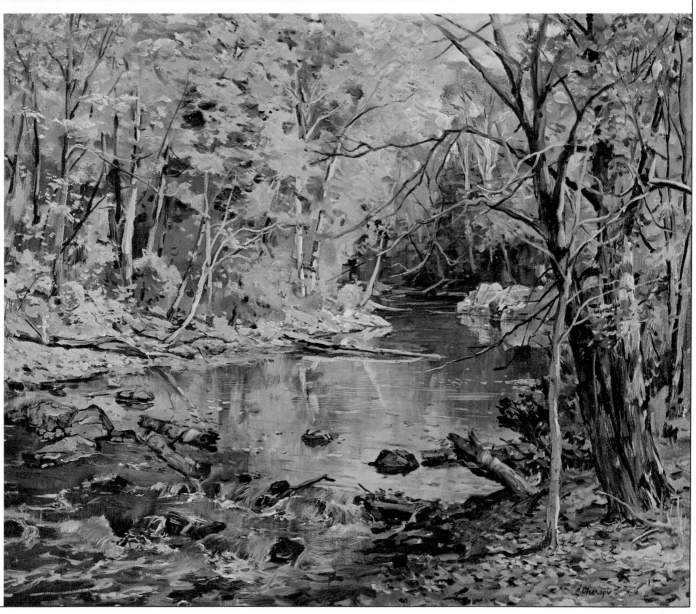

Painting Warm and Cool Hues

1. The artist drew the tree trunks in warm tones that suggested the general warmth of the colors to come. Then he began to block in the sky with delicate mixtures of the three primaries (red, blue, and yellow). For a particularly airy sky tone, he prefers cobalt blue to the slightly heavier ultramarine, plus alizarin crimson, yellow ochre, and white.

He began to brush in the darks of the nearby tree trunks and suggest the dark shape of a fallen log in the foreground, working with burnt umber, a heavier, more subdued brown than most other earth colors. The sky colors were carried down to the horizon with deeper mixtures of cobalt blue, alizarin crimson, yellow ochre, and white.

2. Next the artist brushed warm colors across the foreground, keeping these more subdued than the hotter tones of the trees. For such foreground tones, the yellow-brown and red-brown earth colors—yellow ochre, raw sienna, burnt sienna—are particularly effective, heightened with cadmium yellow light or cadmium red light. The large areas of the foliage were brushed in with brighter mixtures of cadmium yellow light, cadmium red light, and alizarin crimson, softened with white, earth browns, and an occasional hint of a warm, subdued blue such as ultramarine or cobalt. Notice how the sky colors are carried in among the trees.

3. Now that the entire canvas was covered with wet color, the artist began to define the shapes of the tree trunks, the edges of the foliage, and the trees at the left. The darks of the tree trunks are mainly burnt umber, modified with white, blue, and an occasional trace of alizarin crimson. The tree to the extreme left is mainly alizarin crimson and ultramarine blue.

4. With all the broad shapes blocked in, the artist could now concentrate on details. Bright touches of yellow, yellow-orange, and orange were added selectively to the foliage. The artist broke some blue "sky holes" through the warm tones of the foliage. With a slender, pointed brush, he traced the lines of branches and twigs, grasses and weeds along the ground, and fallen leaves. The hot touches of cadmium yellow light and cadmium red light were slightly muted with earth colors to prevent them from popping out. Notice how the artist introduced hints of blue among the tree trunks to make the darks cooler. The most important colors on the

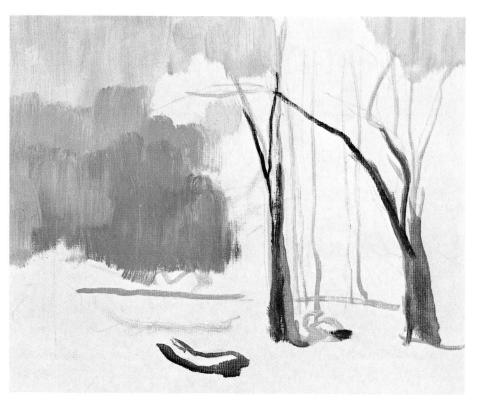

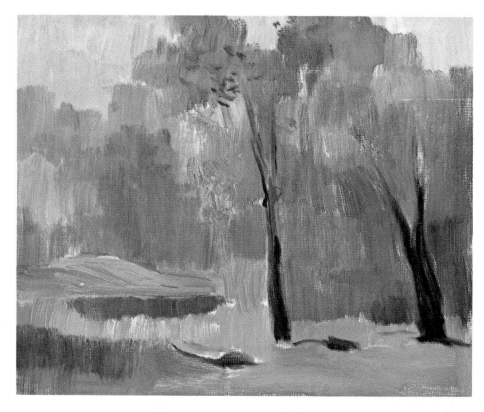

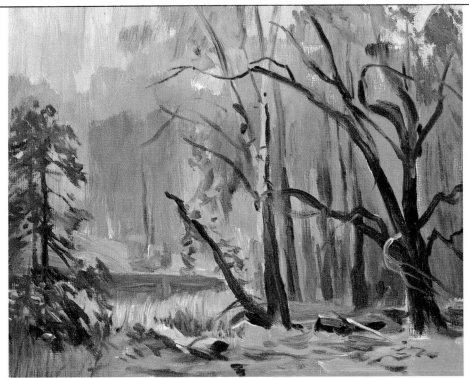

palette for this type of picture would be cadmium yellow light and cadmium red light, of course; a subdued blue such as cobalt or ultramarine, perhaps with some help from phthalo blue or Prussian in the darks; alizarin crimson, used sparingly; and a range of earth colors that would include yellow ochre or raw sienna, burnt sienna or Venetian red, and burnt umber for the heaviest browns—provided that this somber color wouldn't be allowed to invade the brighter colors on the canvas.

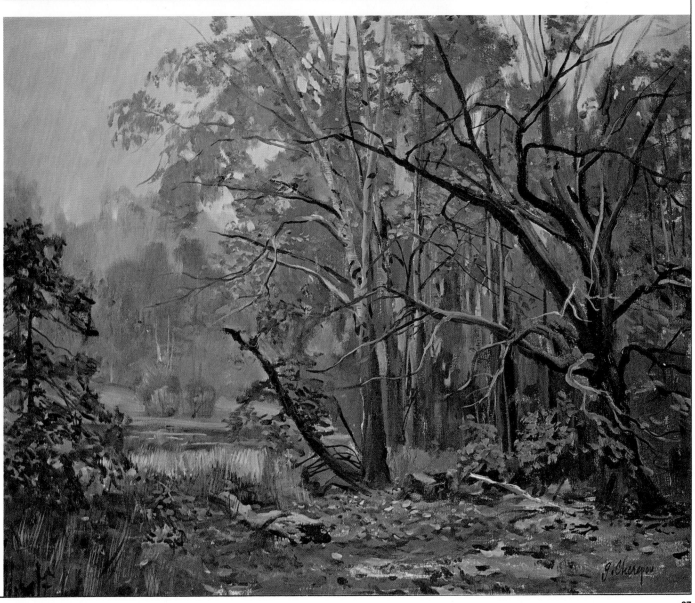

Painting Sunlit Colors

1. The artist began with a grayish brush drawing to define the road and the trees in the foreground, paying particular attention to the gnarled tree to the left, which he drew in much more precise strokes than the rest of the landscape. Except for a few strokes to suggest distant tree trunks, he made no attempt to draw the intricate foliage; this would be developed later. Grays like the tones of this brush drawing are more interesting if they are made from blue-brown mixtures rather than steely black and white.

The most complex single form in the painting would be the old tree, which the artist began to paint in a beautiful range of grays. Such colorful grays are always mixtures of blues (ultramarine, phthalo, or Prussian) and earth browns (burnt umber, raw umber, burnt sienna, or Venetian red) with yellow ochre for a suggestion of golden warmth. The hot colors at the edges, particularly the reflected light in the shadows at the left, can be burnt sienna or Venetian red. This brilliant note of reflected light will be muted later on, but it's always best to start out with strong colors and subdue them in the final stages of the painting.

2. Brilliant greens and green-golds like those in the foreground are usually yellow-blue or yellow-green combinations. Cadmium yellow light and phthalo blue (or Prussian blue) will yield particularly brilliant greens and yellow-greens. So will cadmium yellow light and viridian or phthalocyanine green. The artist also warmed these sunlit portions with a reddish tone such as cadmium red light or burnt sienna. The shadow areas of the road were painted with mixtures similar to those in the tree trunks, while the lighted portions contain yellow ochre, a touch of cadmium red light, and a fair amount of white.

3. (Opposite page, top) The foreground mixtures—the brilliant greens and yellow-greens—were carried back into the distant trees. The sunny yellow-greens were warmed with cadmium red light. Pale blues (ultramarine or the more delicate cobalt can be most useful here) were introduced into the birches to the right. Touches of the bright road color were dashed in along the edges of the tree trunks on both sides of the road. Cool colors, containing more blue, were brushed into the shadows on the road. For touches of really deep green, such as

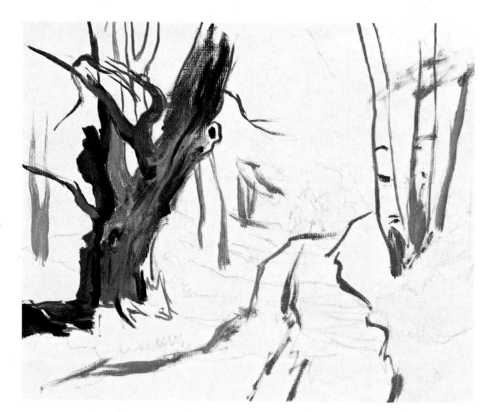

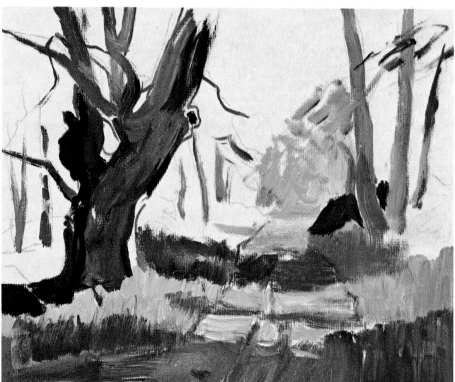

the artist used here, there are various possibilities: phthalo or Prussian blue with burnt sienna; or viridian with burnt sienna.

4. (Opposite page, bottom) Now that the entire canvas was covered with

wet color, the artist moved back in with smaller brushes to suggest details. Throughout the foliage he added touches of yellow-green to suggest leaves caught in the bright sunlight. Pebbles and weeds were painted on the road, which contains cooler notes

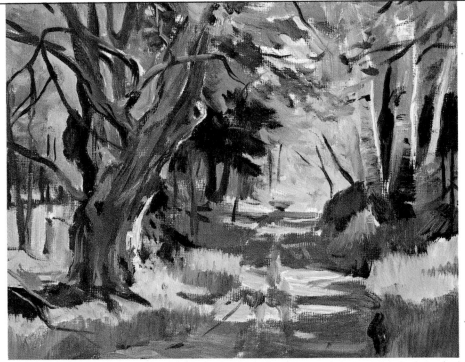

in the shadows. He also subdued the sunlit patches of the road with yellow ochre and white. Cooler grays, containing more blue, were painted into the gnarled tree trunk, though a hint of the warm shadow remains on the left-hand side. The horse and rider were added, along with more branches, grasses, and weeds. "Sky holes" were added at the top. The patches of light on the tree trunks were made paler. The palette for such a sunny picture would have to contain the two basic yellows, cadmium yellow light and yellow ochre; phthalo or Prussian blue for the richer green mixtures and the powerful darks; ultramarine blue (or perhaps cobalt) for the more delicate greens, and warm and cool grays; cadmium red light, burnt sienna, or Venetian red for the warm colors; and viridian or phthalocyanine green as an alternative to blue in some of the green mixtures.

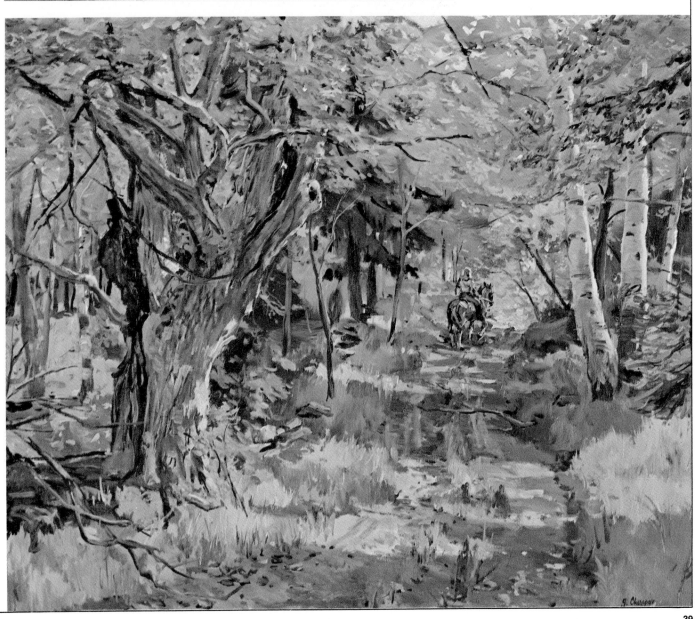

Painting Soft and Strong Colors

1. After making a simple brush drawing in cool tones, the artist began to block in the major colors that would appear both in the shore line and in the water. Such deep blues must be phthalo blue or Prussian, with burnt sienna, Venetian red, or light red in the warmer strokes. The deep, bright greens would have to combine cadmium yellow light and phthalo or Prussian blue with an occasional hint of red-brown earth color.

2. For the soft sky tone, the artist turned to a more subdued blue such as ultramarine or cobalt, plus alizarin crimson and yellow ochre. These colors were repeated in the pale water at the lower left. The deep greens of the shore line at the right—the same mixtures described in the previous step—were painted into the water. The flash of light on the mountainside is cadmium yellow light with a hint of a powerful blue such as phthalo or Prussian. For the touches of brown, the artist introduced burnt sienna, which also appears faintly in the water below. The strokes follow the contours of the mountains.

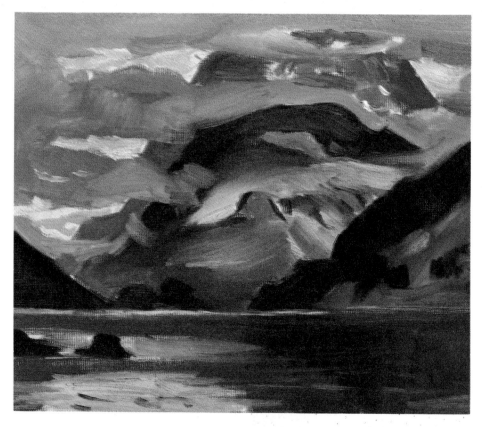

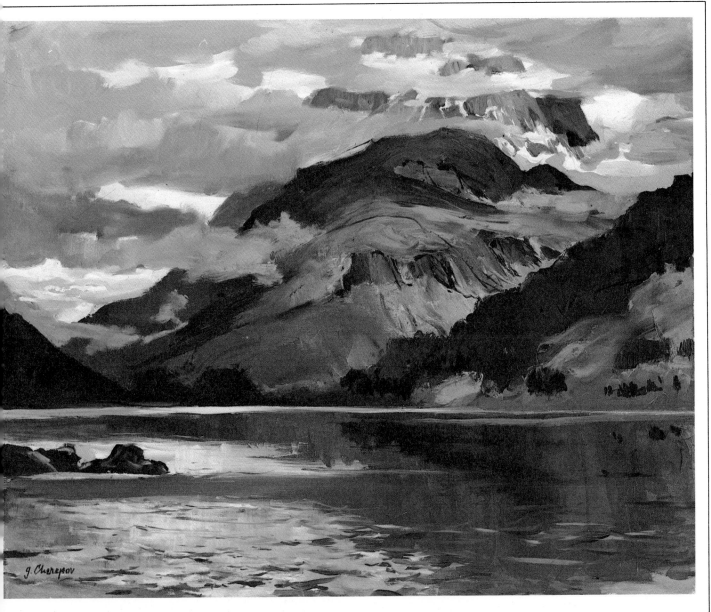

g. Cherepov

3. The clouds were cooled further with blue-white mixtures. The artist strengthened the contours of the landscape with crisp darks—which can be made with mixtures of red-brown earth colors and phthalo or Prussian blue—blended with more cadmium yellow light in the brighter portions. He then concentrated on details such as the sunlit mountainside and the ripples in the water, which were drawn with short, crisp strokes. The ripples are touches of blue that pick up the sky color. But notice how many hints of warm color there are in the light patch of water. These same warm colors appear among the clouds. Both types of blue are important in this type of painting: a strong, deep, cool blue like phthalo or Prussian for the deepest tones; and softer, more subdued blue such as ultramarine or cobalt for the softer blues and grays. The sky also contains alizarin crimson and yellow ochre. The darks on the mountainside contain a red-brown earth color such as burnt sienna, Venetian red, or light red. And atmospheric mixtures like those in the sky and water always need a great deal of white. Except for the ripples in the foreground, this sort of painting contains very few details, which means very few small strokes. Painting sky, mountains, and water means painting with big brushes and big strokes.

Conveying Atmosphere and Distance

1. Paul Strisik painted a group of tall, dignified aspens in the mountains on a luminous, overcast day. At the original site, the background mountains and fields were too horizontal; with the vertical trees, they formed a series of intersecting straight lines. In his initial wash-in, the artist varied the elements to make the composition more interesting. He gave the mountains a slanting contour and lowered the fir trees and the distant field to emphasize the *height* of the aspens.

He painted the sky with a very light gray wash mixed from yellow ochre and cobalt blue. The distant mountains were painted ultramarine blue grayed with ivory black and warmed with cadmium red medium. The artist mixed a wash of burnt sienna and ultramarine blue for the distant fields and used raw and burnt siennas in the foreground, with burnt sienna and ivory black for the weedy area in the nearest portion. For the pines, he made a warm mixture of phthalo blue and burnt sienna, and with his cloth, wiped out some of the turpentine wash for the light trunks of the aspens. He noticed that the dark trees looked *light* against the dark background mountains but *dark* against the light, overcast sky. This kind of "interchange" happens often in nature. Students often worry so much about an object's local color that they ignore its *value* in relation to its surroundings. Although the aspens are a light tree, they formed an unmistakable silhouette against a much lighter sky.

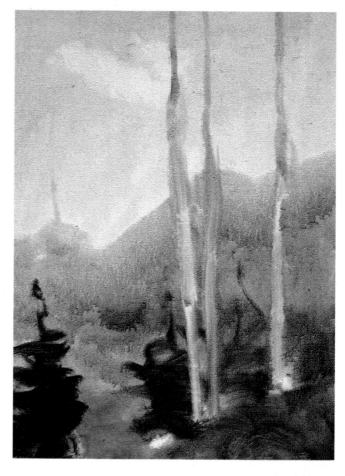

2. Here, the artist roughly applied thicker pigments for the sky, using ivory black and white. He then painted the mountain more solidly, using the same colors as before but with more pigment and white to give them body. Mr. Strisik used a variety of colors for the horizontal plane of the earth: yellow ochre and raw sienna, grayed slightly; burnt sienna; and occasionally cadmium red medium and ivory black for the bushes.

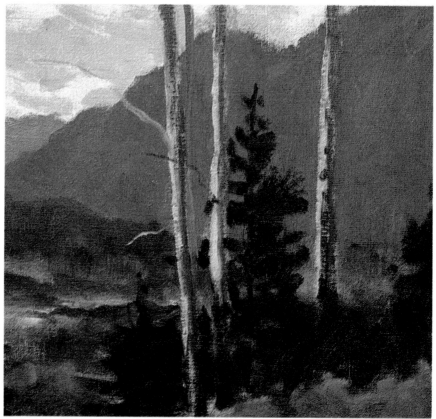

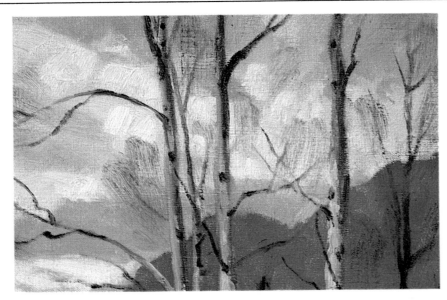

3. The artist refined the sky before developing the tree branches, and then he painted the more prominent limbs. He simply suggested the rest, rather than paint each of the hundreds of small branches (which would have created a tangle) by scumbling with a dull, reddish violet mixture. He then added and removed branches until the spatial divisions looked interesting. The artist added a dark tree on the right, filling up a distracting open area, and kept the pines (a mixture of ivory black and cadmium red) and bushes simple so they would remain a background for the trees. At this point he had enough information to finish the painting in the studio.

4. In the studio, the artist added atmosphere to the distance by introducing lighter values along the top edge of the mountains (ultramarine blue, white, and a touch of ivory black). By lightening this area, he suggested the effect of the brilliant sky eating away at it. The sky now looked more luminous.

He developed the branches, put a tree on the left—to stop your eye from going out of the picture—and added a few red (terra rosa) and yellow (yellow ochre) leaves. The artist used raw sienna where the leaves became dark against the sky. He did not overdo these spots, since an isolated dot can attract more attention than a large mass. He also added twigs and brush to the foreground. Since he couldn't paint each branch, he summarized the details in a silvery (ivory black and white) scumble. He applied the scumble with an up-and-down motion of the brush to suggest the way the brushes grew. A few dark branches explain what the scumble represents.

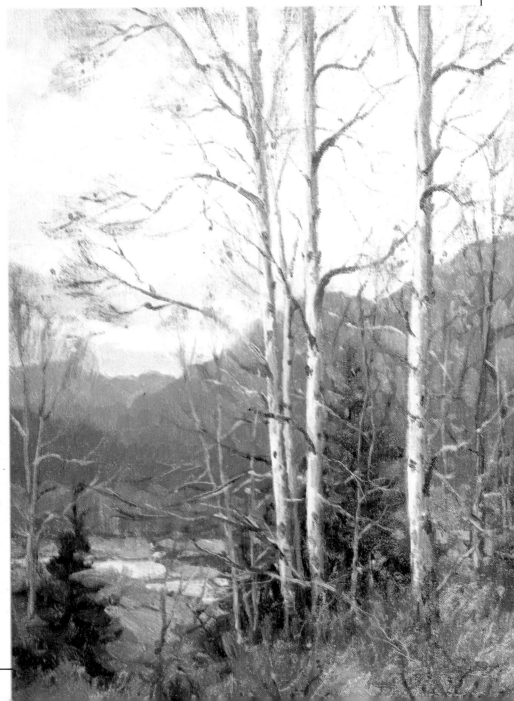

Aspens, 12″ × 16″ (30 × 41 cm), by Paul Strisik

Painting an Overcast Day

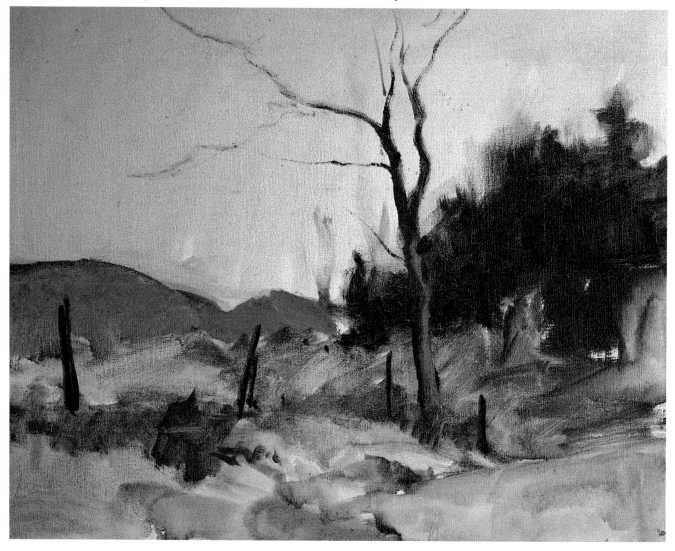

1. (Above) Paul Strisik first saw this site on a sunny day but felt it would be perfect on a day that was bright but overcast. He especially liked the lone tree silhouetted against the sky and was also attracted to the dynamic, contrasting movements of the sloping landscape.

To begin, the artist blocked in the picture with washes, exaggerating the contrasting, interlocking lines of the trees and hills. He painted the distant mountain cobalt blue and cadmium red medium, and mixed burnt sienna and phthalo blue for the background pines. The foreground bushes were painted primarily burnt sienna, dulled with ultramarine blue. To paint the road he switched to yellow ochre, grayed with a little ivory black. The foreground rocks were painted ivory black and white; the main tree, ivory black; and the sky, too, was painted a thin wash of ivory black. That may seem like a lot of black, but washes of

this color would suggest the character of a silvery gray day—and would also relate well to the greens and yellows that would be added to the painting later on. When the artist added these warm colors, the grayish mixtures would take on a subtle violet tinge.

2. (Opposite page, top) At this point the artist painted the sky more thickly, using a mixture of ivory black and white, with touches of cadmium yellow and white in the brightest areas. Farther away from the sun, the sky became less warm and brilliant, and so he replaced the cadmium yellow with orange. Because this was a subtle matter, the artist tried to vary the color so that the change would be *felt* rather than seen. In order to assure that the sky farthest from the sun would have less energy in it, he also grayed these areas with a hint of ivory black and white.

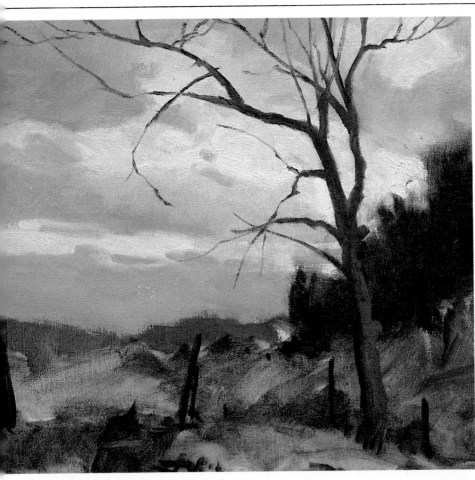

3. (Below) After painting the sky, the artist developed the branches of the tree. The painting had been thoroughly established at this stage. Further refinements would be like grace notes in a piece of music—they would add to the work but wouldn't be important in a structural sense.

The artist emphasized the quality of an overcast day by scumbling with a silvery gray color reflected down onto the land from the sky. Notice, for example, how gray and light the road is at its crest. Cadmium red medium, black, and white gave the artist the color he wanted for the hundreds of small tree branches against the sky. The posts and rocks on the left were included to balance the weight of the dark pines on the right. Notice, by the way, that although the artist kept the mass of firs simple, he did a few of the nearer trees more carefully; they explain the mass without breaking it up. Later, in the studio, he made a few subtle adjustments and corrections to finish the painting.

The Sentinel, 16″ × 20″ (41 × 51 cm), by Paul Strisik

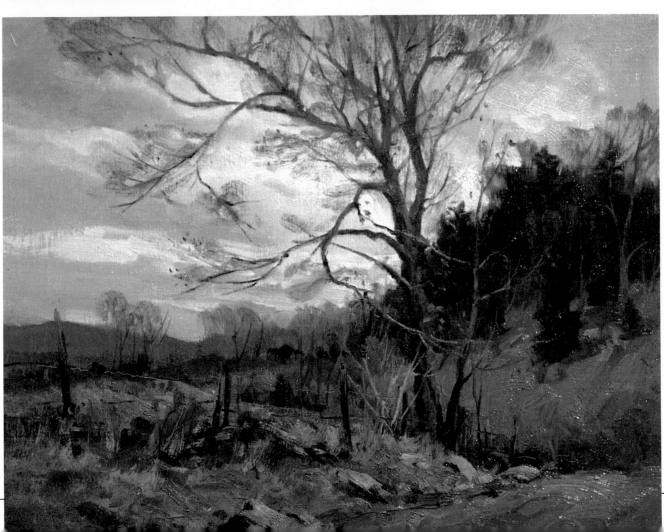

Unifying Color

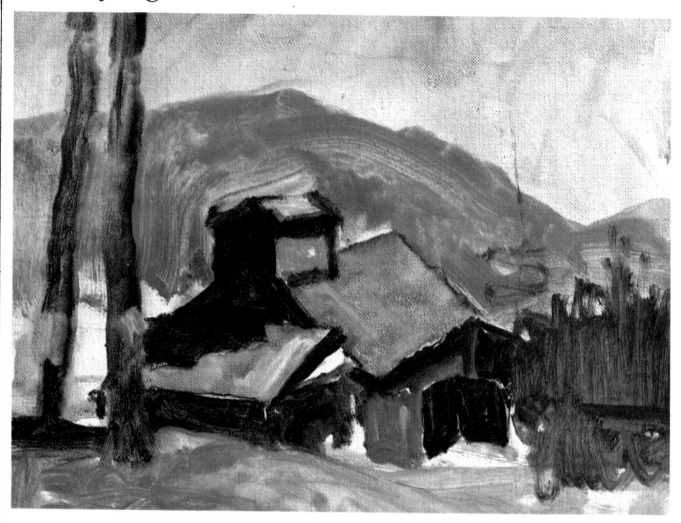

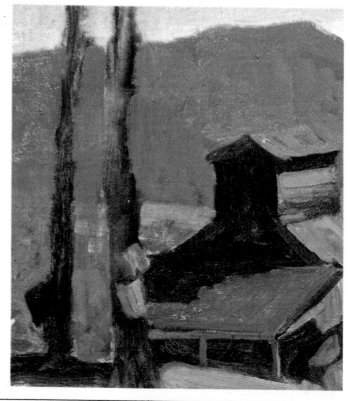

1. Paul Strisik found a sugar shack in Vermont especially interesting to paint because it was made of a variety of old materials. Because nothing matched, the building had its own distinctive shape and character.

The artist lowered the mountain and varied its shape in order to avoid a domed look. He tried to establish the strong light-and-dark pattern early. He painted the mountain in ultramarine blue with a touch of cadmium red medium, and the shadows, ultramarine mixed with burnt sienna. All the darks were painted the same color at this stage, since the artist was trying to establish value rather than color. The foreground was painted a light wash of yellow ochre.

2. Mr. Strisik painted the mountain flatly and more solidly. He added a hint of the green fields in the distance, using a mixture of cobalt blue and yellow ochre grayed with a touch of the gray-violet hue of the mountain. The patches on the rusty roof were painted with a mixture of warm, dull reds (mostly terra rosa) and burnt sienna, with hints of cobalt blue and white in the cooler areas. The tar-paper roof of the nearby shed was painted with ultramarine blue, alizarin crimson, and white, warmed with yellow ochre. The result looks dark but has the vitality you'd expect to see when a dark surface is lit by the sun. The side of the sugar house was painted with ivory black, white, and yellow ochre. The artist used a lot of warm burnt sienna in the interior darks to convey the feeling of looking *into* the depths of the shadows. The ground was painted with raw sienna and white.

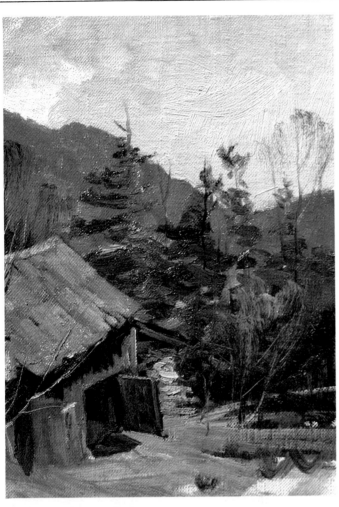

3. At this stage the artist developed the pine trees with phthalo blue and burnt sienna and suggested the sunlit areas with phthalo blue and yellow ochre. He added descriptive details to the roof and walls and placed a few trees in front of the nearby shed to direct attention out toward the clearing. By making the branches light (using yellow ochre and white), the artist added sparkle to the foreground, and he scratched in some branches with the end of his brush. He put in extra leaves, details of the shed door, and so on, until he'd gathered enough material to go back to the studio.

4. Once in the studio, the artist felt there weren't enough darks in the picture, and so he made some of the distant evergreens stronger in value. He also changed the contour of the mountain, strengthening its form, and added blue to the top of the mountain to push it farther back in space with atmospheric perspective. He lightened the ground in front of the open shed door in order to separate it more clearly from the foreground bank. He also added more reflected sky color to the roofs of the building. These subtle touches distribute color throughout the painting and give it a stronger feeling of unity.

Griffin's Sugar Shack, 12″ × 16″ (30 × 41 cm), by Paul Strisik

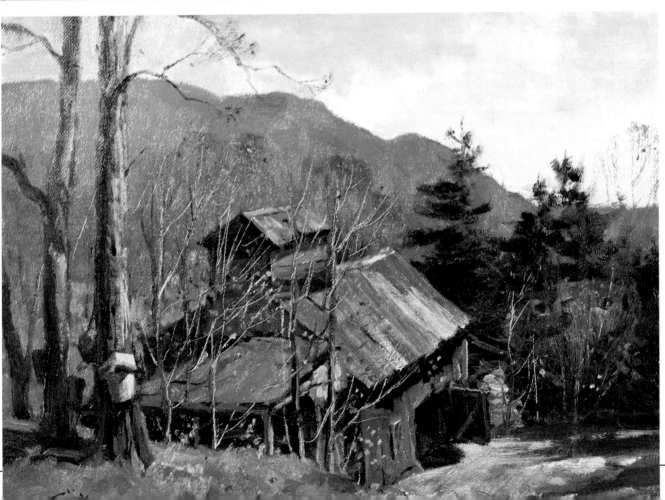

Painting Cool Tonality and Value

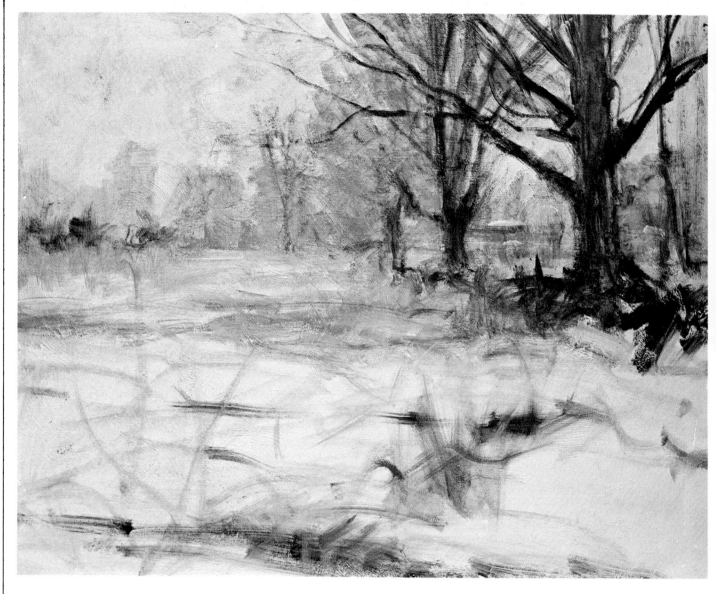

1. Richard Schmid painted a scene with an overall cool, gray tonality marked by temperature changes rather than conspicuous color changes. Using transparent mixtures, he established the major elements of the scene with just five values. The white canvas, the lightest light, constituted most of the foreground areas and the sky. He mixed ivory black and burnt sienna for the darkest dark (at the base of the right-hand tree and on the underside of its lower branches), and for the dark halftones in the trunks and branches of the trees, where the burnt sienna slightly predominated. The very warm dark at the right is pure burnt sienna. He used two principal middle tones: the cool blend of cobalt blue and yellow ochre in the distant tree, and the warmer mixture—yellow ochre with a little cobalt blue and viridian—in the middle ground.

2. Mr. Schmid began developing the painting with the sky, using cobalt blue, yellow ochre, and white. With the same colors, plus touches of terra rosa and burnt sienna, he brushed in the distant trees on the left. Continuing to the right, he indicated tree branches in the middle ground with slightly broken color. The background on the right was finished with a suggestion of buildings.

Next the artist concentrated on the principal focal point, the large maple trees on the right. Using mixtures of burnt sienna and cobalt blue with ivory black, yellow ochre, and white, he painted the trunks and main branches with medium brushes and a palette knife. Working upward into the smaller branches, he switched to small bristle brushes and sables. The most delicate touches were applied with the edge of a palette knife.

3. Finally the artist completed the foreground. Snow, cornstalks, and clumps of grass were identified with minimal detail so they would not compete with the large trees for attention. The snow areas were all brushed on with mixtures of white, cobalt blue, and small touches of terra rosa and yellow ochre, and then alternately smoothed and scraped with a palette knife. With broken color, the artist partially obscured some transparent darks that remained from his initial block-in. The soft areas of grass were dry brushed with vertical strokes of mostly warm mixtures of cadmium yellow, yellow ochre, and terra rosa. Mr. Schmid unified the painting by lightly drybrushing broken color throughout.

Winter Landscape, 22″ × 28″
(56 × 71 cm), by Richard Schmid

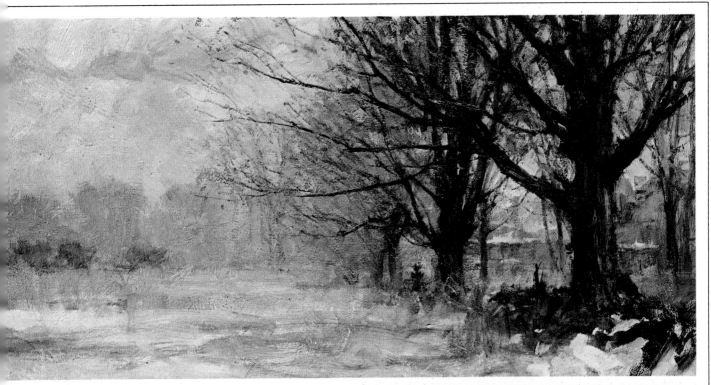

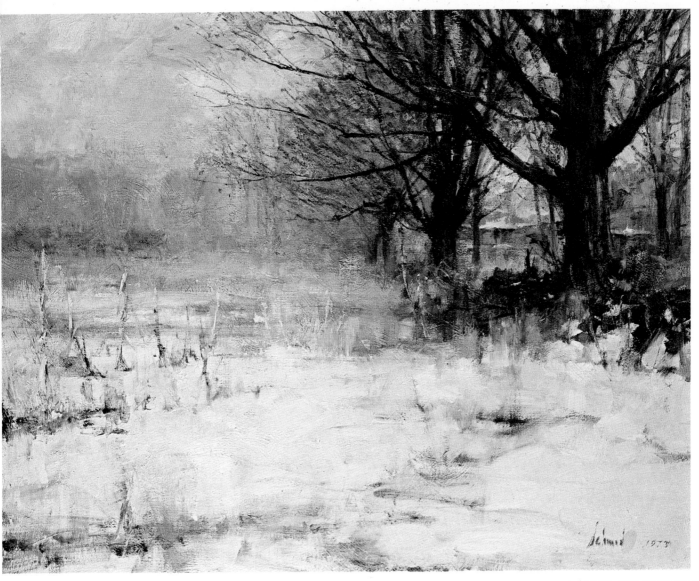

Conveying Atmospheric Distance

One of the greatest problems in landscape painting is achieving a convincing feeling of three-dimensional space and air—called aerial perspective. Particles of moisture and dust suspended in the atmosphere make both lights and darks appear progressively less intense, and give colors an increasingly bluish cast, as objects recede in the distance. On crystal clear days with very little "atmosphere," you can draw upon memory and experience to introduce greater color and value differences into your painting than are actually visible.

In the student painting at right, the greens are practically the same values and colors in the distance as in the foreground trees. This makes the picture appear flat. Only linear perspective—the drawing—shows that some things are farther back than others. The water has been painted an uninteresting blue instead of reflecting the green trees on the distant bank.

To create the illusion of distance with color, it is sometimes helpful to imagine very transparent layers of bluish gauze hanging in the air every 25 to 30 feet (7½ to 9 meters). Colors should become bluer as they recede—and if enough red is present in the trees, the distance should become purplish rather than blue.

When Foster Caddell painted the landscape below, he continued to paint the early morning haze that

hovered about the stream, even after it had diminished. Notice that he put four distinct planes in the picture: the foreground (the tree group on the right), the near middle distance (the tree on the left), the far middle distance (the trees in the center and the group behind the near trees on the right), and finally, the distance (the far

bank beyond the stream). In each plane he painted the shadows of the trees progressively lighter and bluer, and the lights progressively darker and less yellow.

The Old Mill Stream, 24" × 30" (61 × 76 cm), by Foster Caddell

Using Lights and Shadows

In the student painting at right, the road has been placed in the exact center of the painting, with almost equal amounts of space on each side. In an effort to make the road appear to recede, the student has extended it too high in the picture. Its edges, as well as the grass growing in the center, are too hard and straight; and the design of the shadows, relative to the thrust of the road, is too rigid and parallel to the bottom of the canvas.

The student picture also shows some other common mistakes. The sky is a flat blue, and the painting lacks aerial perspective—notice that the distant hills and trees are the same colors and values as the nearer ones. On the right, an exaggerated effort has been made to explain that trees are "trees with trunks" rather than simply a pleasing abstract design that happens to be trees. And the stone wall and trees on the left are repetitious in shape and design.

A more interesting solution to the road would have been to place it off-center, as Foster Caddell has done in the painting below. In addition, he has given the shadows and sunlight falling across the road and adjacent foliage a more pleasing diagonal thrust, subordinating the design of the road itself to the decorative design of the lights and shadows. In any landscape painting, there should always be a very positive design of lights and darks—but achieved in a soft way. In this painting,

the road is lower than the field on the left, which is the way the scene really was. The artist has indicated a figure walking in the road to give the viewer a sense of scale and bring attention to the center of interest.

The dark mass of foliage at the top overlaps the light tree on the right, instead of just touching it. The artist has painted the sky lighter near the horizon and on the left, where the source of light is. The distant trees and hills are a hazy, atmospheric blue-

green, which gives the painting a greater feeling of depth. Mr. Caddell has also used more diversified colors among the greens, and the blues and purples of the sky are reflected in the shadows on the road. This painting reflects Mr. Caddell's belief that an artist should take every opportunity to see, feel, and use beautiful color in landscape painting.

The Valley Road, 24″ × 30″ (61 × 76 cm), by Foster Caddell

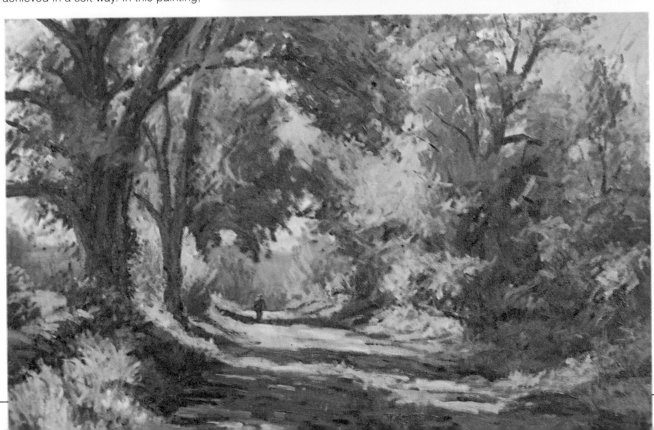

Placing the Horizon in a Landscape

One of the cardinal rules in painting, warns Foster Caddell, is that you should not put two pictures in the same painting. Compose your painting so that two areas will not complete with each other for attention as they do in the student painting on the right. Here the horizon divides the picture in half, and the colors in the background are as bright as those in the foreground. The water is an uninteresting blue that does not reflect the hues of the cloudy sky or colorful landscape.

In Foster Caddell's painting of the same scene, below, you can see how the sky, though interesting, plays a subordinate role to the landscape. The horizon has been placed relatively high to eliminate conflict between these two areas, and the painting is better because of this. The artist has diminished the importance of the most distant areas by placing them under a cloud shadow, eliminating any lights there that might conflict with the foreground. He has given a great deal of thought to the design of the textures, shapes, and patterns in the complex marshes. The water has become an interesting area because reflections, wind ripples, and marsh grasses have been designed selectively.

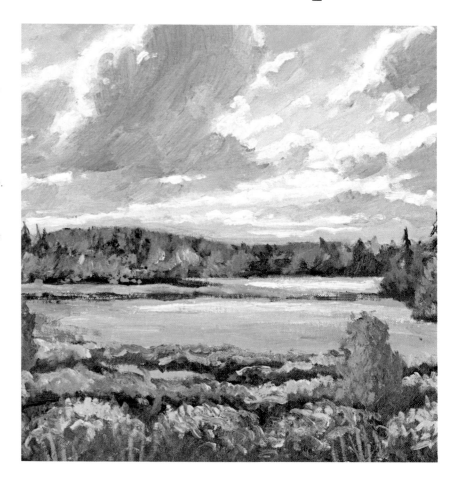

Autumn Tapestry, 24″ × 30″ (61 × 76 cm), by Foster Caddell

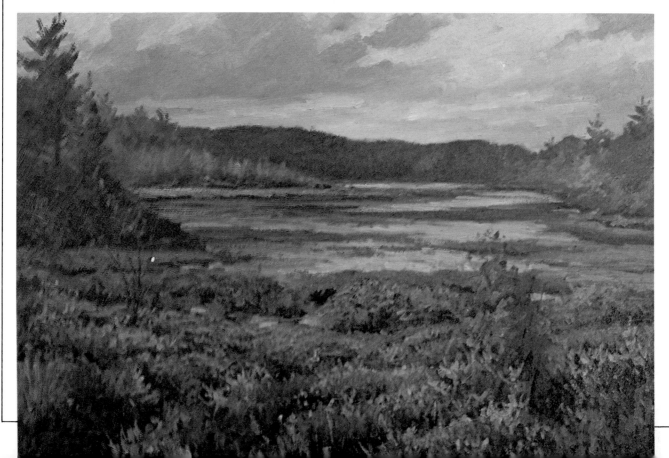

Creating Dramatic Effects with Backlighting

The amateur painting at left is uninteresting because the artist has handled light and color in a flat manner. The light comes from behind the artist, falling on the subject evenly and leaving no pattern of light and dark with which to model form and create areas of emphasis.

Mr. Caddell transformed this ordinary scene into a memorable one by painting it in early morning backlight. The luminous sky is reflected on the pond lilies, which appear to shimmer against the dark reflections of the trees. Rays of sunlight penetrating the morning mist separate the distant and middle planes, and the artist has created interesting and varied silhouettes for the tree masses, diminishing them in height to create a greater illusion of distance. Notice that under these lighting conditions, the light hits only the tops and edges of the masses. The artist has introduced individual grasses and lilies into the foreground to break up the water area, but he has diminished detail farther back in the painting to enhance the feeling of depth.

Morning Mist, 24" × 30" (61 × 76 cm), by Foster Caddell

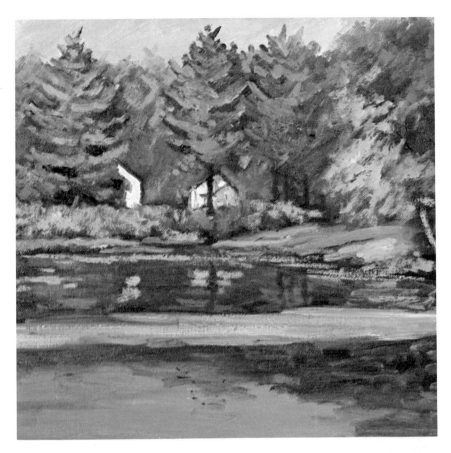

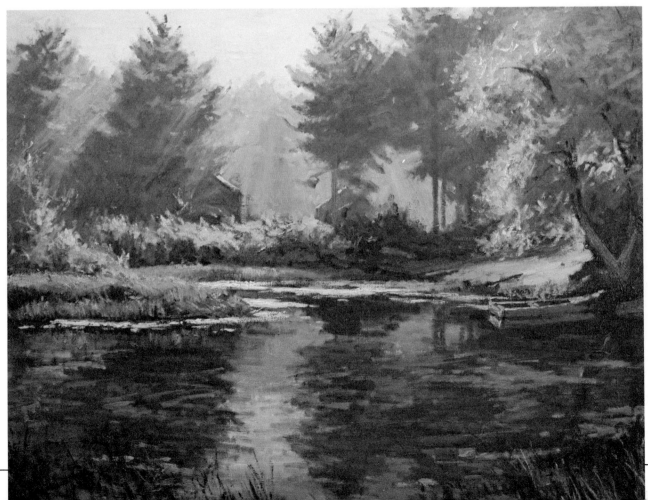

COLOR IN LANDSCAPES

Good color is difficult to achieve in landscape painting because outdoors, colors appear to change constantly with the light, atmosphere, and seasons. There is no substitute for painting directly from nature as much as possible. This section will introduce you to some techniques for observing and painting nature's colors more successfully in oil. You'll learn to observe how an object's hue is affected by direct light, color reflected from other objects, and cool shadows; how to use color boldly as well as with restraint; achieve color variety in your painting without losing overall unity; convey a mood through color; paint a scene with limited color; and capture the transient hues in skies and clouds.

Using Atmospheric and Local Color

One morning, Foster Caddell found one of his favorite painting spots bathed in a beautiful mist from the double waterfall below the gatehouse. The moisture in the atmosphere affected the intensity and hue of the many greens, and gave him the idea for the color interpretation he used in the painting on the opposite page. Details from this painting can be compared with amateur sketches of the same scene to learn how atmospheric effects can be used successfully to improve your handling of color and detail in landscape painting.

The sketch at right is much too busy—the recording of facts, rather than aesthetics, has dominated the artist's thinking—and the colors and values are too flat. All the boards and rocks are carefully spelled out, but the dramatic light—which is more important artistically—has been ignored. The color possibilities in the foreground weeds have not been exploited, and the handling is quite crude.

The detail below the sketch shows how Mr. Caddell has handled the same scene, allowing the dramatic light and atmosphere to influence local color. The atmospheric blue found in summer landscapes is French ultramarine blue, not cerulean. This color lightens the shadow passages and affects these darks more and more as they recede into the distance. The highlights in the tree and bush are primarily permanent green light, cadmium yellow pale, and white with a bit of flesh color here and there for modification. In the foreground pickerelweed, there's alizarin crimson and white in the flowers, and cerulean blue on the portions of the wet leaves that reflect the sky color. Note how the artist has managed to work a darker value adjacent to lights in order to make them sparkle more.

The sketch at the bottom of page 57 is an example of what happens when a painter is overwhelmed by the mass of foliage and unable to organize its design. Monotonous color and repetitious form result in a lack of atmosphere, and there is no illusion of depth. The solution lies in design and pattern as well as correct value and color. While there aren't many variations of color possible in a painting of summer greens, the detail from Mr. Caddell's painting shows how he has taken artistic license and placed a few flecks of red on the edges of the large tree trunk. The greens in the middle distance are dominated by French ultramarine blue from the mist rising from the hidden falls. A little flick of a skyhole at the top of the trees, painted with a mixture of flesh color and cerulean blue, gives added spatial depth. Because the summer greens were all quite similar, Mr. Caddell concentrated on achieving value differences to enhance atmospheric depth, and he simplified the foliage.

Overall, Mr. Caddell's painting reflects his belief that you must capture the *essence* of the landscape, not put down everything you see. By enveloping most of the detail of the distant bank in haze and mist, he simplified this area. This, in turn, gave more impact to the passages where the sunlight did sparkle—the foreground weeds, bush, boat, and trees on this side of the falls. The trick here was to make the darks in this area dark enough to be sufficient foil for the lights—yet not too dark, because they were in the middle distance and therefore were also affected by the mist rising from the splashing water. Learn to analyze colors under atmospheric conditions such as this. Mist can give a scene an unusual effect, making it more poetic. But to paint something as intangible as morning mist, you must analyze what is actually happening to the landscape and understand the visual effect so thoroughly that you can continue to paint it even when those conditions no longer exist.

POOR

BETTER

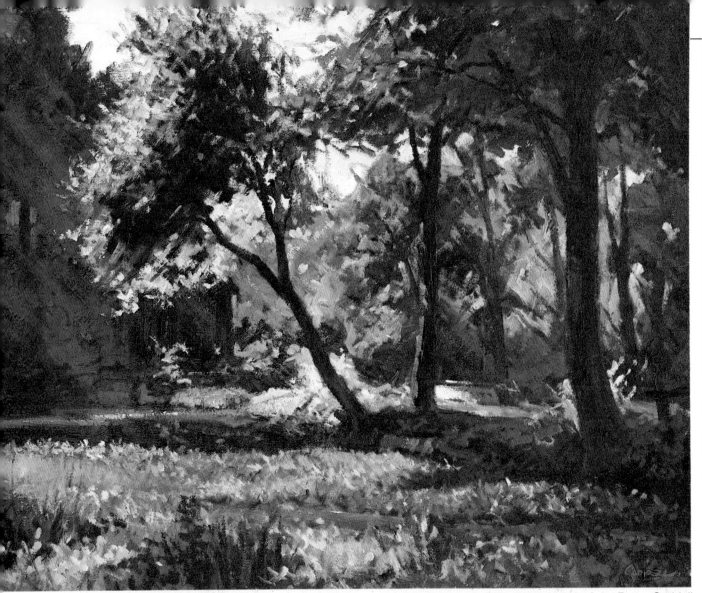

Misty Morning at the Gatehouse, 20″×24″ (51×61 cm), by Foster Caddell

POOR

BETTER

Sunlit Summer Greens

When Foster Caddell painted the scene on the opposite page (top), his main considerations were designing the pattern of bright sunlight in the composition and setting off the color of the old farmhouse to provide relief from the dominant summer greens. Details from this painting are compared with student sketches of the same scene to demonstrate more effective ways of handling these two painting problems.

The sketch at right is a classic example of what happens when an artist fusses over the wrong things in a painting. This student spent so much time on details that say "house" that the glorious color possibilities were overlooked. (Also, the perspective of the house, which was actually *above* eye level, has been drawn inaccurately.) The overall yellow of the house shows little variation in color or temperature—even in the shadow areas.

Compare the sketch with the detail of the house from Mr. Caddell's painting. First, he painted the shadow side of the house a cool blue-purple with French ultramarine blue, alizarin crimson, and white. While this was still wet, he superimposed the local color of the house—represented by yellow ochre and raw sienna—over it. In the lower section of the building, he introduced some permanent green light to show color reflected from the sunlit lawn. The sunny sections of the house were painted with white, yellow ochre, and a touch of cadmium red light. Notice the difference in color between the white trim on the sunny side and the same trim on the shadow side of the house. Mr. Caddell has used the color possibilities of the house to advantage, but he has also remained conscious of its relationship to the overall pattern of lights and darks in the scene.

In the sketch at the bottom of the next page, there is no evidence of shadows or light patterns—everything has been painted one color. Because of this, the scene lacks a feeling of sunlight. The color has been handled in a flat manner Mr. Caddell refers to as "house painting." There's no sign of the complex color mixing that can occur right on the canvas. Next to the sketch is a detail from Mr. Caddell's painting. Here the sunny greens run the gamut from permanent green light with cadmium yellow pale, to some that are diluted mostly with just white. Here and there the artist managed a few warmer passages, justified by painting grass that's been burned by the sun. The flower beds run the gamut of warm yellows through greens to flesh color. He resisted painting individual flowers and simply suggested them.

Throughout his painting, Mr. Caddell has taken full advantage of the rich color possibilities in a sunlit landscape. He has paid attention not only to the warm areas, but also the cool ones—notice how the cool shadows on the roof reflect the blue of the sky. He has also handled values effectively. The area where the sunlight splashes on the front of the house is actually lighter than any part of the sky in the surrounding area. The effect of sparkling sunshine in a painting is governed by the value relationships between the light and dark areas, and the beautiful patterns they make. The time of day you select is very important, and sometimes nature has to be helped a bit by artistic ingenuity. (But if you must change things a bit, do it in a way that *could* have happened, advises the artist.) The *amount* of light must be considered, too. In painting, as in life, the more limited anything is, the greater importance it has. Mr. Caddell's painting actually has more darks than lights, but he has designed a dramatic pattern of values that directs attention to the lights. Notice how the light pattern starts on the distant field to the right of the large tree trunk, splashes across the road, climbs the sloping lawn and flowers, and ends up revealing beautiful colors on the old farmhouse.

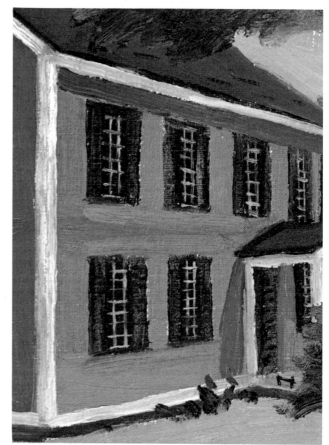

POOR

BETTER

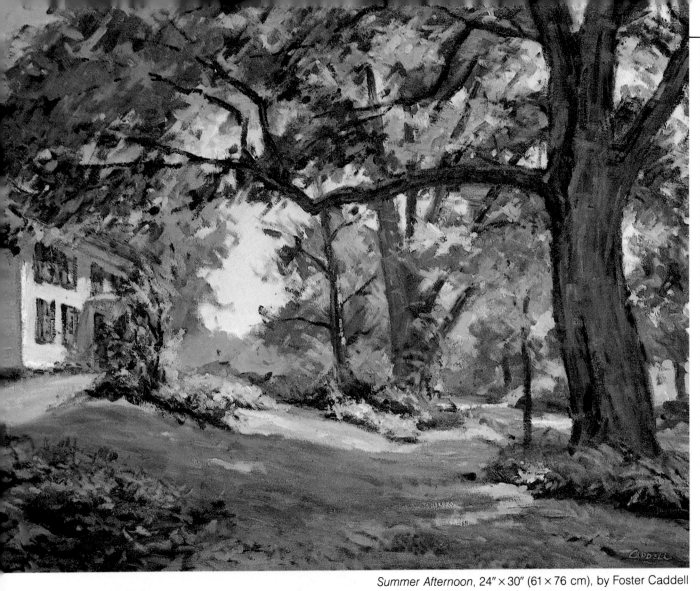

Summer Afternoon, 24″ × 30″ (61 × 76 cm), by Foster Caddell

POOR

BETTER

Painting Authentic Winter Hues

Many painters lack a sense of reality in their winter paintings because they don't go out and paint from nature. Foster Caddell feels that observing the landscape directly helped him achieve the authentic colors and atmosphere of winter in the painting on the opposite page.

The student sketch at right lacks the necessary progression of value changes to give the illusion of space and distance. The color is poor, too, because the basic atmospheric color was realized with burnt umber and cerulean blue and therefore lacks the purplish cast actually found in nature. The sky becomes a pure blue too abruptly and lacks the atmospheric quality that would make this color transition softer. The greens of the fir trees are too light and too yellow.

In the detail from Mr. Caddell's painting, below, you'll notice that although the color of the snow is darkest in the foreground, it's still lighter than the branches of the foreground tree. The artist painted the snow with French ultramarine blue and alizarin crimson, and scumbled in burnt sienna for the warm branches and dead leaves of the trees. He made each successive layer of distance get lighter and bluer until he reached the distant hills in the upper right, which he painted a light blue. This was achieved with the colder blue, French ultramarine, as opposed to the cerulean blue used in the sky.

The amateur sketch at the bottom of page 61 reveals another common problem in painting winter landscapes: an overall sameness of color and value, which creates visual monotony. There is no sense that sunlight bathes some portions of the scene, with other areas thrown into cloud shadows; there is no progression of values to create an illusion of distance; and the snow areas are too similar and generalized.

The detail from Foster Caddell's painting shows how he accentuated spatial planes, not only with color and values, but also with the play of sunlight over some areas. These effects are constantly changing in nature and demand great selectivity to make the most of them in your painting. The cleared snow areas in shadow were painted bluish, and where the sunlight hits the trees, the artist has made the warm colors with Naples yellow, cadmium red light, and alizarin crimson.

The atmospheric color of winter in Mr. Caddell's painting is a muted purple, an effect caused by the reddish color of the bare limbs and dead oak leaves still clinging to the branches seen through the basic blue of the atmosphere. Interspersed with this is the subtle blue-green of the fir trees, a wonderful complement to the warm colors. Notice how the hues of the landscape are echoed in the clouds, giving the painting an overall color unity.

When Mr. Caddell painted the scene, it was an "open-and-shut" sort of day—the sun would poke through the clouds and light up different portions of the land at different times. The artist had to decide how to use this effect in his painting, and just where to plan his light patterns. Most of the time that the light was on the hillside by the farm, it was also on the foreground field. He decided to keep the foreground field in shadow in order to add drama and impact to the light just beyond the farm buildings. To balance this, he chose to have the sun's rays coming down on the valley on the right of the middle distance.

POOR

BETTER

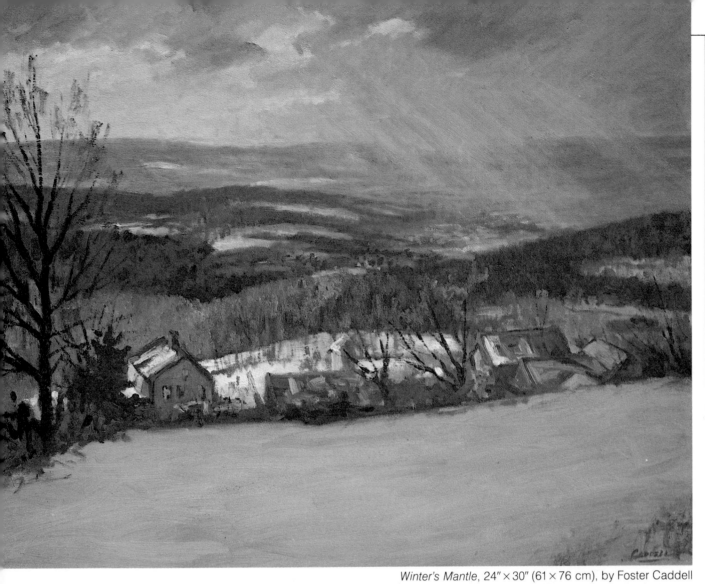

Winter's Mantle, 24″ × 30″ (61 × 76 cm), by Foster Caddell

POOR

BETTER

Using Impressionistic Color

Foster Caddell captured a typical New England farm scene just as the morning sun was burning off the valley haze. He wanted luminous color in the sky but realized that he had to handle it in a restricted way so that it would not look overdone. He unified the painting by carrying some of the warm colors from the weeds and grasses into the sky area. Details from student sketches show how many amateur landscape painters fail to see the color possibilities in large, open areas of sky or grasses.

As the sketch at right demonstrates, the safest and most obvious way to paint a summer sky is making it blue all over. Most amateurs paint the sky first, but it's practically impossible to get the correct color and value unless you can relate it to something else on the canvas. This sky is too dark, and the color is not only flat but also the *wrong* blue—French ultramarine instead of cerulean. The artist has not observed the luminous, transient color changes that occur when the sun burns off morning haze.

If you observe the sky carefully, you'll discover that it is very colorful—not just blue—and that its colors change with the weather and the time of day. The problem in painting skies in general, and those of early morning or late afternoon in particular, is that their effects are extremely transient. This requires the painter to rely heavily on memory and knowledge in order to paint them.

It's not easy to capture that sensation of a morning haze. You must be sensitive to unusual, transient effects and be able to put down what you see and feel after it's gone. Keep the following points in mind when painting morning haze: The light from the sun is warm in color. Also, when you look toward the sun, the sky is always much lighter than when you look at the sky in the opposite direction.

When Mr. Caddell began painting the sky area shown in the close-up below, he had already indicated the values and colors of other elements in the landscape for comparison with the sky. He painted the warm sky with Naples yellow, cadmium red light, a touch of alizarin crimson, and white. Then he worked down from the top of the painting with cerulean blue. He superimposed a pale alizarin crimson over parts of this and worked the colors back and forth until he had achieved a pleasing effect.

The flat green field at the bottom of the next page reveals that the student had difficulty interpreting the area in an interesting way. Both the value and color used are incorrect, and instead of receding, the field looks like a flat wall. But the artist was painting a freshly mowed green lawn with little detail or color variety to orient the viewer. How could this problem have been solved?

The detail from Foster Caddell's painting offers a very good solution—he "borrowed" clumps and weeds from a nearby field to make this area more lively and interesting, and to relate it to the rustic farmhouse on the hillside. The darker greens, made with viridian and burnt umber, show the presence of clumps and hummocks. Where the grass gets lighter as it climbs the hill, the artist added flesh color to warm the green and neutralize the color. The colorful flowers were painted mostly with alizarin crimson, plus a touch of cerulean blue in places. Here and there he added bits of earth reds and yellows to indicate taller dead grasses. In the nearer grasses, Mr. Caddell used upright strokes for added depth and detail.

As you experiment with color, whether you're painting luminous skies or other subjects, Mr. Caddell advises keeping your values within each area consistent. He stresses that the critical decision in color is how much you can use without making it look garish or overdone.

POOR

BETTER

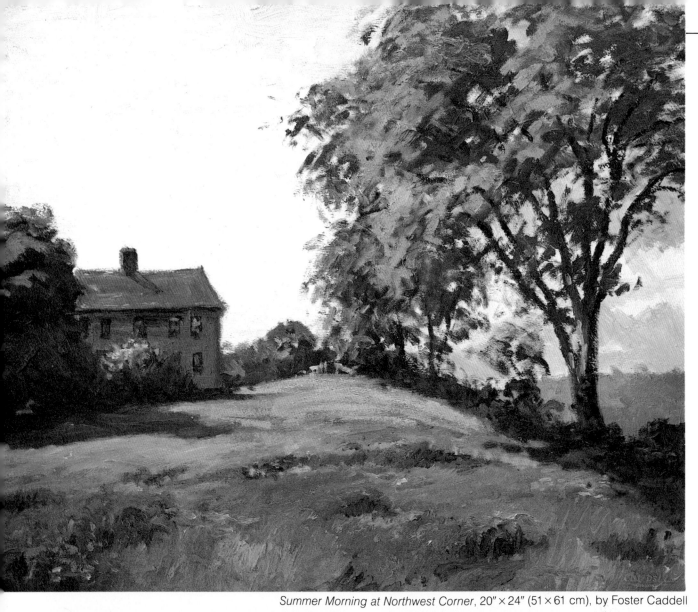

Summer Morning at Northwest Corner, 20″ × 24″ (51 × 61 cm), by Foster Caddell

POOR

BETTER

Backlighting and Reflected Color

When Foster Caddell painted the scene on page 65, he handled two color problems that often present great difficulty for the student: painting reflected lights and imbuing a brilliantly lit sky with luminous color.

The sketch at right indicates the artist was stating individual objects rather than focusing on the play of light upon them. There's too much concern with showing that the building has a white door and window, and no attempt has been made to get a feeling of light falling on the scene as a whole. The colors are too ordinary and matter-of-fact, and there isn't enough bold contrast. There's also no feeling here that the artist took any delight in handling the pigments.

Reflected light is the colored light that bounces off an object hit by direct light and is deflected into a nearby object. The stronger the illumination, the shinier the object's surface, and the brighter the color of the object hit by the light, the more color and light are reflected into nearby objects. The detail of Mr. Caddell's painting almost makes the viewer feel the sunshine beaming down on the sandy area and being reflected up into the shadow side of the building, giving it lovely warm color. Notice how this area of color attracts more attention than the illuminated section of the mill. Shadows are usually cool, but here the color is warm. The critical factor is getting it just the right value. Notice the delightful splash of white that sufficiently says "door" and indicates the detail on the front of the building.

When painting reflected lights, remember that they can never be as bright as the lights; however, they must be more luminous than the general shadow value and must be influenced by the color of the surface from which they are reflected.

Backlight is not easy to paint, but when it is done well, it can give a painting a great feeling of radiance and luminosity. The main problem in painting skies (backlit ones included) is that of overcoming the influence of preconceived ideas. As the sketch on page 65 shows, skies are usually painted too blue and with little, if any, feeling for color variations. In addition, it's hard for amateurs to paint a backlit sky like this one brilliant enough. Thinking of the house in the background as being plain white prevents the student from observing that it's really darker than the sky and should be painted as such. Skies are usually lighter when you are looking toward the sun than looking away from it. Also, a sky should "arch" in value. That is, it should be painted lighter near the horizon and gradually deepen in color and value as it goes higher.

Another way to achieve a luminous effect is through contrast. By strategically placing darks against the sky, as Mr. Caddell has done with the large tree trunk in his painting, you can create the effect of a very bright, luminous sky. Mr. Caddell painted the warm sky primarily with Naples yellow, and while it was wet, painted cerulean blue, alizarin crimson, and cadmium red light into it. (Of course, white was added to all these light colors.) The white house, which was in shadow, is silhouetted against the sky, adding to the sky's luminosity.

POOR

BETTER

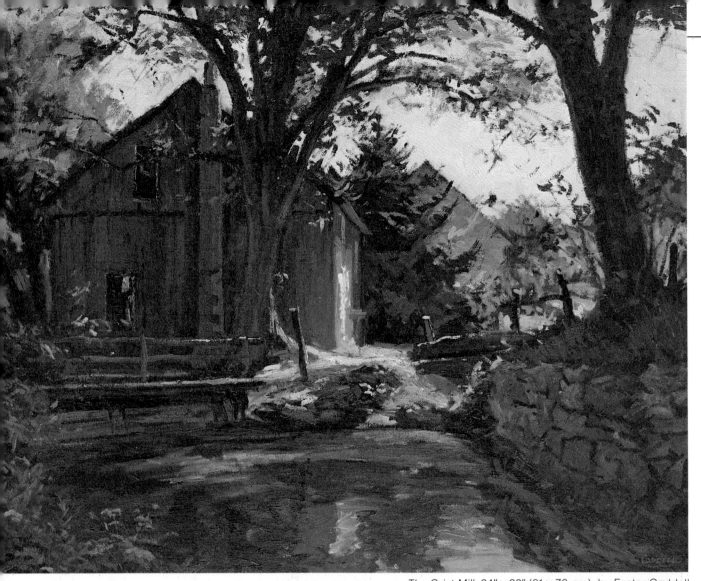

The Grist Mill, 24″ × 30″ (61 × 76 cm), by Foster Caddell

POOR

BETTER

Seeing and Exploiting Color

When Foster Caddell painted this wintry scene, he devoted most of the canvas to the dramatic sky and threw the foreground into a cloud shadow to further subordinate it. Although the outdoors can look bleak at this time of year, the illustrations on these pages demonstrate how color can be found in such a scene and exploited in your paintings.

When you paint outdoors, you must get used to *really looking* at the landscape. You can't take anything for granted. Everyone knows that skies are blue and clouds are white—but are they really? Students often paint with this preconceived idea. The sketch at right shows a lack of understanding of cloud forms and color, as well as a lack of daring on the part of the artist. The cloud shadows, which have been painted with just Payne's gray and white, are not dark enough. The edges of the clouds are too stiff. All in all, this sky lacks drama, depth, and interesting color.

Many people paint skies as though they were a flat curtain hanging behind the scene. You must learn to paint them so they go back in distance, just as the landscape does. Introduce as much color as you dare, within the limits of possibility for the time of day you're depicting.

To paint skies successfully, you must make a study of them. Go outdoors and make color sketches of the various cloud formations. In this way, you'll build up an understanding of their shapes, colors, and designs, so that you'll have knowledge to fall back on when you try to capture a fleeting effect.

Mr. Caddell's painting, as demonstrated by the close-up below, has diversity in the cloud shadow colors and values. The great contrast created by the light edges brings the viewer's attention up into the sky. In the shadow areas the artist used cerulean blue, which he turned slightly purple by adding alizarin crimson and then modified to a gray with tints of cadmium red light and Naples yellow. The whole idea was to realize the beautiful variations of colors possible, and not lose them by overmixing.

The weedy area in the sketch at the bottom of the next page illustrates other landscape elements in which students often overlook color possibilities. The weeds have been rendered only in burnt umber, with many individual brush strokes. Although the artist intended them to read as "weeds," these clumsy strokes take on the characteristics of a picket fence. And because water is usually thought of as being blue, too much intense color has been used in the open channels. The snowy passages have been painted with just blue and white.

Foster Caddell's interpretation of the same subject shows keen observation of the color variations present in every element of the landscape. The bare weeds were painted with alizarin crimson, French ultramarine blue, and variations of both raw sienna and yellow ochre, exploiting all their color possibilities. In this rendering, the artist has achieved greater feeling of texture and detail with far less actual delineation. The color of the snow is also much better here. The introduction of raw sienna gives the feeling that there are ice sheets under the top snow.

As an artist, you must not see in an ordinary way. You must learn to see things poetically, extracting all the possible color variations from the commonplace. A very important part of painting involves the study of contrasts, or what Foster Caddell calls "relativity." Because of the scarcity of strong colors, at a bleak time of the year, the bit of color that the landscape *does* have becomes important.

POOR

BETTER

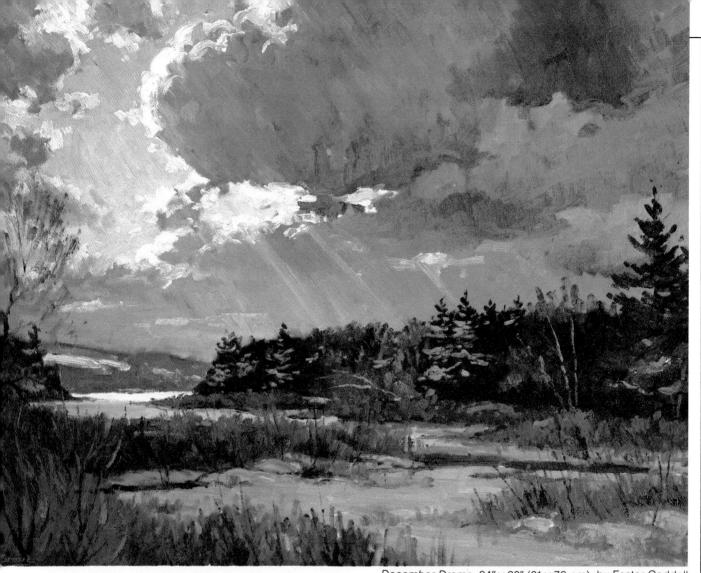

December Drama, 24″ × 30″ (61 × 76 cm), by Foster Caddell

POOR

BETTER

Using Bold Colors

In the autumn, so many vivid colors are present in the landscape that many painters may either go wild with color or be afraid to use it boldly enough. But nature is always harmonious, even in its extremes, and with practice you can learn to make strong color work well in your paintings. In addition, you can utilize the effects of sunlight to enhance and unify such a scene.

In the sketch at right, colors that should be strong and brilliant are too dull. And even if the light had shone on the area behind the foliage in this way, the painting would have been better if the artist had waited for the light pattern to shift and provide a more advantageous background. The lightest areas should have been given the benefit of a strong contrast.

Below the sketch is a detail from the painting shown on the opposite page. The artist, Foster Caddell, painted the background area first with French ultramarine blue with a touch of burnt umber and raw sienna. Then he introduced permanent green light into it to give the impression of foliage in shadow. The bright foliage was painted with cadmium yellow pale and white, with touches of permanent green light in some places and cadmium yellow deep in others. The presence of warm light on the earth creates a delightful passage among the yellow-greens. Notice how the tree trunks are suggested boldly with a combination of flesh color and cerulean blue.

Rays of light must be executed sensitively to be successful. In the sketch at the bottom of the next page, the rays have been handled harshly, their angles are inconsistent, and they are much too light in value to convey the subtle effect that the artist desired. The detail of a comparable area from Mr. Caddell's painting has the necessary feeling of atmosphere and light. For better control, he painted the effect of the light rays over the background after it was dry, strategically placing them against a shadow passage. He painted them with the cooler French ultramarine blue and white with a bit of flesh color added to gray the mixture. Notice how he varied the sizes of the rays, as well as the spacing between them, in order to avoid monotony. Remember that such rays of light must fall at angles consistent with the position of the source of the light—the sun—and that they should not be tapered like a funnel. Light rays can be painted into wet color or added after the background has dried for a soft "dry-brush" effect, as Mr. Caddell has done in this painting. The secret to painting such effects is keeping them soft and unobtrusive.

In painting, there are times to whisper and times to shout—and you can see both ends of the scale. Don't go along a monotonous middle road, using color and value timidly just because you are afraid of making a glaring mistake. Don't underestimate the amount of brilliance and gusto a passage in your painting needs in order to carry well from a distance. Many times color can be used in its purest strength and greatest intensity, right from the tube. Mr. Caddell used it in the section of his painting that he wanted people to notice first—the bush and tree in the center of interest—and played it up as much as he dared. Needless to say, the adjacent contrasting background colors and deeper values help, for in situations like this, much of the emphasis is attained by playing down the passages adjacent to the brilliant sections. When they aren't dark enough, you lessen any impact that the main passage might have. This principle of contrast is important to good landscape painting.

POOR

BETTER

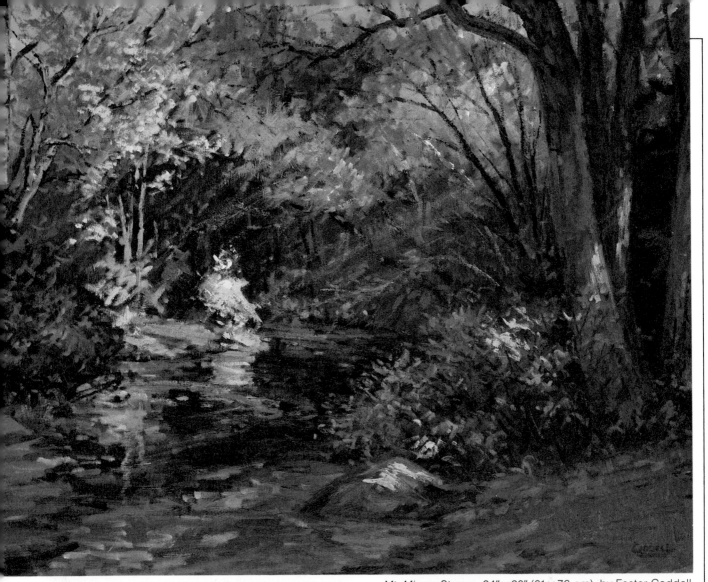

Mt. Misery Stream, 24″ × 30″ (61 × 76 cm), by Foster Caddell

POOR

BETTER

Creating a Mood with Color

Foster Caddell wanted the viewer to be able to sense the still, cold, crisp atmosphere of the winter morning he depicted in the painting on page 71. He has done this through color, even though the subject itself had limited color.

The artist who painted the sketch at right has failed to convey a sufficiently cold, frosty feeling. The colors lean too much toward umberish grays rather than cool, soft blues, and the distant hills on the left lack the delicacy of value and color that would push them back spatially. Because the sketch shows a concern with statistics and facts, it records the place but does not communicate the mood of the cold weather.

A detail from Mr. Caddell's painting of the same subject is primarily a study in cool blues, with French ultramarine predominating. Notice that the artist introduced passages of alizarin crimson while the underpaint was still wet. The warm colors in the sky were painted delicately. He started with Naples yellow and cadmium red light into white, and then progressed upward into viridian green, cerulean blue, and finally, at the top of the painting, French ultramarine blue. Notice that he's added a delicate hint of warmth in the foreground field—a touch of cadmium red light and Naples yellow. But it must be subtle to be effective. Under these lighting conditions, the weathered gray barn becomes a beautiful variety of blues.

The student sketch at the bottom of page 71 lacks variety in color. The sky is a flat blue, the trees are an umberish brown, and gray predominates overall in the hills. There is no modeling of form in the hills, which could have been defined by patches of sunlight striking some surfaces. Time was wasted explaining that there was a stone wall in the foreground, and the artist missed exploring the nuances of color and atmospheric effects—which *should* have been the theme of the painting.

The detail from Mr. Caddell's painting shows how he separated the nearby trees from the distant hills behind them by underpainting the trees a darker blue and adding warmer notes of alizarin crimson and raw sienna to it, as well as keeping the base color on the hills a light blue. In the tree area on the distant hills that face the sun, he subtly introduced soft reds and yellows to suggest the presence of sunlight. However, the sunlight on the oak trees in the *foreground* gave him an excuse to use stronger warm hues—alizarin crimson and raw sienna—on their leaves, since they're closer. Notice the hint of permanent green light in the nearest hedgerow. It suggests some evergreens, offers another subtle variation of color, and complements the adjacent reddish tones.

Although the colors in Mr. Caddell's painting are predominantly blue—the coldness of the color enhancing the wintry chill of the painting's mood—he found rich variations in color, including warm hues, by observing the subject carefully as he painted. The trees on the distant hill have a little warmth in the sections that catch a bit of the early morning sun. Notice that even the snow areas here are not just plain white. The tree area at the foot of the hills is made up of oak trees, and since most oak leaves stay on all winter until the new leaves force them off, they provide some warm colors. A few nearby evergreens provide another color variation to complement the oak leaves. Notice that because of the distance, no dark is very dark. The snow-covered field contains subtle variations of color, with warm reds and yellows in the lights and cold reds in the shadows. The artist has managed to achieve a delicate balance of warm and cool colors throughout the painting.

POOR

BETTER

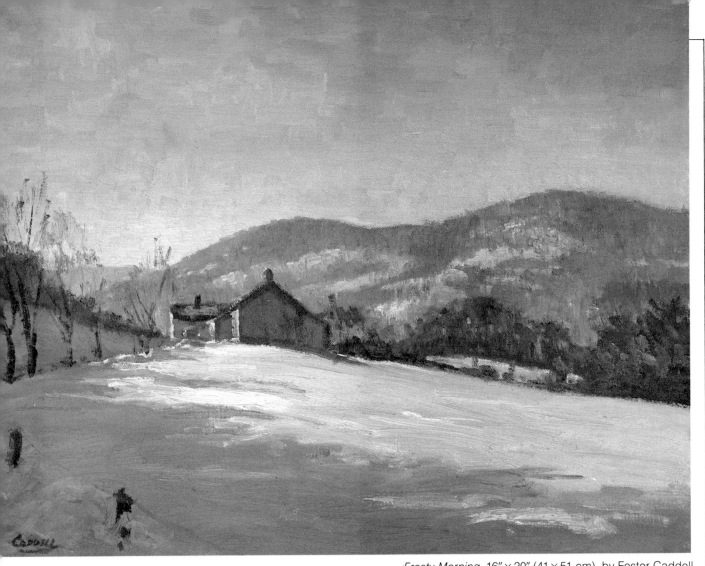

Frosty Morning, 16″ × 20″ (41 × 51 cm), by Foster Caddell

POOR

BETTER

Varied and Unified Color

Foster Caddell is well acquainted with this field. In late summer, just before the autumn foliage colors come along, it becomes what he terms "nature's Oriental carpet." Nature's colors are always harmonious, but the wild New England asters in the foreground mingling with the goldenrod and joe-pye weed in the middle distance make this scene a particularly charming one to paint. The challenge was to organize the shapes and colors found in a field of flowers into a dramatic pattern—and to design a sky that would complement and enhance the landscape.

The wrong blue—French ultramarine instead of the warmer cerulean blue—was used in the sky at right, making it too red. The clouds, executed in variations of Payne's gray and white, are unimaginative in color and resemble plaster of Paris. The forms are too hard, and the painting lacks the soft, feathery edges that could have been achieved by painting fresh pigment into wet color.

A detail from Foster Caddell's painting shows how he handled the sky area. First he established the basic design. Then he began painting the cloud shadows, primarily with cerulean blue plus a touch of alizarin crimson and white. Next he indicated the patches of blue sky with cerulean blue. Only then did he begin work on the light passages in the clouds. Since it was late afternoon, and he wanted to convey that in the painting, he introduced a bit of warmth with Naples yellow and cadmium red light. Using these basic colors, he allowed the shapes to flow back and forth, wet into wet, until he'd created a design and sky he felt satisfied with.

As the sketch on the next page shows, many amateurs paint pale flowers just "white," with no color variations. The artist did not consider that the foreground was in a cloud shadow, nor that its color would also be influenced by the cool sky above. Students also tend to try to paint the hundreds of individual flowers instead of grouping them into a pleasing design. Notice, too, that the flowers in the background are almost the same size as those in the foreground, defeating any illusion of distance.

The detail from Mr. Caddell's painting shows how he handled the same situation. Here the grass was laid in basically with permanent green light, with variations of earth colors painted into it while it was still wet. The artist used the deeper burnt umber to indicate stalks under the flowers, and raw sienna and burnt sienna to suggest some dried grasses among the lush greens.

In the flowers, he used mixtures of cerulean blue and alizarin crimson in the cool areas, and flesh tones where there was a feeling of warmth. The challenge here was to create a feeling of luminosity without going as light as the middleground, where the sun is shining. Notice that there is a sense of individual flowers only in the foreground.

A critical decision in all paintings, but particularly in this one, is the time of day selected to depict the scene, and the choice of the ever-important play of light over the material at hand. And the sky must serve a definite purpose in a landscape painting. When a large part of the canvas is devoted to the sky, you must put some interesting pattern into it without upstaging the landscape itself. In addition, the colors you use must complement and harmonize with the landscape. To depict the time of late afternoon that he had chosen, Foster Caddell designed the sky so that most of the light areas would be on the side from which the sunlight was coming. He also made the dominant flow of the cloud masses complement the angle of the hills. With the foreground in shadow, he knew the dominant color of the flowers would be cool from the light in the sky above.

POOR

BETTER

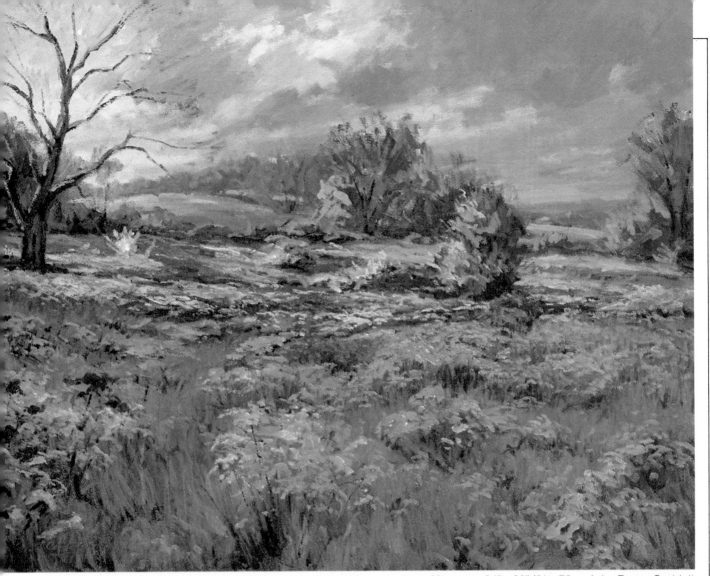

Late Summer, Late Afternoon, 24″ × 30″ (61 × 76 cm), by Foster Caddell

POOR

BETTER

Using Warm Hues and Cool Shadows

Every subject has a definite color harmony that has to be "felt" by the artist. In painting this scene, Foster Caddell was intrigued by the play of the autumn colors against the weathered white clapboard houses. He made the sky color almost directly complement the sunshine on the leaves, adding even greater sparkle to the brilliant trees. He also restricted the amount of light and set it off against cool shadows to increase its brilliance through contrast.

The sketch at right lacks sparkle because the leaves on the near (shadow) side are too light in value, the tree appears flat, and the light coming through the leaves on the far side has therefore lost impact. The timid attempt to paint the house behind in shadow has failed to exploit tonal contrast to make the leaves in front of it more brilliant.

Compare the sketch with the close-up below it. Notice that on the shadow side of the tree, which is now sufficiently deep, warm yellows and oranges have been painted into the basic green to show that the leaves are starting to turn color. The shadow side of the house behind them was painted a deeper blue, with hints of alizarin crimson painted into it to show color reflected from the purplish sky.

The artist made some of the highlight brushstrokes in the tree as clean and brilliant as he could by using cadmium yellow light and cadmium yellow deep right off the palette to complete the effect of sparkling backlight.

Handling backlight seems especially difficult in the autumn because the profusion of colors makes it more difficult to see values correctly. The critical decisions must be made in the shadow passages of the foliage. If they're painted too light, it diminishes the effect of light in the highlights. If they're painted too dark, they have a dull, heavy look instead of brilliant luminosity.

The sketch at the bottom of the next page fails to take into account the way light falling on objects affects their colors, and the many cool colors present in shadows have been overlooked. Instead, the artist has painted the local colors of objects. The shadow side of the white house was painted a flat, ordinary gray and is far too light. Too much attention has been paid to details in the windows and not enough to the general quality of the color. The shadow across the road has been painted a "dirt" color—raw sienna—and lacks the cool colors that should also be present. The sky is a flat blue.

The close-up from Mr. Caddell's painting shows how he exploited the colors in cool shadows. He painted the shadows a little too blue at first so that he could work other colors into them while they were still wet to achieve the right balance. Notice how the green of the grass, plus a bit of alizarin crimson from the sky color, reflects into the shadow side of the house. The artist treated the road shadows in the same way, underpainting them with blues and purples and then introducing warm earth colors into the wet pigment. The white cottage was painted darker and colder than the sunlit grass in front of it—which is the way it actually appeared.

To determine the colors with which an object should be painted, you must first ask yourself, "Does direct light fall on it?" The answer to this question will help you decide how to handle the color. Remember that there are two sources of light in nature. The main one, from the sun, is naturally warm in color, but the second source is the subtle cool light that filters down from the sky and illuminates shadow areas. As soon as you begin to realize that the presence or absence of direct light on an object is as important as its local color, you'll have made a giant step toward successful landscape painting.

POOR

BETTER

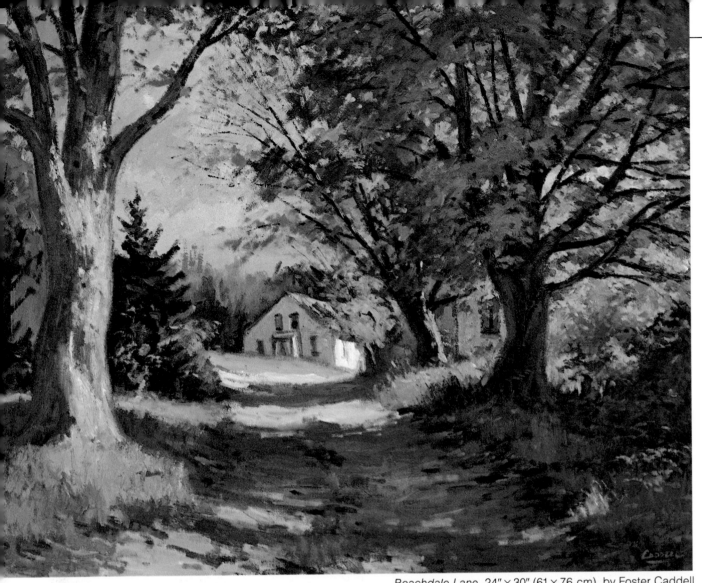

Beachdale Lane, 24″ × 30″ (61 × 76 cm), by Foster Caddell

POOR

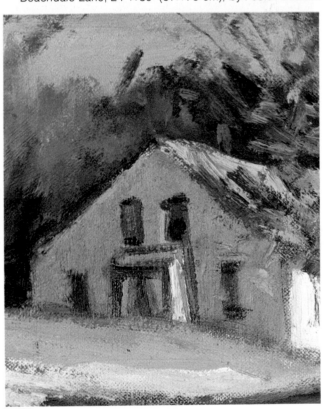

BETTER

PAINTING SEASCAPES

The sea is constantly in motion—it can never "hold still" for the artist, not even for a second. Its color and character are also influenced by the presence of rocks or headlands; the weather; sunlight and shadow; and the colors of the sky and atmosphere. This part of the book focuses on how to paint seascapes under a variety of different conditions: on a bright day, in early morning light, shrouded in fog, bathed in a golden glow with the sun near the horizon, and on a moonlit night. With an understanding of how waves behave and are affected by other elements of nature, you can learn to paint better seascapes in oil.

Painting a Breaker

1. The illustrations on this page show how seascape artist E. John Robinson paints a breaker. With a thin wash of ultramarine blue, he began the painting by making a simple outline showing the form of the breaker and indicating the area of foam. Using undiluted viridian green, he scrubbed in the wave, leaving the areas of foam and transparency untouched.

2. Next he blended undiluted cadmium yellow pale into the transparent area and added a small amount of it to the green areas, blending the two colors gradually where they met. He made sure there would be no visible line of separation between the yellow and green.

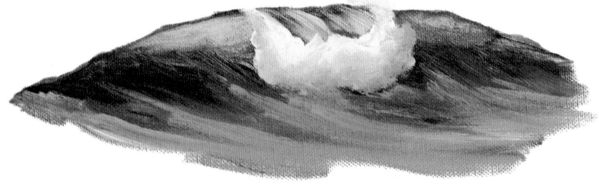

3. He created the feeling of depth at the base of the wave by adding ultramarine blue mixed with a touch of burnt sienna. He was careful not to paint into the transparent area. He then added a bit of pale yellow to white and scrubbed the mixture into the top portion of the foam. Using the same mixture, he added a few streaks of foam along the curl. Using a mixture of blue and white, he painted the shadow area of the foam. He also used the same blue mixture in front of the wave, where the smooth surface of the water reflects the blue atmosphere.

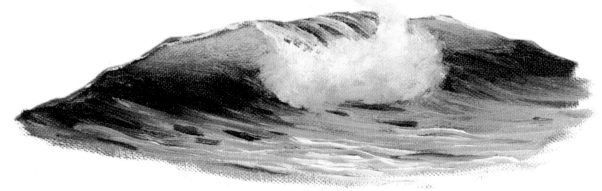

4. Finally, Mr. Robinson added touches of highlights and texture, using the yellow-white mixture for the highlights and the blue mixture used in step 3 for the dark areas.

Painting Sunlight and Atmosphere

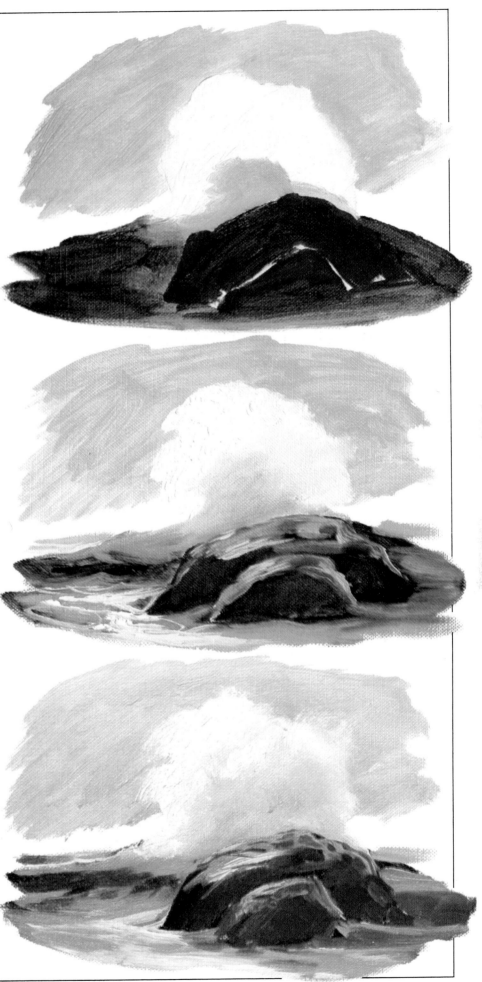

1. E. John Robinson did the oil sketch on this page to show how to handle local color, atmospheric effects, and sunlight and shadow in a seascape painting. Using a pale blue mixture for the sky, white for the foam, viridian green for the water, and a mixture of one part burnt sienna and one part ultramarine blue for the rock, he blocked in the sketch with the local color of each element. He didn't worry about the details at this stage—he would apply them later.

2. For the atmospheric colors, the artist mixed a very pale blue from ultramarine blue and white and then scrubbed the mixture lightly over the entire underpainting, applying it most heavily in the areas facing the sky— the flat surface of the water and the top of the rock. Blending pale yellow and white for the sunlight, he applied the mixture heavily over the areas in direct sunlight. These occur mainly in the foam, but the sun also strikes areas of the rock and foam trails.

3. To complete the sketch, Mr. Robinson developed the shadows in the foam, mixing a purple from alizarin crimson and ultramarine blue, and adding plenty of white. For the shadows below the rock and in the water, he used the same purple mixture but added less white to make it deeper.

Painting a Sunny Coast and Sea

1. The artist began by drawing the forms of the rocks carefully with rather straight brush lines to capture their blocky shapes. The cloud shapes were drawn with blue brush lines and left as bare canvas. The artist covered the sky between the clouds with small strokes of cobalt blue mixed with white. For a bright blue sky, cobalt is especially suitable, since it's more delicate than either ultramarine or phthalo blue—although you may wish to experiment with these blues as well. (Another possibility might be cerulean.)

Note how the brush strokes grow smaller, paler, and less dense toward the horizon. Because the sky grows both warmer and paler toward the horizon, the artist interspersed strokes of yellow ochre (with a fair amount of white) among the blue strokes. The yellow strokes become denser at the horizon. At this stage, the artist also began blocking in the shadow planes of the rocks in blue-brown mixtures.

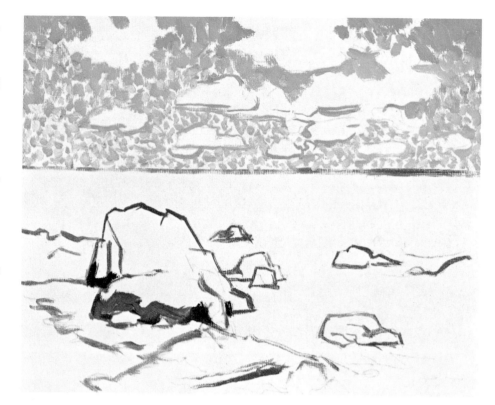

2. Next, strokes of pink (alizarin crimson and lots of white) were interspersed with the blue and yellow strokes in the sky. Now the sky was almost completely covered with wet color, except for the clouds, which remained bare canvas. In a coastal landscape, the color of the water always relates to the sky, and so the artist blocked in the tones of the sea with deeper blues—for this, cobalt could be replaced by ultramarine, which often looks like a darker version of the same color—and hints of the same pink and yellow mixtures that appear in the sky above. Notice how the color of the sea grows warmer in the foreground, where we begin to see the sandy bottom.

3. (Opposite page, top) With short strokes, the artist fused the separate colors in the sky—but did not blend them completely. In this way, he avoided turning his blue-pink-yellow mixture into a kind of brownish mud. He also retained a feeling of vibrating light. The clouds were painted with mixtures of the sky colors, plus more white in the lighted areas. The rocks were further developed with rough, irregular strokes of blue-brown mixtures—ultramarine or cobalt blue, burnt sienna or perhaps burnt umber, yellow ochre—that create browns, tans, and a fascinating variety of warm and cool grays.

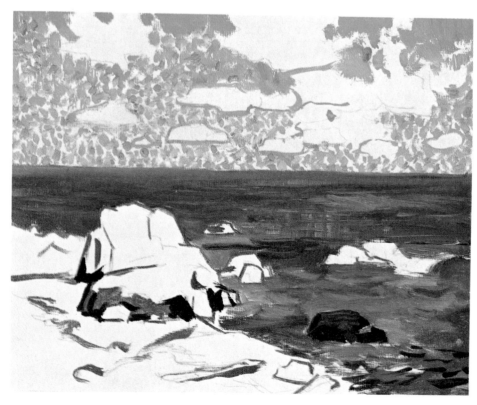

4. (Below) The artist worked with blue mixtures and a hint of yellow ochre to cool the sky so it would relate more precisely to the color of the water, though you can still see a good deal of warm color in the lower half of the sky and in the clouds. He drew long, horizontal strokes (darker versions of the sky mixtures) into the water to suggest distant waves and reflected light. The water in the foreground has been animated with small strokes of warm color (burnt sienna, yellow ochre, and white are important here) to suggest ripples catching warm sunlight. The artist also toned down the warmth of the rocks with mixtures of blue, yellow, ochre, white, and burnt sienna. Different mixtures of the sky colors appear in the shadowy section of the beach. The most important colors on the artist's palette were cobalt (and possibly ultramarine) blue, yellow ochre, burnt sienna, and alizarin crimson, with occasional help from cadmium yellow light and cadmium red light in the sunlit foreground.

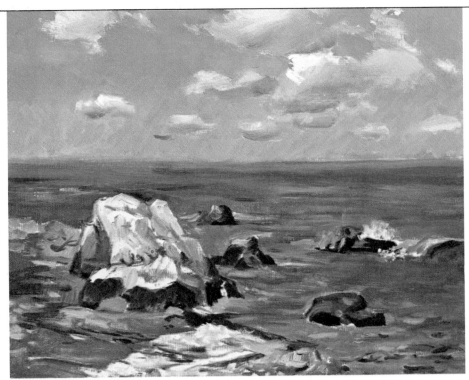

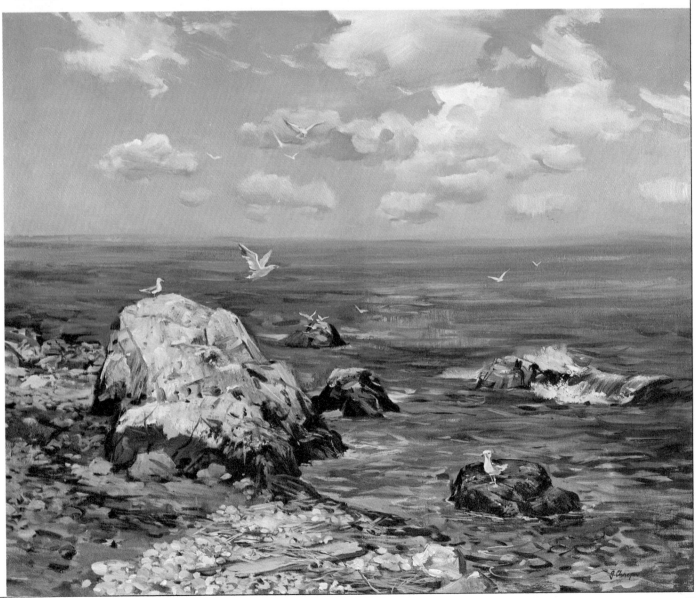

Painting Waves in Morning Light

1. After making preliminary line and value sketches, the artist applied the local colors as an underpainting. He painted the water, except the wave, in ultramarine blue with a touch of viridian green and made the wave itself predominantly viridian with a touch of ultramarine blue. He used a combination of burnt sienna and ultramarine blue on the rocks, and left both the sky and the area of white foam untouched. Ordinarily, skies also have local color, but the artist had decided to make this particular sky almost entirely atmosphere—a mixture of mist and sunlight—and so he had to wait until he'd applied the atmosphere colors to paint in this area.

2. The artist used a mixture of ultramarine blue, white, and a touch of alizarin crimson to paint the mist that nearly obscured the background sea. The colors of the atmosphere are always reflected in the local colors, and so he worked this mixture into the foreground water, particularly into the horizontal surfaces that faced the sky and therefore contained a great deal of reflected color. He stopped blending as he approached the vertical surface of the wave. The rocks were wet from the activity of the water around them and also reflected the colors of the atmosphere, and so he also blended the atmosphere mixture into the local colors of the rocks.

3. Adding sunlight to a painting also requires the addition of corresponding shadows. For the sunlight colors, the artist mixed pale yellow and white, plus a touch of alizarin crimson to warm the mixture. He mixed the pale lavender shadow colors from ultramarine blue, white, and a touch of alizarin crimson, keeping the mixture on the blue side. Blending the sunlight mixture into several areas of the sky and foreground foam, he applied it thickly on the major wave and then blended it into the shadows. The rocks received a different treatment: He first warmed them with a mixture of pale yellow and alizarin crimson (the sunlight mixture without white), and then used the original sunlight mixture (with white) for the highlights. By blending in some of the sunlight mixture, he brought out the pale green color of the wave.

4. The last touches added to a painting often make or break it. In this case, the artist had to know just when to stop or he would have lost the feeling of "newness." He added very little texture to the rocks, but added

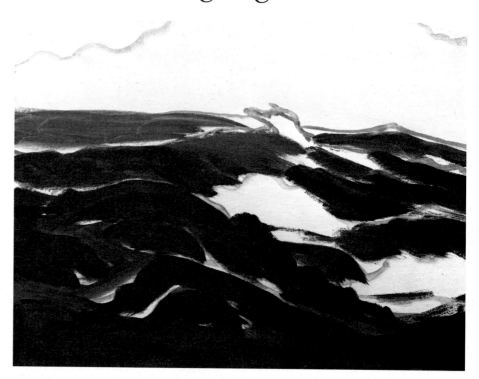

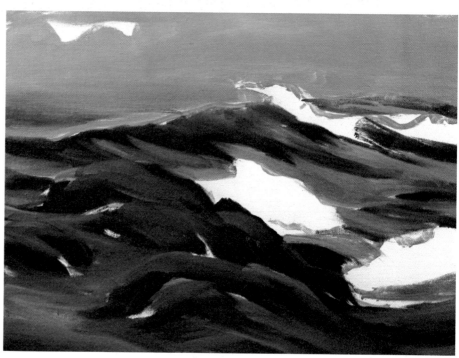

considerable texture to the foam patterns of the wave. This minimized the importance of the rocks and made the wave the center of interest. Using a large, dry varnish brush to blend and soften the values in the sky, he decreased the amount of depth and created more of a misty effect. Finally, he whipped the foam on the wave back and forth and softened the edges of the foreground foam.

Summer Morning, 24″ × 36″
(61 × 91 cm), by E. John Robinson

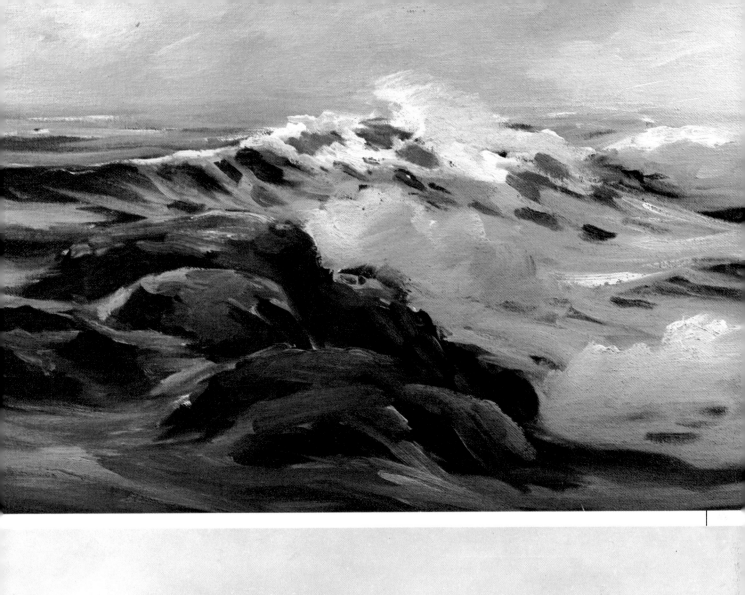

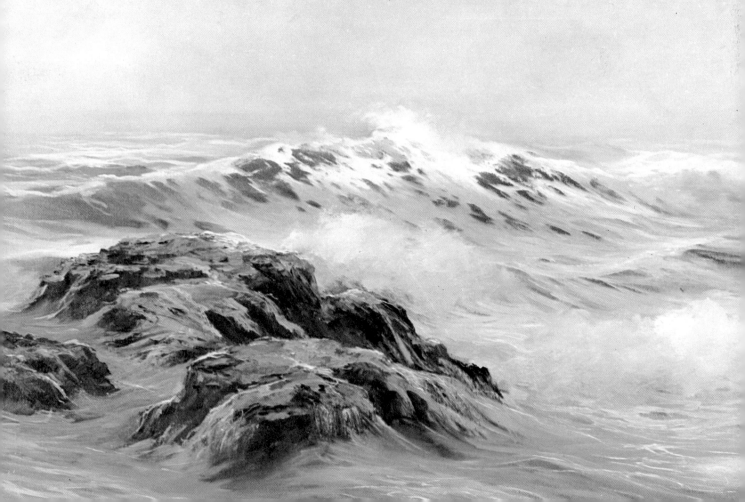

Painting a Foggy Sea

1. When you paint a foggy sea, very little local color remains visible after you have added the atmosphere and sunlight. Therefore, it was necessary for Mr. Robinson to apply only a small amount of paint to his canvas for the underpainting of this seascape. He used a mixture of ultramarine blue and viridian in the water, and burnt sienna with a touch of ultramarine blue for the rocks, and scrubbed these colors into the canvas. Since they were only the underpainting, he didn't want them to be so thick that subsequent colors would be lost when he added them; he didn't thin them, however, because then they would have been too weak. It was not necessary to paint in the local colors of the sky, because the colors of the atmosphere would be the only ones to show.

2. The atmosphere in the scene was primarily a lavender-blue, which the artist made by adding ultramarine blue and a touch of alizarin crimson to white oil paint. The atmosphere filled the sky, except in areas where the sunlight was very strong, and was reflected by the background sea, the distant rocks, and the top surfaces of the water and rocks in the foreground. When you add reflections of atmosphere to water, be sure to follow the contours of the water's surface with your brush strokes. Notice here how the artist curved each stroke and gave it a definite direction, even though the strokes were quite sloppy at this stage of the painting. (Remember, refining should be done in the last stage.)

3. For the most part, it's the sunlight that grays down this painting. Mr. Robinson used a mixture of pale yellow and white for the actual sunlight, adding very little white in the most brilliant areas and applying the paint very thickly there so that it would not blend with and become lost in the underpainting. He applied pale yellow with more white added in the weaker areas of sunlight and used its complement, pale lavender, for the shadows. He whipped these colors into the wet atmosphere, and as they blended they produced a neutral gray color. Notice that the addition of sunlight made the green areas of the water appear transparent.

4. At this stage, the artist decided too much detail was visible for the amount of fog he wanted to add, and so he painted more atmosphere over everything except the highlights in the center of interest. He blended the

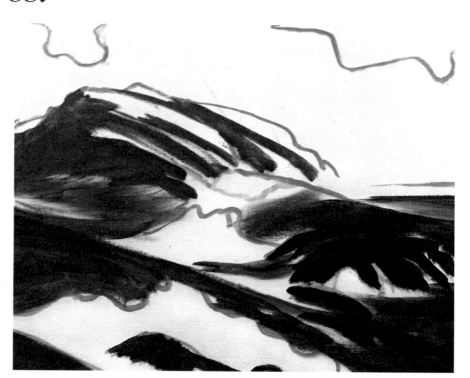

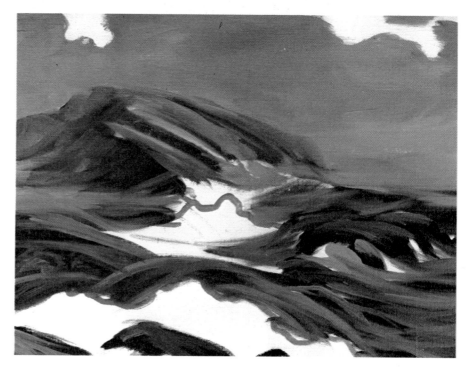

sunlight color with that of the atmosphere and added a bit more white to lighten the entire painting. The artist applied the greatest amount of texture, as well as the highest values, in the center of interest in order to draw attention to it. He whipped a dry varnish brush back and forth in the background to soften the edges and make the rocks appear to fade into the fog.

Quiet Moments, 24″ × 36″ (61 × 91 cm), by E. John Robinson

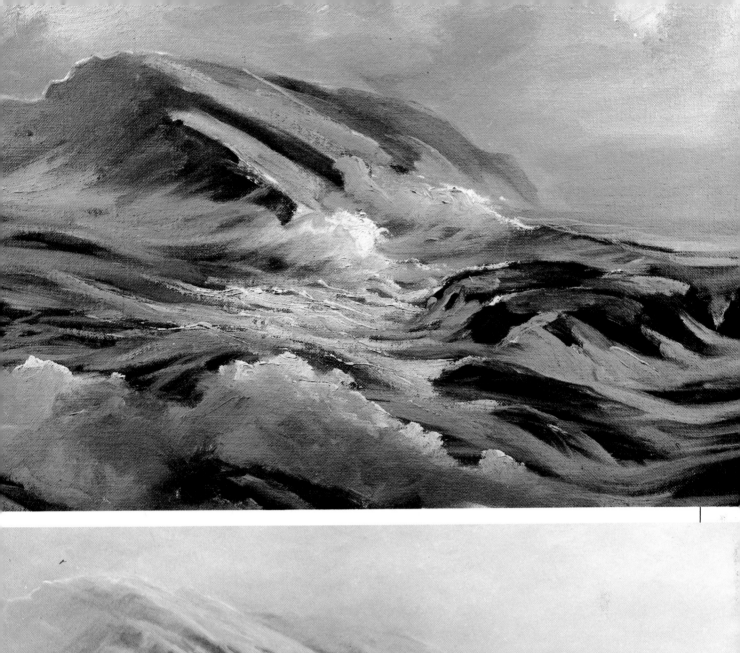

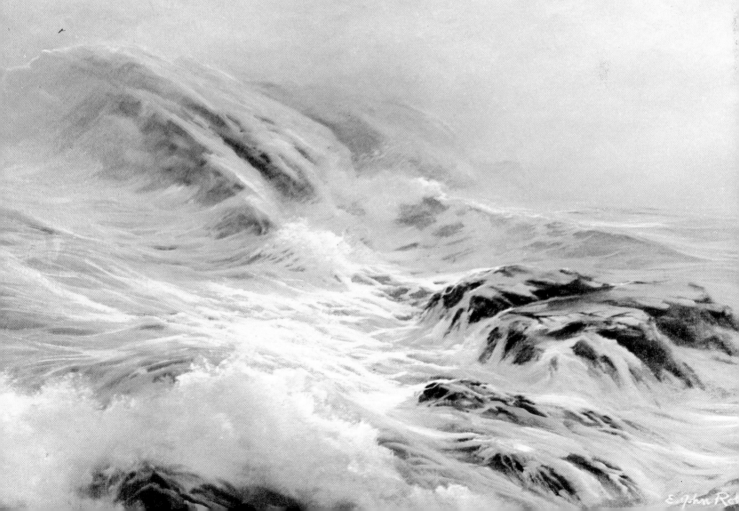

Conveying Cross Currents

1. This painting is entirely of water, with only a hint of submerged rocks below the surface. The artist started at the top of the canvas with undiluted viridian and added ultramarine blue to it as he worked downward. He used a mixture of burnt sienna and ultramarine blue on the rocks. He left the areas of pure sunlight unpainted.

2. Since there would be no sky showing in this painting, the artist could only suggest the atmosphere of the day by showing its colors reflected on the surface of the water. The artist followed the contours of the moving water as he added reflections of the unseen sky, using a mixture of undiluted ultramarine blue and white. In most areas, he allowed the atmosphere color to cover, rather than blend with, the water to suggest the clear atmosphere and indicate the nearly smooth, highly reflective water.

3. The sunlight was painted with a mixture of cadmium yellow medium and white. Mr. Robinson painted the lightest areas first—the foam and foam trails facing the sun. Next, he added the bounced, or reflected, lights throughout the composition, being careful not to lose the continuous movement suggested by the lines. Where the sunlight did not reach, he added shadows throughout the composition, being careful not to lose the continuous movement suggested by the lines. For the shadows, he used a lavender mixture that contained just enough alizarin crimson to keep it on the warm side. He created the transparent area, which is part of the center of interest, by blending the cadmium yellow medium mixture into the viridian he had previously applied in the water.

4. The refinement of this painting required a lot of patience. First the artist used a dry varnish brush to soften all the edges except for a few in the center of interest. Then he used the atmosphere color and the sunlight mixture to further define the contours of the wave and swells. As he did this, the entire painting became lighter, and more reflected sunlight and atmosphere became visible. The subtle silhouette patterns in the transparent wave, along with the artist's use of thicker paint in that area, kept the center of interest from losing importance as he added detail and color to other areas. He used the patterns over the submerged rocks merely to add textural interest and to deepen the shadows in the foreground.

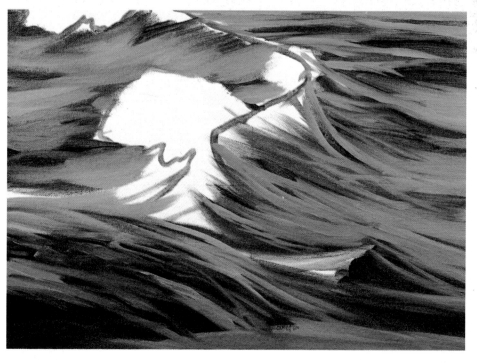

Cross Currents, 24″ × 36″ (61 × 91 cm), by E. John Robinson

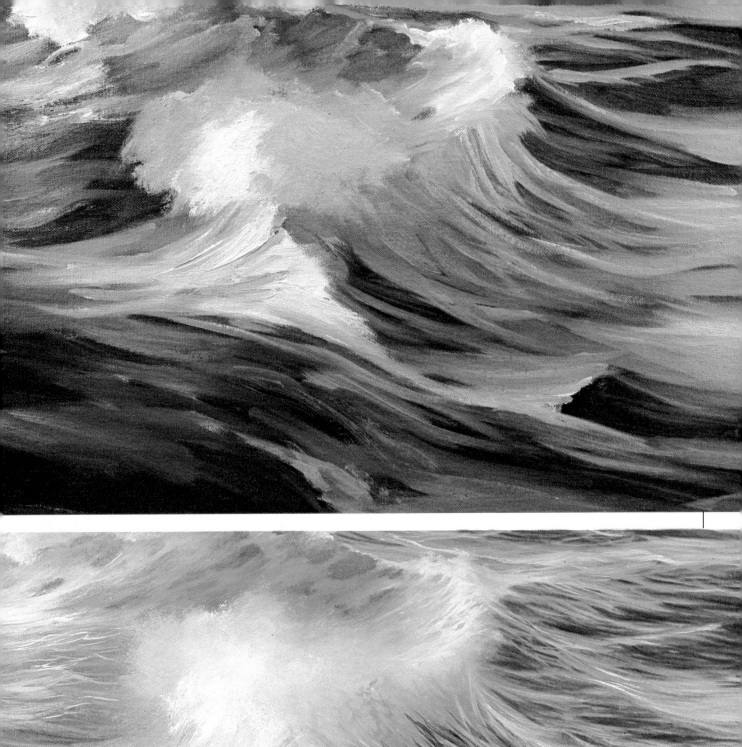

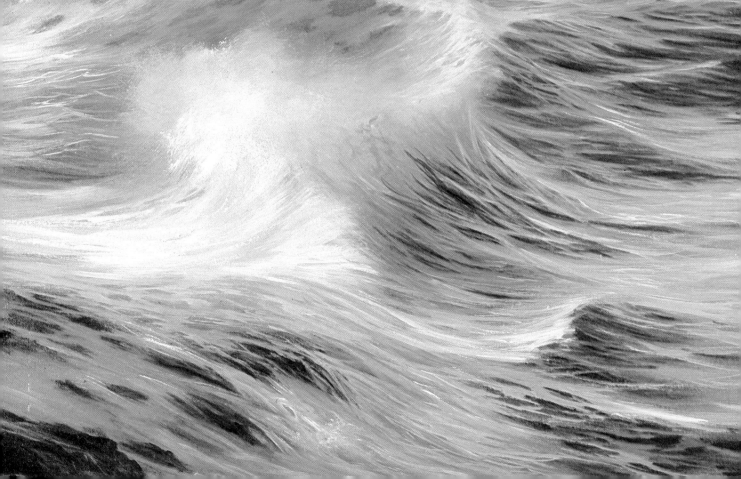

Painting Sea and Glowing Sunlight

1. Knowing that the overall color of his painting would be the warm glow of the sun, E. John Robinson applied very little local color to his canvas as an underpainting. He added pale blue on each side of the sky and painted in the gray cloud in the center using a mixture of burnt sienna, a touch of blue, and white. He used the same mixture with less white to paint in the headland. For the local color in the waves, he used viridian green and burnt sienna, which combined to create an olive green effect. To paint the sand, he mixed a thin wash of burnt sienna and cadmium yellow deep, and then grayed it down by adding some of the mixture he had used for the cloud. He used undiluted burnt sienna on the rocks.

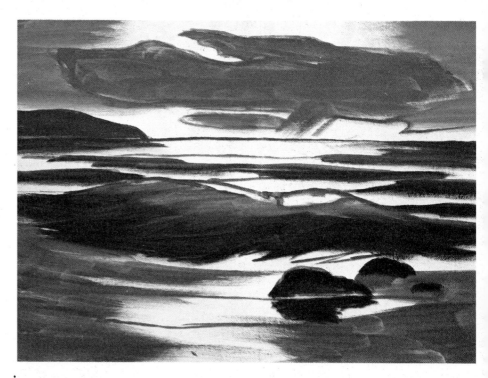

2. In this painting, the atmosphere color would be influenced more by sunlight than by reflected colors from the sky. The artist began painting the atmosphere in the center of the canvas, applying undiluted cadmium yellow deep in the background and down through the foreground, blending its edges with the gray of the sky, water, and sand. He mixed the yellow with burnt sienna and blue and added it to the clouds to give them more form. Then he used the same mixture to add reflected light on the headland and in some areas of the foreground. Notice that the addition of atmosphere colors to the backlit wave made it begin to look transparent.

3. Mr. Robinson had already applied most of the sunlight colors as atmosphere, and so he simply refined the glow effect at this stage. He mixed cadmium yellow deep with white and applied it as highlights in the central area of the picture. He used this mixture very sparingly so that he wouldn't dull the effect of the glow. The wave became somewhat opaque because of the addition of opaque white paint, but the transparent effect was still visible. Then the artist applied blue in the shadows. This did not disturb the color harmony because blue is the complement of orange, and cadmium yellow deep is very close to orange. Mixed into the yellow underpainting, the blue caused some areas to appear green, and so the artist added a touch of alizarin crimson to those areas to dull the green.

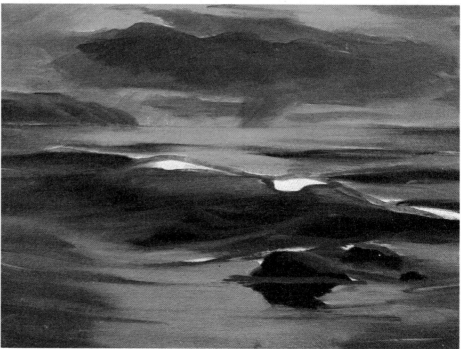

4. The artist added foam patterns to the wave and foreground, a few more swells in the background, and more reflected light in the central area. The foam patterns were the most important addition here, because they gave texture to an otherwise flat wave and added enough interest to attract the viewer's eye from the areas of glow to the wave. The areas of scud and slick in the foreground would have been too broad if Mr. Robinson hadn't added some texture to break them up. He did very little hazing with a dry varnish brush, just a bit in the sky area to make it recede.

View from the Beach, 24″ × 36″ (61 × 91 cm), by E. John Robinson

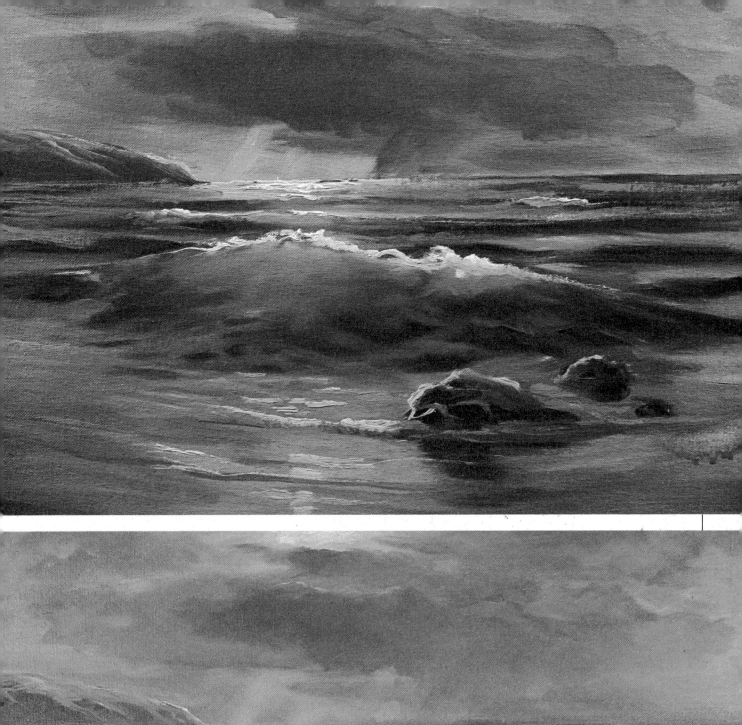
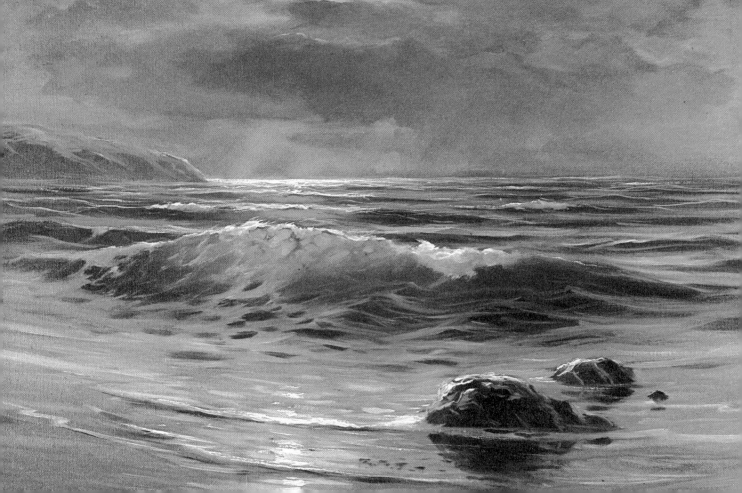

Painting Moonlit Waves

1. Moonlit skies are sometimes warm and sometimes cool, but never black. Because the artist had decided that the moonlight would enter his painting from the left and fill it with plenty of light, he used gradations of light to dark in the sky as he approached the right side of the canvas. The mixture he used was two parts ultramarine blue to one part burnt sienna, lightened with white and a touch of pale yellow. He added more white to the same mixture and filled in the clouds. For the water, he used a mixture of undiluted viridian green and burnt sienna; for the rocks, burnt sienna and ultramarine blue. He left the foam and the moonlit areas unpainted.

2. Because he wanted a warm, pale yellow moonlight, the artist chose its complement, violet, for the atmosphere. He worked the violet into the local color in the clouds, over the flat surfaces of the water, and into the tops of the rocks. Although he used much more of the mixture in the distant rock on the right than in the foreground rocks, he did not add enough to obscure the rock, because he wanted the atmosphere to be very clear.

3. The intensity and color of moonlight vary greatly from one night to another. Sometimes moonlight is slightly green, and at other times it is a warmer yellow. However, it is usually very white with a touch of pale yellow, and this is the mixture Mr. Robinson chose for the moonlight in this painting. First he blended the mixture with the local green to create a transparent effect in the water. Then he used it to add highlights to the foam and clouds and blended the same mixture with the burnt sienna of the rocks to give them a near-orange hue. He painted the lavender mixture he had used for the clouds into the darker portions of the white foam and worked more of it into the clouds as well. The artist used the same mixture without white to paint the shadows on the rocks and the shadows they cast on the water.

4. The painting still required a good deal of texture, which the artist added even in the distance to indicate that the atmosphere was clear enough to allow details to show up. He used reflected light to create an impression of movement in the spill-offs around the rocks. He added cracks and crevices on the surfaces of the rocks. Then he added more atmosphere and glints of moonlight to make the rocks more important and create enough interest in them to lead the eye from one to another and finally to the center of interest. He also added textured foam patterns below the foam burst to give the viewer a visual reward for following the lead-in to the wave. These highlights and textures suggest a lot of action, removing this painting from the usual placid, romantic category of moonlit seascapes.

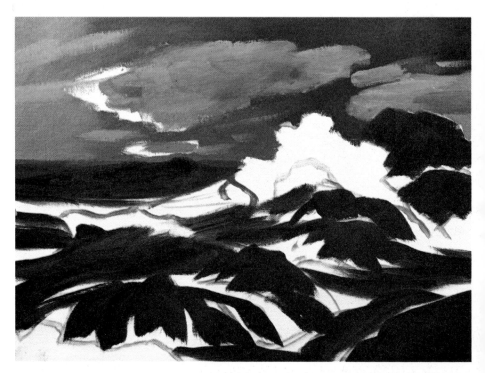

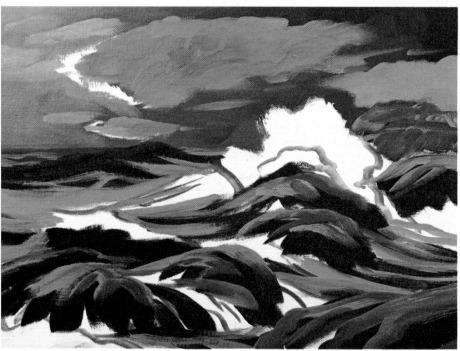

Night Waves, 24″ × 36″ (61 × 91 cm), by E. John Robinson

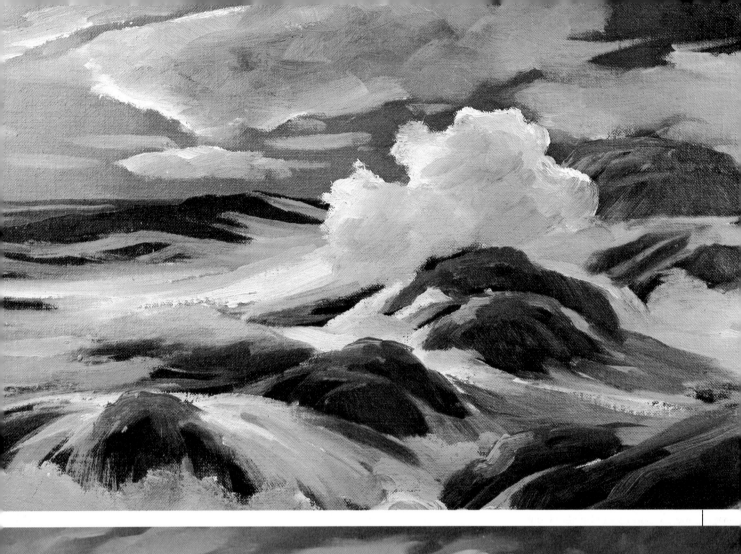

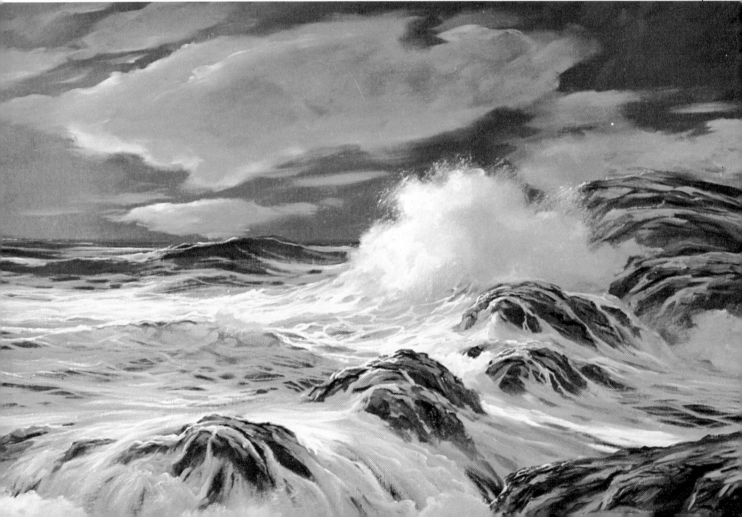

SHARP FOCUS REALISM

The realist painter often faces the problem of creating a work that is not only successfully precise, but *real* looking, as if the objects rendered aren't just props put together for a painting, but actually existing in life. This section will help you discover how to add the character and authenticity to your paintings that will bring out this kind of realism. Detailed step-by-step demonstrations show when various decisions are made during the process of painting, and how even preliminary drawings and rough sketches are crucial stages in a painting's development. The following pages show: how you can use the initial drawing to help the painting; at what stages to use wash-ins, block-ins, and glazes; where and when to add the effects of lights and shadows; how to create textures—and scratches, scuff marks, and highlights—with a paintbrush or toothpick!

Texturing Wood, Rust, Porcelain, and Enamel

1. Ken Davies was immediately attracted to the idea of painting this wonderful old cabinet and little white teapot. He began by doing a complete drawing on gessoed Masonite panel, working carefully with a 2H lead pencil. He drew everything, even the nail heads, and shaded in the shadows. A kneaded eraser was kept handy for cleaning edges and correcting mistakes. Notice the precision of the edges around the pot. In sharp-focus realism, there can be no vagaries in the drawing—it has to be exact. Sometimes you may be tempted to leave a difficult part of the drawing less than perfect and "fix it when you paint." Don't—it's a lot easier to be precise with a pencil than with a brush.

2. The artist then washed in the entire painting. The wash-in provides a quick way of getting a fairly accurate impression of the finished work. You can usually tell at this stage whether or not the painting will be successful. If it's not, it can be thrown away and at this point, you would have lost just a minimal amount of time.

For the teapot, the artist thinned the paint to a transparent consistency with a mixture of turpentine, linseed oil, and damar varnish (about a third of each). The shadows on the pot were painted with a mixture of white, cobalt blue, and raw umber—one of the artist's favorite mixtures.

3. Here is a close-up of the cabinet and the washed-in background area behind it. The artist painted the background with straight burnt umber and textured it with a large round bristle brush.

4. After the background area was dry, he glazed it down in value with more burnt umber until the texture was just barely visible. You can also see the side and top of the cabinet here. To block them in, he scumbled a semiopaque color—a mixture of white, cerulean blue, raw sienna, and raw umber—over the wash-in of step 2.

5. He then added the final wood texture over the block-in with a very small sable brush and took advantage of some of the texture of the original wash-in, which showed through. He used cobalt blue and raw umber for the darks, and white, raw umber, cerulean blue, and a touch of yellow ochre for the lights.

6. Again using the white, cobalt blue, and raw umber mixture, he painted the nail heads on the cabinet. Very little cobalt blue was used, however—just enough to slightly neutralize the umber. On the more rusted nail heads, he added a slight amount of burnt sienna.

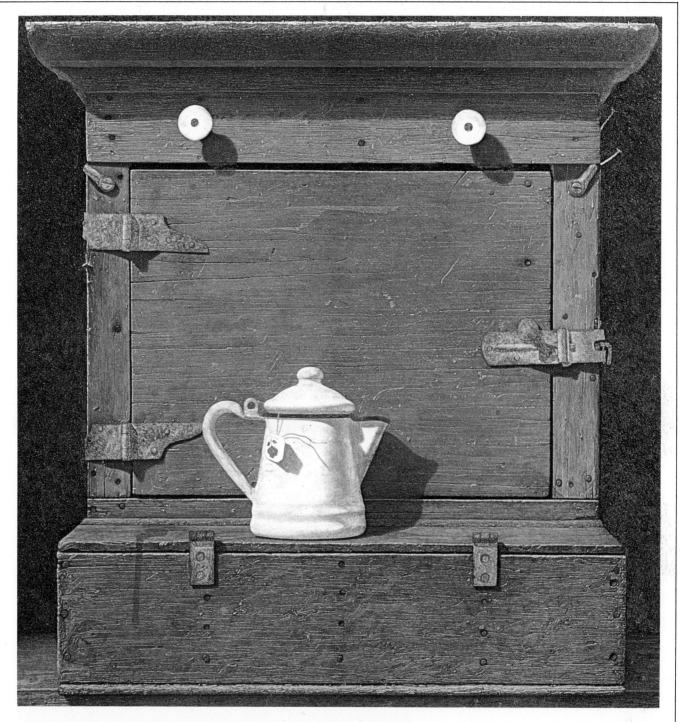

7. Here, the artist has blocked in the door of the cabinet. For this block-in, he applied a bit more opaque color, since the texture of the wash-in was a little monotonous. At this stage in the painting, the cabinet has been detailed and is ready for glazing. A mixture of cobalt blue and raw umber was used to glaze the shadows. You can see how the three-dimensional effect is increased when the shadows are glazed in. The artist had expected to use some viridian green in this mixture, but when he saw that it made the shadows too green, he eliminated it completely.

8. Here is a close-up of the washed-in latch. The artist painted it roughly, with a transparent wash of raw umber warmed with burnt sienna in order to create texture. Some of the pencil drawing shows through the light wash here.

9. He continued to block in the latch with more opaque color, using cobalt blue, raw umber, and some burnt sienna, which he combined with small amounts of white and yellow ochre to give it body. Note that the blocked-in area is much darker and grayer than the wash-in.

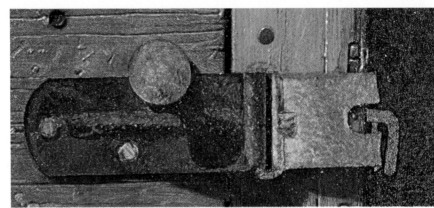

10. After the colors were blocked in, he daubed them carefully with a worn brush to blend them. To finish the latch, he waited until this was dry before adding his final touches. When it dried, he added highlights and dark accents to the texture of the latch with a no. 1 sable brush.

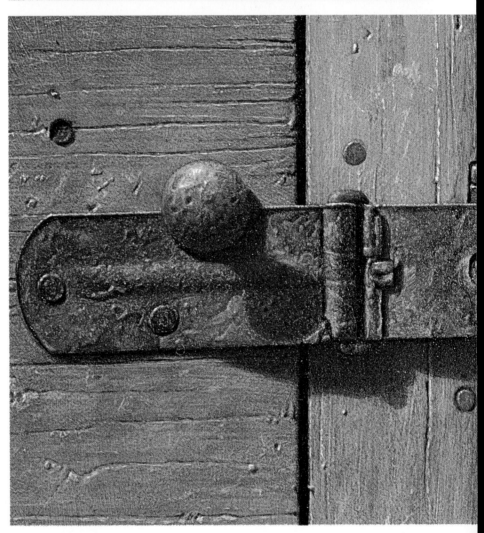

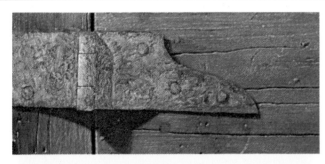

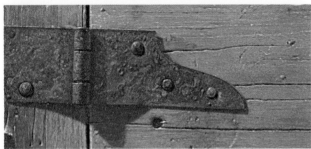

11. This is how the hinge looked after the wash-in stage (top). To finish it, (bottom) the artist used exactly the same procedure and colors that he used on the latch. The tiny highlights are not white, but a fairly dark mixture of white, yellow ochre, and raw sienna. They look lighter than they really are because of the very dark values around them.

12. (Below) Here the artist finished the white knob. He darkened the edge on the shadow side and highlighted it on the light side. He textured the knob with subtle scratches and painted its metal center, and used burnt sienna for the slight bit of rust there. The knob may *look* white, but the artist actually painted it with a warm gray several values darker than white.

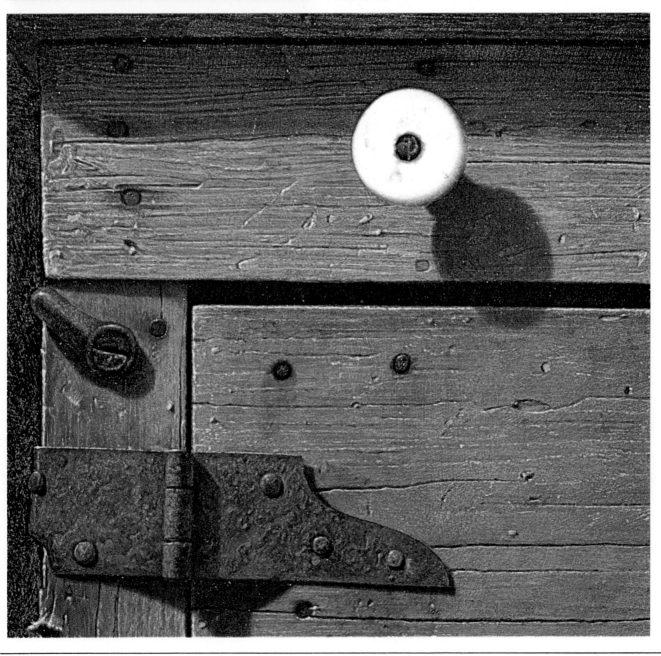

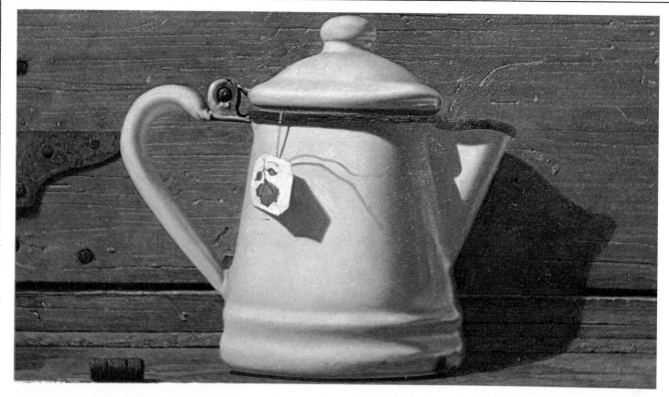

13. The artist blocked in the teapot and blended all the shadows carefully by stroking and daubing them with a worn filbert sable brush. The shadows, at this stage, were just very slightly lighter than they would be in the finish.

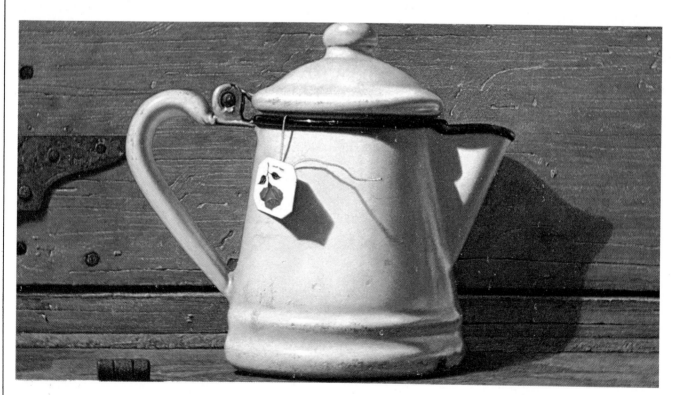

14. To finish the teapot, the artist glazed the shadows just a shade darker. He added scratches, scuff marks, and highlights to the surface and finished the string and teabag. The highlights on the little metal staple on the tag required the use of one of his smallest brushes—a no. 0000 sable!

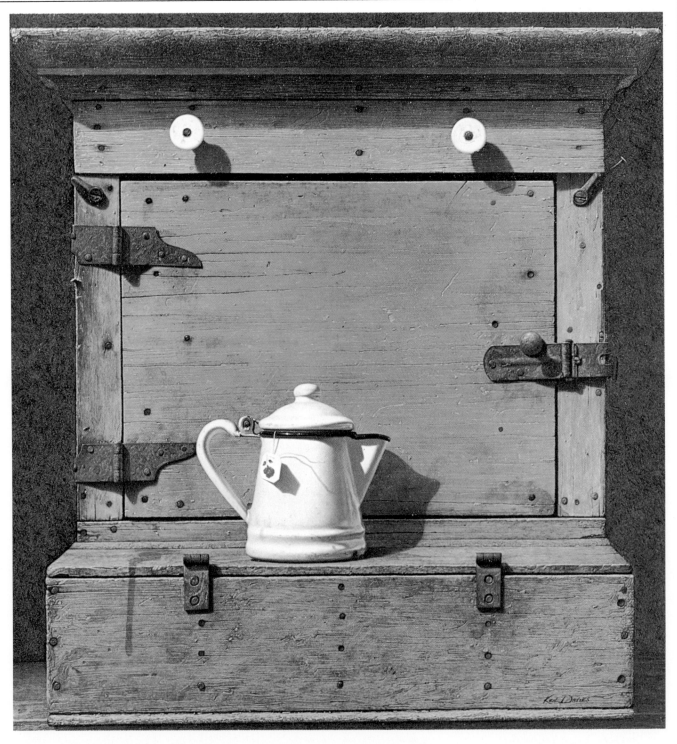

15. Note how the tea pot is just slightly off center—it's more to the left—furthering the painting's sense of realism. It doesn't look like a painting of two props, but of an actual arrangement. You can also see how the artist's careful attention to even the slightest scratches and highlights have added to the painting's overall authenticity. Compare the finished painting here to the stage on page 89 to see the difference his detailed texturing made.

Tea Break, 22½″ × 21½″
(57 × 55 cm), by Ken Davies

Painting Cast Iron and Brick Surfaces

1. (Opposite page) Ken Davies drew this finished drawing based on a rough sketch he'd done earlier. Because he liked the effect of sunlight on the potbellied stove, and didn't prefer just one effect, his previous sketch had incorporated several lighting effects from different times of the day. This was a crucial first step in establishing the final composition of the painting. The finished drawing was done on illustration board and sprayed with fixative. Then the entire surface was coated with retouch varnish to seal it.

2. The artist washed in each brick individually, exaggerating the red color of the bricks. But, except for the floor and the small area in the shadow at the left, white paper had been left for all the mortar between the bricks. (The painting looked terrible to the artist at this point.)

3. Now the mortar had been added and the painting had begun to look a little better to the artist (he was still anxious to get the glaze on over the red and crude-looking bricks).

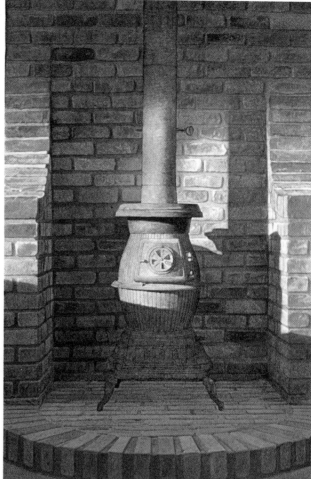

4. Next the artist washed in the stove and stovepipe. The painting had to dry for several days before he could glaze on the shadows. When the painting was dry, he glazed the shadows over the bricks. This added the effect of light that attracted him to the subject in the first place. The glaze was a mixture of raw umber and cobalt blue, which helped to neutralize the red color of the bricks that had been exaggerated during the wash-in stage.

5. As you can see in this close-up of the washed-in stove, the artist has allowed the drawing to show through, as he does in many of his paintings to aid in the block-in and finish.

6. The light areas on the body of the stove were composed of a simple mixture of burnt umber and white, giving the effect of warm sunlight striking the cold cast iron.

7. The artist has developed the shadows on the floor under the stove and on the bricks, and added detail in the light areas. Note how the combination of lighting effects work to create a uniquely lit center of interest. The striking precision of the individual bricks is the result of painting in each brick one at a time.

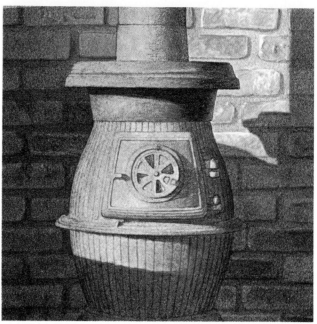

Kitchen Potbelly, 18⅜″ × 12¼″
(47 × 31 cm), by Ken Davies

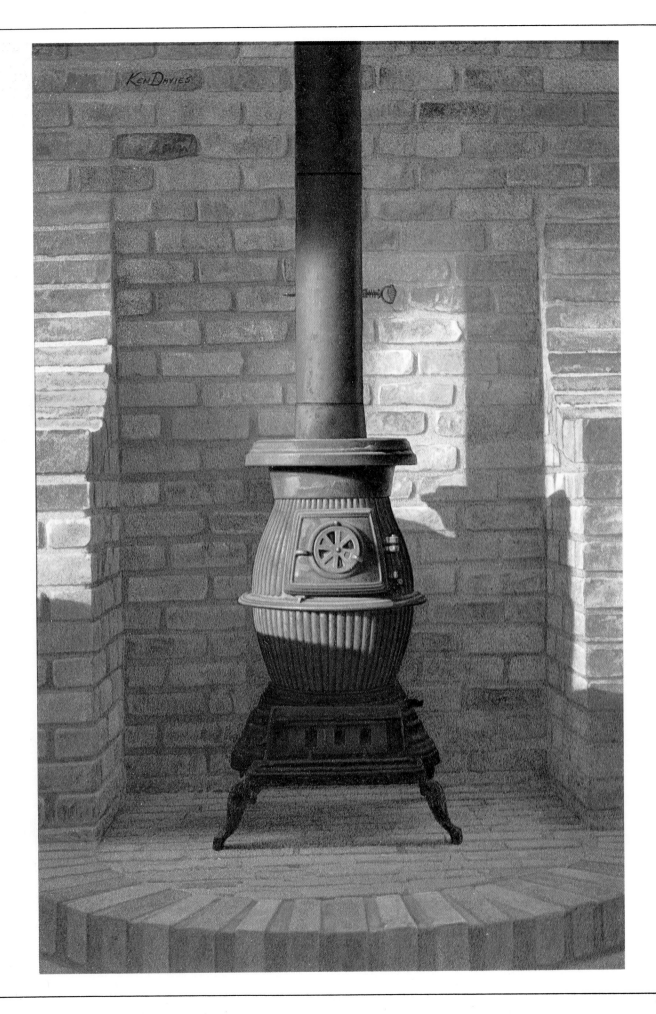

Painting Clapboards in Light and Shadow

1. The provocative abstract quality of the lights and shadows on this old meeting house were what inspired Ken Davies to create his painting. He started it with a drawing on gessoed Masonite. The actual building had no shades on the windows—both were like the one on the left. He added a shade on the right-hand window for two reasons: to vary the two dark shapes, and to lighten the right side of the painting, which was heavier due to the large diagonal shadow. The artist felt that adding the shade would keep the area more in balance with the left side.

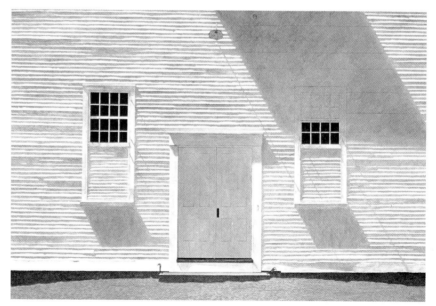

2. In the wash-in stage, the artist painted all the shadows with a thin mixture of cobalt blue and raw umber. He left the light areas unpainted—at this point they were still white gesso. He textured the ground in front of the building roughly by daubing it with a bristle brush while the wash was still wet. He added the effect of the light by painting a thin mixture of white and yellow ochre over the whole clapboard area. Only the large shadows and the doorway remained the original wash-in. This white-yellow mixture added the warm glow of sunlight to the lighted areas, as opposed to the coldness of the raw, bluish-white gesso.

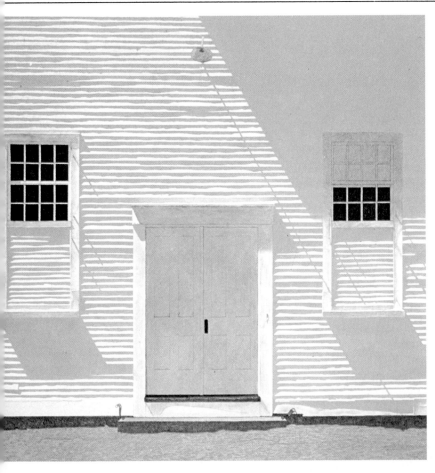

3. Here he painted the larger shadows with the white-yellow wash and blocked in the middle section of clapboards with an opaque mixture of white, cerulean blue, and raw umber. Notice how this block-in coat has a richer, warmer look than the milky quality of the rest of the shadows. At this stage, the artist has blocked in all the clapboards and large shadows, while the doorway and window are still just washed in.

4. (Below left) This is a close-up of the left-hand window. The artist painted the subtle reflections in the dark windowpanes. The window shade (which was an afterthought in the total composition) and window frame has been roughly blocked in. The color of the dark windowpanes was *not* painted black, but a mixture of ultramarine blue and burnt umber.

5. (Below) In this close-up of the right-hand window, you can see that the upper half is just washed in, while the clapboards in the lower half have been blocked in.

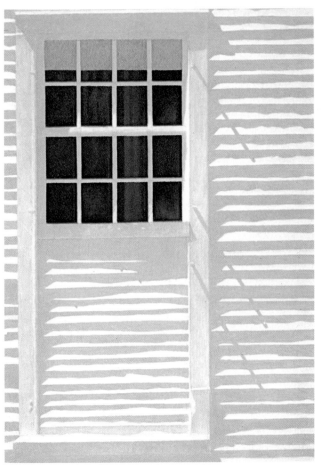

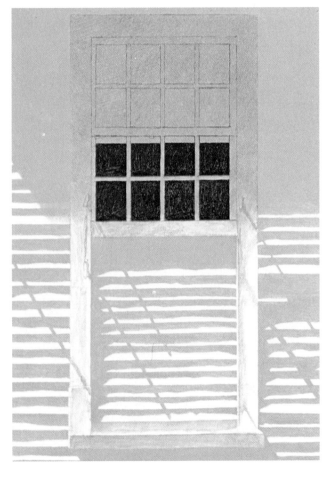

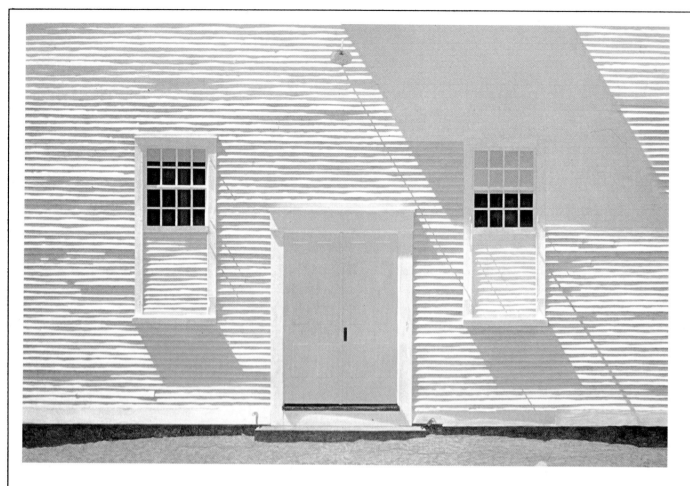

6. Here the artist blocked in the doorway. Notice the shade in the left-hand window. If you compare this stage with an earlier one, you can decide for yourself whether or not the addition of the shade is an improvement. The artist finished glazing most of the clapboards at this stage, except for the strip across the top of the painting. Notice how the glazing extends into the large shadows and the shadows under the windows.

7. (Opposite page, top) The right-hand window looked like this (left) before its final detailing. The finished right-hand window is on the right.

8. (Opposite page, bottom) In the close-up of the door (left), notice that the drawing lines of the panels on the doors still show lightly through the paint. They'll act as guidelines for the final glazing and finishing steps. This is how the door looked before its final detailing. The finished door is on the right.

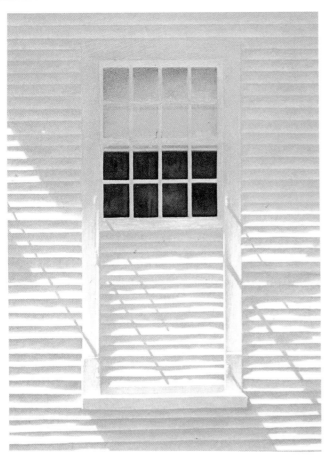

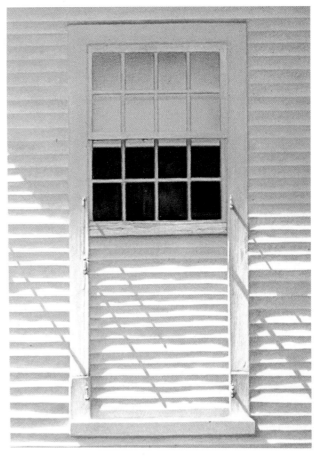

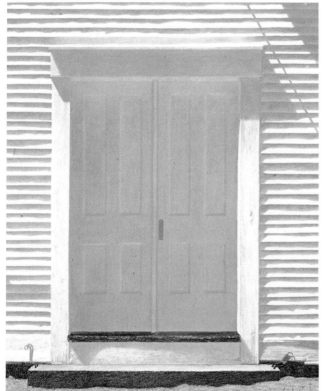

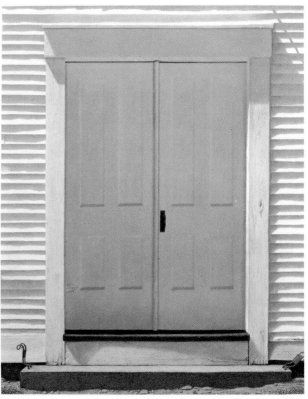

9. (Top) At this stage, the left half of the foreground was still in the wash-in stage. The artist had to finish the dark foundation of the building before he could paint in any grass or stones.

10. Here the artist has finished the foreground. Many of the stones were suggested by the original texture of the wash-in. Where the daubed texture (see above) suggested a stone or pebble, the artist simply painted a shadow on one side and highlighted the other side with the mixture for the light area. For the light areas, he used white, yellow ochre, and, in places, a touch of raw sienna; for the shadows, he generally used raw umber with a touch of raw sienna. He scratched the blades of grass out of the sap green glaze with a toothpick or an old hardened sable brush while it was still wet. He added opaque color to the light areas and placed shadows where they seemed to be suggested by the scratching.

11. The artist has successfully conveyed the play of lights and shadows on this old meeting house. Note that the upper part of the door is a very subtle warm tone, blending down into the cooler color of the rest of the door. This is because very little reflected light from the blue sky is hitting that area because of the overhang of the doorway. The warm reflected light from the ground, therefore, is not neutralized, as it is on the rest of the door.

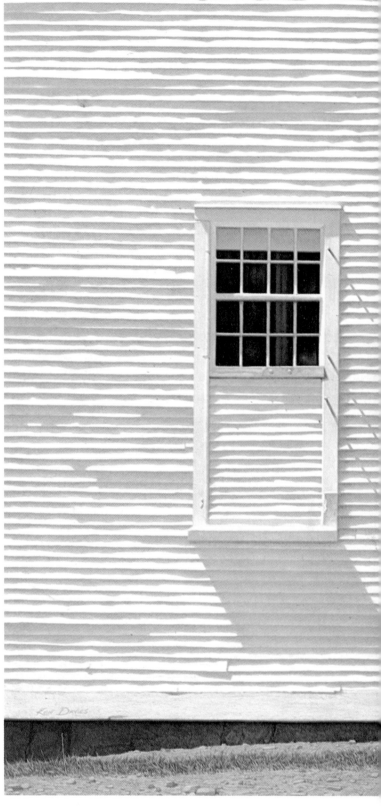

Clapboards and Shadows, 24″ × 35½″ (61 × 90 cm), by Ken Davies

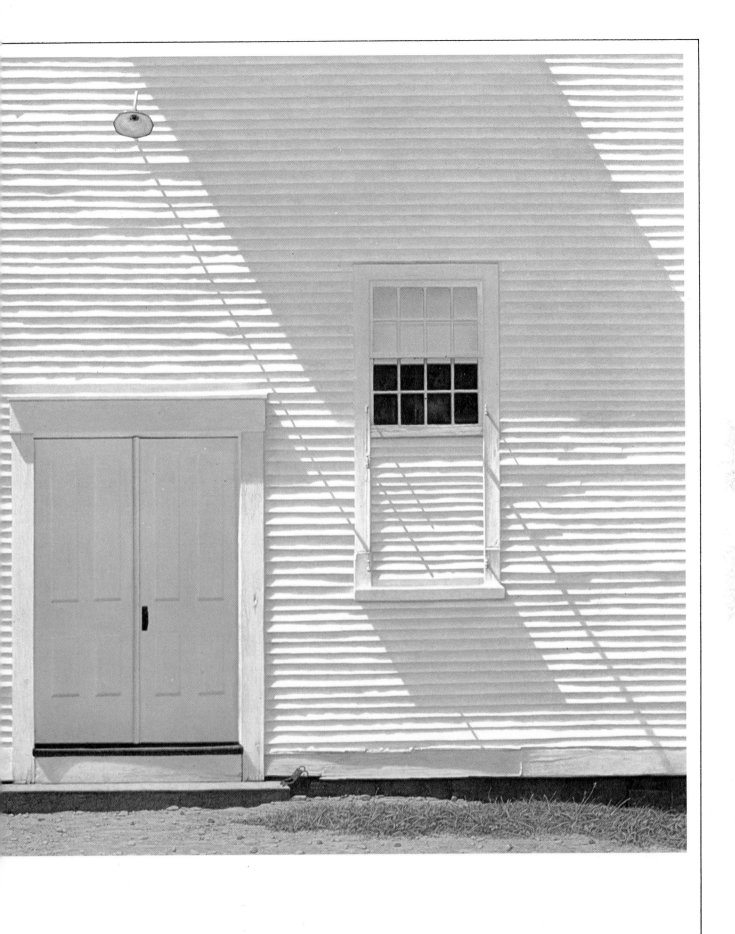

PAINTING FIGURES AND PORTRAITS

This section discusses what are probably the most intriguing and challenging painting subjects of all—the human portrait and figure. From pencil studies to finished paintings, the step-by-step demonstrations on the following pages explain and show many techniques used to achieve favorable results in figure and portrait painting.

Some of the concerns of portrait and figure painters addressed are: working *toward* the darks; resolving the basic value structure of a painting; handling fair, swarthy, and dark skin colorings; suggested pigment mixtures that work well for flesh tones; painting traditional portraits (from the shoulders up); portraits that convey a sitter's personality; the effect of light in figure and portrait painting; and nude and semi-nude figures.

Painting the Human Face and Form

An artist's reasons for painting portraits and figures as opposed to landscapes or still lifes are difficult to pinpoint, but a big part of it may be that the human face and form are probably the most challenging—and fascinating—subjects to paint. Conveying the sensual effect of light on a reclining nude in a sunlit room, or portraying a sitter's reserved or frivolous personality as well as his or her features are difficult assignments for the artist.

From the beginning of a painting, even in initial rough sketches and preliminary compositions, the figure and portrait painter works with an important person—the model. Do you find that you're concerned about your model's comfort—and even distracted worrying whether he or she is bored or cold? Artist Jane Corsellis found that letting her model select her own poses put her—and the model—at ease. If your problem is feeling too intense and awkward working so closely with just one other person, you may want to try taking a class. There, the presence of other people will make the working arrangement much less intense. You should know too, though, that the other people there may be distracting.

Too many painters simply load up their palette, pick up a brush, nod to the model to stand or sit, and then begin painting. Actually, it's best to work out your composition before you start painting (although this preliminary work doesn't always guarantee that problems won't crop up as the painting evolves). It often takes hours and even days to plan and compose your paintings thoroughly. Even though a pose may appear splendid to the eye, there is no assurance that it will work well on a canvas, since a correctly drawn limb doesn't necessarily insure a pleasing visual element in the painting. You may find that choosing a pose with a preconceived concept works well for you, as it does for artist Charles Pfahl. Try involving the concept in your preliminary pencil studies, where you work out the painting's contours, proportions, and patterns of light and shade. Even the sketches you don't use can be helpful if you file them away and refer to them in the future. Just remember to refer to them! Many artists get some of their best painting ideas from old sketches, and you may resurrect some interesting memories that you'll be able to incorporate into the painting you're working on at the time.

To arrange the interior in your painting really well, study it from every angle, see how the light strikes it from different viewpoints, and carefully analyze the elements it lacks or contains. You may want to then add, subtract, or rearrange objects until the final arrangement suits you. The figure can be an integral part of the interior, very involved with its surroundings, as Jane Corsellis likes, or it can be an incidental element in the painting. You'll find that, depending on what you like best, you'll probably include the figure both ways.

Painting the head, or the traditional portrait, encompasses no particularly sophisticated refinements. It's merely a straightforward exercise in painting that, once learned and acquired, can be successfully repeated no matter who the subject may be. However, in planning the portrait, it's a good idea to formulate several important practical decisions before beginning the actual painting.

Many portraitists suggest painting the head in actual life-size for two reasons: (1) this presents a most realistic appearance, and (2) it makes it easier for the painter to execute since it lends itself most comfortably and naturally to the artist's eye and hand. The second best choice is to paint the head smaller than life-size. The third and worst choice is to paint it bigger than life since the effect it produces is often distorted, unreal, and freakish.

After you've determined whether you'll paint your portrait life-size or not, you'll need to work out the value structure. Ask yourself, will it be generally light in value or low in value? Also, will it be painted in vignette form (a rough, informal shape with some of the white of the canvas showing) or painted fully to the edges? Will the effect be formal or informal? Serious or lighthearted? What expression will the subject's face register—stern, laughing, pensive?

Since these combinations of value, mood, shape and emotion are infinite, it's best to establish both in your mind and in your model's just where you're heading.

In planning the portrait you'll also need to ask yourself, what's the general shape of the model's head—round, square, narrow? What about the eyes, the nose, mouth, complexion, general proportions, the attitudes the sitter projects? Having analyzed, digested, and weighed these factors, experiment with a few poses (unless you have a preconceived pose as discussed above). Try the sitter facing front, ¾ to the left, ¾ to the right, in left and right profiles. Now decide on *your* viewpoint. You can work with your sitter placed at your eye level or slightly below. Or you might attempt placing the sitter somewhat above eye level. None of these poses are better than any of the others, they are merely alternates you may want to consider and finally decide upon while planning the portrait. The one that naturally seems the most attractive is the one you should finally adopt.

Another important planning decision concerns your choice of the background for the painting. Experiment with backgrounds on various colors and values. These decisions should be based on earlier ones determining the mood and effect you're seeking—strong and dramatic or soft and placid, for example. The color of the model's hair, complexion, and costume are vital in the determination of the background. A few general guidelines you may want to follow are: For blond or white hair use a darker, contrasting background. For brunette hair use a middletone background running more toward the light side if it's contrast you're seeking. For a punchy, dramatic effect employ a background of value and color the direct opposite of the subject's. For a soft, subtle effect use a background that's close in value and color to that of the subject.

John Howard Sanden has found that the ideal background is a single value darker than the darkest halftones in the sitter's face. Try that approach too.

Before the very first stroke can be laid, there are at least a hundred decisions to be made, and the responsible painter must learn to juggle the swarm of thoughts racing through his brain and to translate them into an effective working procedure.

Quietly stand and consider your subject. Focus on the background; the hair; the light side of the face; the dark side of the face; the costume. Note the values. See how the lights relate to one another and then do the same for the darks.

Now you're ready to proceed.

The color mixtures on the opposite page are suggestions for you to use in formulating your flesh tones—they're not pat formulas for various complexions. As stated in the color section of this book (see page 29) colorings and complexions are as individual as people are. Use these mixtures as a springboard from which you can experiment. And do experiment! You'll discover your own ways to achieve just the right flesh tones you want.

Mixing Light Colors

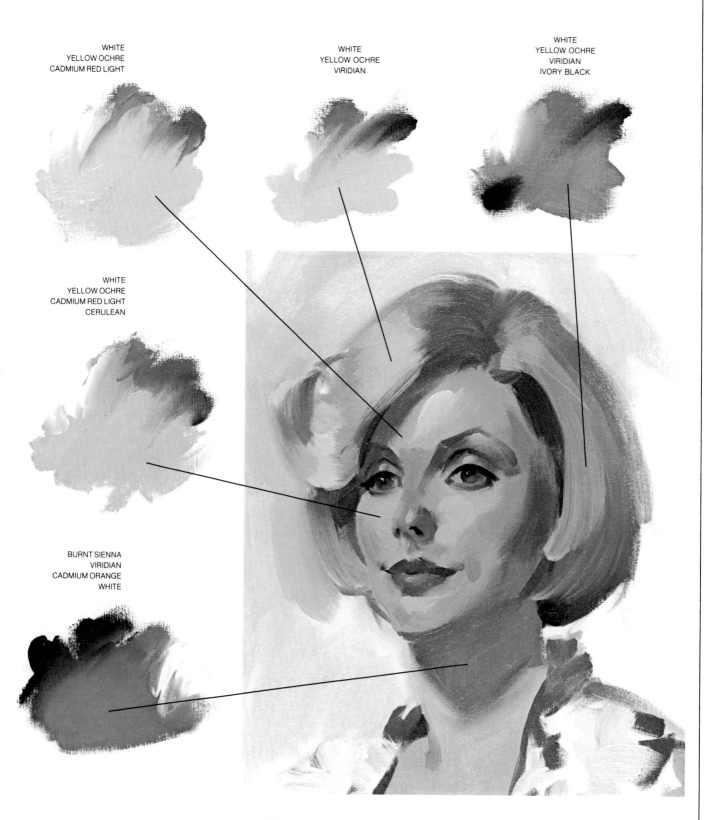

WHITE
YELLOW OCHRE
CADMIUM RED LIGHT

WHITE
YELLOW OCHRE
VIRIDIAN

WHITE
YELLOW OCHRE
VIRIDIAN
IVORY BLACK

WHITE
YELLOW OCHRE
CADMIUM RED LIGHT
CERULEAN

BURNT SIENNA
VIRIDIAN
CADMIUM ORANGE
WHITE

Fair Complexion. When you paint a fair complexion such as this subject's, a mixture of white, yellow ochre, and cadmium red light provides the most appropriate flesh color for the overall tone in a light area such as the forehead. It contains no cool or gray accents at all. It's also interesting to note that natural blond hair is not bright yellow but rather a combination of dull, cool, greenish tones in the highlights and some darker greens and blacks in the shadows.

Mixing Cool Colors

WHITE
YELLOW OCHRE
CADMIUM RED LIGHT
CERULEAN

WHITE
YELLOW OCHRE
IVORY BLACK
BURNT SIENNA

IVORY BLACK
BURNT UMBER
ALIZARIN CRIMSON

WHITE
YELLOW OCHRE
CADMIUM RED LIGHT
CADMIUM ORANGE
CHROMIUM OXIDE GREEN

WHITE
YELLOW OCHRE
VIRIDIAN
CADMIUM RED LIGHT

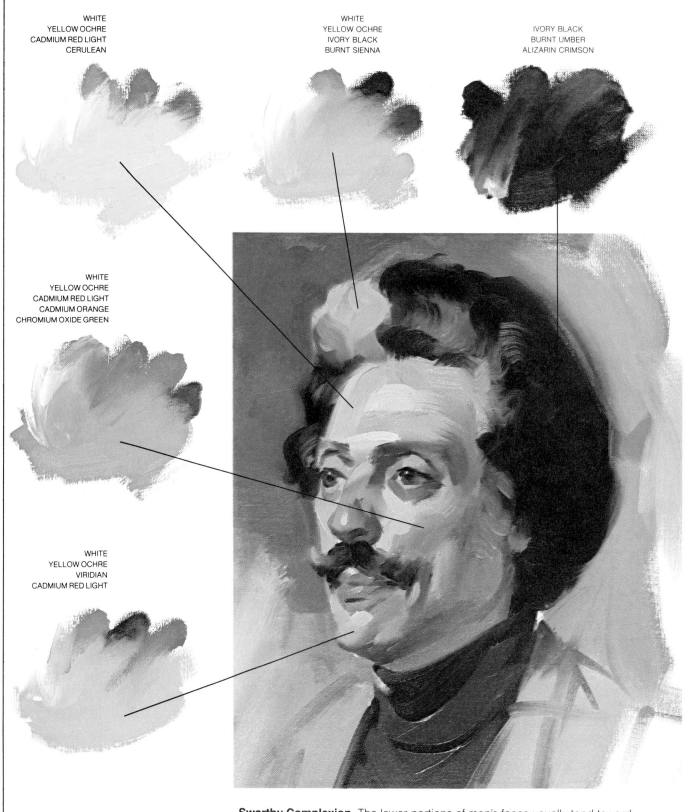

Swarthy Complexion. The lower portions of men's faces usually tend toward greenish halftones due to the presence of the underlying beard. Besides, this man's complexion is naturally swarthier than that of the woman pictured on page 107, which is another factor that led the artist to use a generally grayer, cooler combination of flesh mixtures in this portrait. The top right mixture produces one of the deepest flesh tones possible. However, in this case it possessed enough warmth to include burnt umber and alizarin.

Mixing Deep Colors

WHITE
BURNT UMBER
ULTRAMARINE BLUE

WHITE
BURNT SIENNA
VIRIDIAN
CADMIUM ORANGE

WHITE
YELLOW OCHRE
CHROMIUM OXIDE GREEN
BURNT SIENNA
IVORY BLACK

BURNT SIENNA
VIRIDIAN
WHITE

BURNT SIENNA
VIRIDIAN
CADMIUM ORANGE

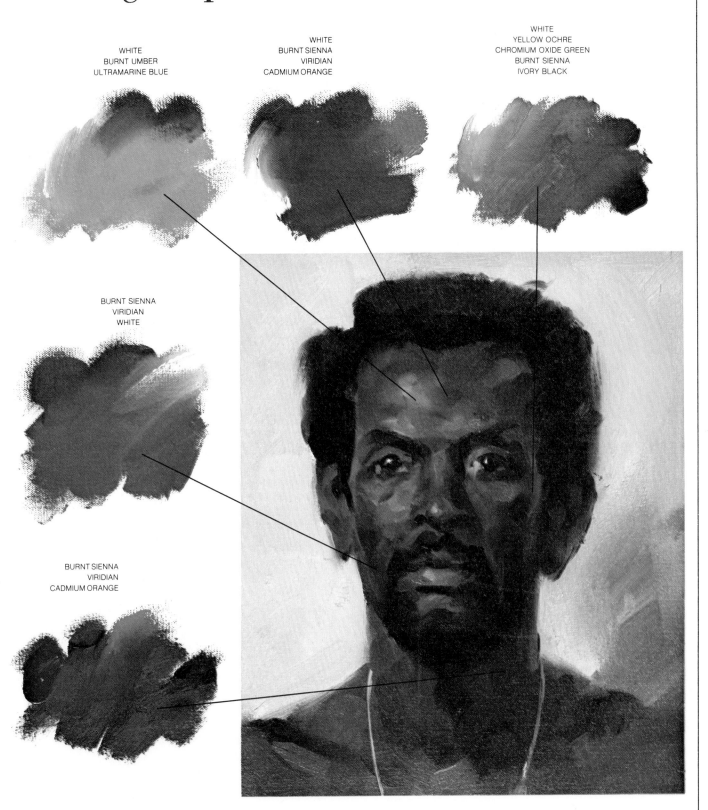

Dark Complexion. Dark-skinned subjects tend to exhibit grayish or bluish highlights. In this instance, the reflected light is strongly on the green side. In painting dark skin, artists sometimes have a tendency to go lighter, fearing they'll lose the nuances of modeling. However, the key to success in this challenging area is keeping those dark portions just as deep and rich as they actually appear. Also remember to provide an arresting interplay of cool highlights against the warm colors surrounding them.

A Woman's Portrait

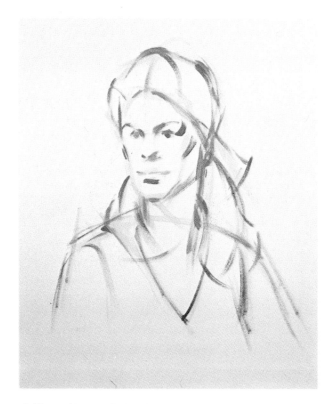

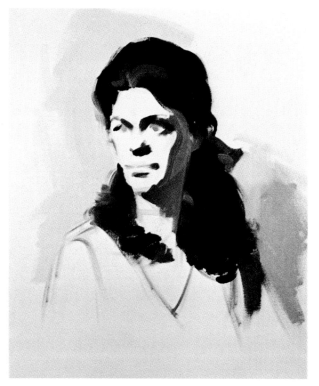

1. The artist usually begins his portraits by mapping the head, which is what he did here. He used a neutral gray tone that was a mixture of white, yellow ochre, and a bit of ivory black and started with the top of the hair and bottom of the chin. He marked the right and left outer contours of the head, the jawline, the outer limits of the neck, the curves of the shoulders, the hairline, the line separating the light and shadow areas, the shape of the hair, and the neck and sleeve lines. He then marked the irises, the bottom of the nose, the mouth, and the shadow beneath the lower lip. He switched to a darker color to indicate the dark shadow line of the hair, restate the hairline, and mark the temple, cheekbones, and ear.

2. He laid in a background tone of black, white, and a touch of cooling viridian. For the hair areas in shadow, he mixed black and alizarin.

Burnt umber, ultramarine, and white were used to paint the lighter hair areas. Next he combined white, burnt sienna, viridian, and cadmium orange with chromium oxide green to paint in the great mass of shadow in the face. Additional burnt sienna was used to sharpen the edge where the shadow met the light. He darkened the original mixture somewhat to paint the shadow cast under the chin and to paint in the corner of the eye, the brow, and the shadow beneath the nose.

He concluded this stage by painting the shadow cast by the hair on the neck and along the shoulder.

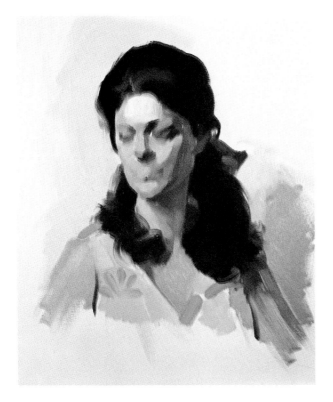 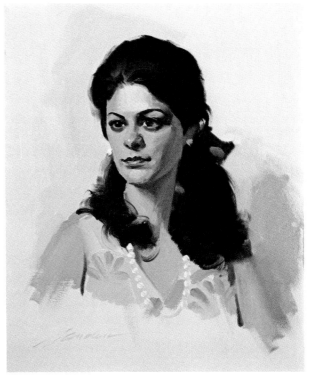

3. Next he painted in all the halftones. He started with the dark side of the mouth, painting it with a mixture of white, yellow ochre, cadmium red light, viridian, and ivory black. The halftones on the right were painted with these same colors, blended in different proportions.

He painted the right cheekbone next with a combination of white, yellow ochre, chromium oxide green, and cadmium orange, warmed with cadmium red light. The corresponding left plane was painted with the same mixture plus a little cerulean blue.

In the area of the chin and halftone falling between the shadow and the light, the artist painted the dark on the model's right with a mixture of white, cadmium red light, yellow ochre, chromium oxide green, and cadmium orange, cooled with a little ivory black. He painted the left plane with a different combination of the same colors. The right temple was painted with a mixture of yellow ochre, viridian, cadmium red light and ivory black. The left temple was a combination of white, yellow ochre, cadmium red light, and cerulean blue, with a touch of ivory black.

The side of the model's nose was painted a combination of white, yellow ochre, ivory black, and viridian. For the front of the nose, the artist used a mixture of white, cadmium red light, yellow ochre, chromium oxide green, cadmium orange, and ivory black. He then painted over the eye sockets with a grayish green tone that resulted when he mixed these colors in different proportions.

The planes where the nose flows into the cheeks were painted with a mixture of white, yellow ochre, and cadmium red light, with cerulean blue on the dark side; the same mixture, without the cerulean blue, was used for the warmer left side.

The neck and V of the collar were painted with white,

yellow ochre, and cadmium red light combined, plus some cerulean blue, with more blue in the lower areas where the color of the material was reflected. The artist added viridian to this mixture to indicate the arms and roughly painted in the dress color and pattern.

Next he painted the lights: the first was on the cheek, made up of white, yellow ochre, cadmium red light, cerulean blue, and cadmium orange; the next was the forehead, painted in white, yellow ochre, and cadmium red light; the final was the highlight on the chin mixed from a touch of alizarin, white, yellow ochre, cadmium red light, and cerulean blue.

4. After the usual refining and redrawing, the artist rubbed the eye socket with his thumb to remove any excess paint and to put in the dark brown irises. He then painted in the dark areas, shaping the eyes and the brows with white, ivory black, and raw sienna, combined. He modeled the nose and blended the tones to produce the effect of roundness, and placed several strategic warm accents around the tip. He painted the nostril openings with alizarin and burnt umber and shaped the wing of the nose.

The upper lip was painted with Venetian red and burnt sienna; the lower lip, with cadmium red and white. He placed the dark accents at the corners and into the middle of the mouth and mixed white and alizarin to place the highlight on the lower lip. A dark greenish tone was put in the shadow area under the lower lip, and several cool halftone planes were added at the corners of the lips. Although the portrait was almost finished, the artist realized at this stage that the chin was painted too long, and so he cut it down with strokes of shadow. He finished the portrait by adding the pearls, earrings, and, in a loose, rather playful manner, the pattern in the dress.

A Man's Portrait

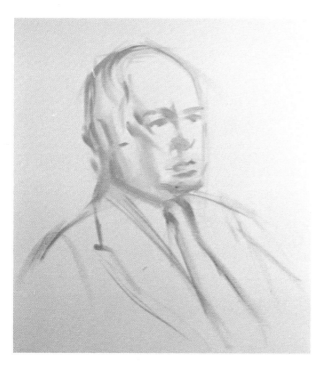

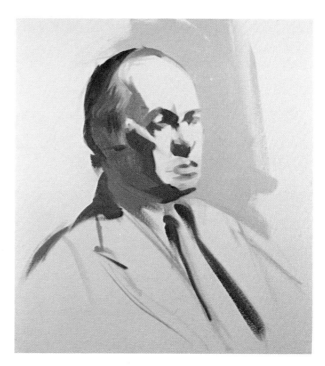

1. The artist began this portrait with a combination of pigments that produced a neutral grayish tone—white, yellow ochre, and ivory black. With this color he marked the top of the head and bottom of the chin, established the left and right outer contours of the head, neck, neckline, shoulders, lapels, and forehead, and indicated the important division of light and dark that separated the head. He then marked the irises, nose, mouth, lip shadow, tie, and hair.

2. The artist painted the background light gray. He separated the hair into dark and light areas, and painted the darks with black, white, viridian, and yellow ochre. He added more white for the lighter portions. The overall shadow tones in the large dark areas of the face were painted with a combination of burnt sienna, white, viridian, cadmium orange, and chromium oxide green.

For the darker accents along the shadow edge, he added more green, and for the lighter reflected tones, he added more white and a touch of cadmium red. The ear was painted with a bit more cadmium red, and ultramarine was added to the overall mixture to show the cool light reflecting from the shirt under the chin. The entire cool shadow on the temple was painted in white, ultramarine, and alizarin. The shadow side of the shirt collar and jacket, the one cast by the tie and lapel, and the shadows in the eye sockets, the corners of the eye, and under the nose were placed next. The mouth and shadow under the chin were done last.

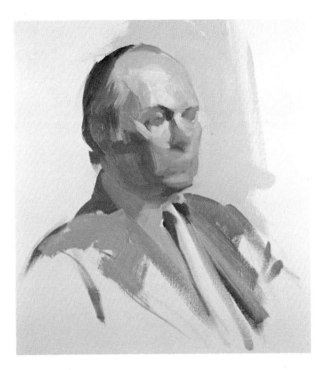 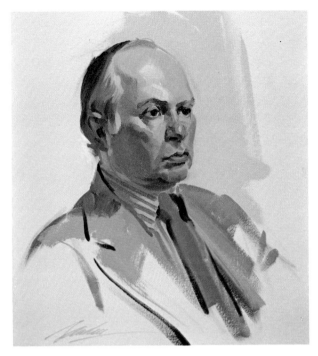

3. The artist began this stage from the model's stronger shadow area by painting the mouth region with a mixture of white, yellow ochre, viridian, cadmium red light, and ivory black. The lighter plane on the other side was painted with a lighter combination of these colors. The plane next to the left cheekbone is a mixture of white, cadmium red light, yellow ochre, chromium oxide green, cadmium orange, and a bit of cerulean blue. The lighter plane on the right was painted a different blend of those same colors.

The chin was painted in a mixture of white, cadmium red light, yellow ochre, chromium oxide green, and cadmium orange with Venetian red. The artist painted the left forehead plane in a blend of white, yellow ochre, viridian, cadmium red light, and alizarin. The lighter side was painted with a mixture of white, yellow ochre, cadmium red light, cerulean blue, and viridian.

Cadmium red and a mixture of white, cadmium red light, yellow ochre, chromium oxide green, and cadmium orange were used for the nose. The eye sockets were painted with Venetian red, ultramarine blue, and a neutral gray that was a combination of white, yellow ochre, and ivory black. The forehead tone just above the light area was painted with white, cadmium red light, yellow ochre, chromium oxide green, and cadmium orange. The artist painted the light areas separately, first painting the cheekbone in a combination of white, yellow ochre, and a bit of cerulean blue, warmed with cadmium red light. He then used the same mixture on the forehead, but diminished the amount of cadmium red light and added more yellow ochre. Several appropriate lights were also placed in the shirt and jacket.

4. To complete the head, the artist first placed the dark brown irises; then he painted the darks that formed the eyes and the eyebrows. Next he modeled the nose, placing the nostrils and shaping the wing and tip. He also applied highlights to bring it forward and lend it the effect of roundness. He then painted the mouth, beginning with the upper lip and moving on to the lower lip, the slash between them, the darks at the corners, and finally the highlight on the lower lip. The shadow was placed beneath the lower lip and additional modeling was done on the area between the nose and the upper lip. He then modeled the ear with dark strokes of burnt sienna and umber and followed up with highlights of alizarin and white. He added cool reflected lights, which picked up the colors of the shirt, and finished the portrait by painting in the tie and the pattern of the shirt.

A Black Man's Portrait

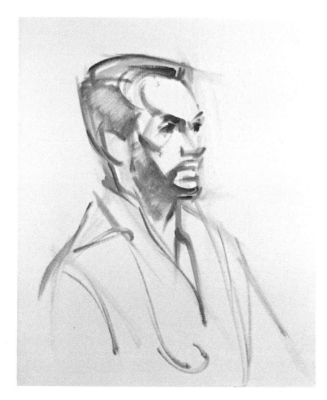

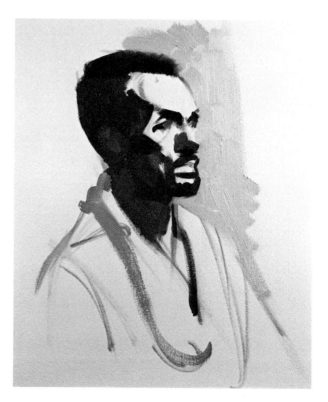

1. As in the previous portraits, the artist used a neutral gray tone (the combination of white, yellow ochre, and ivory black) to mark the top of the head, the bottom of the chin, the left and right perimeters of the head, the neck and shoulders, and the line lying between the shadow and light. Next, he indicated the hairline, eyes, nose, mouth, collar, lapel, shape of the hair, and placement of the ear. The final strokes marked the beard and mustache.

2. The artist brushed in a background tone of black, white, and yellow ochre, and then painted in the darks of the hair and beard with black, burnt umber, and alizarin, with the addition of white for the lighter areas. He then mixed a general tone of shadow for the face and neck by combining a mixture of burnt sienna, viridian, and cadmium orange. He added burnt sienna for the shadow of the nose. The eyes were painted over with the same mixture used for the overall shadow. He also indicated some shadows in the clothing.

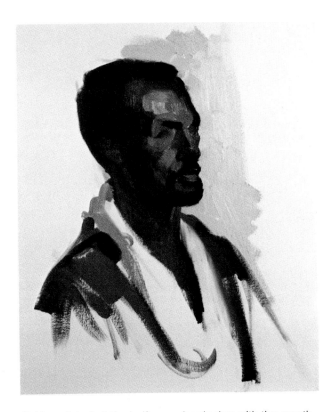

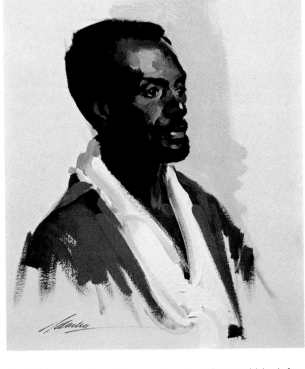

3. He painted all the halftones, beginning with the mouth area, with a combination of the shadow mixture plus white. The cheekbone was painted a mixture of burnt sienna, viridian, and cadmium orange for the darker side. The same mixture, with Venetian red, was used for the warmer, lighter side. The right temple was put in with a mixture of burnt sienna, white, viridian, and cadmium orange. The rest of the forehead, except for the lights, was painted with a mixture of these same colors, plus chromium oxide green and a touch of black. The nose was painted with a combination of viridian, cadmium orange, and burnt sienna. The artist painted the neck with the same mixture, adding white. The bridge and frontal plane of the nose were done in viridian, cadmium orange, burnt sienna, white, and cadmium red light. The upper lip was painted in viridian, cadmium orange, burnt sienna, white, and chromium oxide green. The artist painted the dark area between the lower lip and goatee with viridian, cadmium orange, burnt sienna, and white, plus a dash of ultramarine for a rich, dark accent.

The artist painted the lights in separately: The forehead color was the result of mixing chromium oxide green and a touch of white with a combination of hues: white, cadmium red light, yellow ochre, chromium oxide green, and cadmium orange; the light under the eye was a mixture of burnt sienna, viridian, white, and cadmium orange added to chromium oxide green and cadmium red light; the light area just off the wing of the nostril was a mixture of white, cadmium red light, yellow ochre, chromium oxide green, cadmium orange, and ivory black. He then brushed the highlights onto the forehead, using a blend of burnt umber, ultramarine, and white. The shirt was indicated with alizarin, burnt umber, and black.

The artist did additional work on the lips before going on to the next stage. The upper lip was painted burnt umber, alizarin, ultramarine, and white; the lower was painted in burnt sienna, white, viridian, and cadmium orange with cadmium red light.

4. At this stage the artist used burnt umber and black for the irises, pure black for the lashes, black and burnt umber for the eyebrows, and alizarin and white for the reddish areas of the lids. He placed the all-important highlight, which in this instance was composed of ultramarine and white, on the nose. The highlight on the lip was alizarin and white, and the one on the chin was mixed from chromium oxide green, white, and a bit of burnt umber.

Note the number of reflected lights that appear on both sides of the neck. The one on the sitter's right was mixed from chromium oxide green, black, burnt umber, burnt sienna, and white; the one on his lighter left side, from burnt sienna, white, viridian, cadmium orange, ultramarine, and a touch of white. To finish the portrait, the artist placed some lights in the ear, thickly brushed pure white into the shirt, and used several strokes of cadmium red light to indicate the sweatshirt.

Cool Portraits

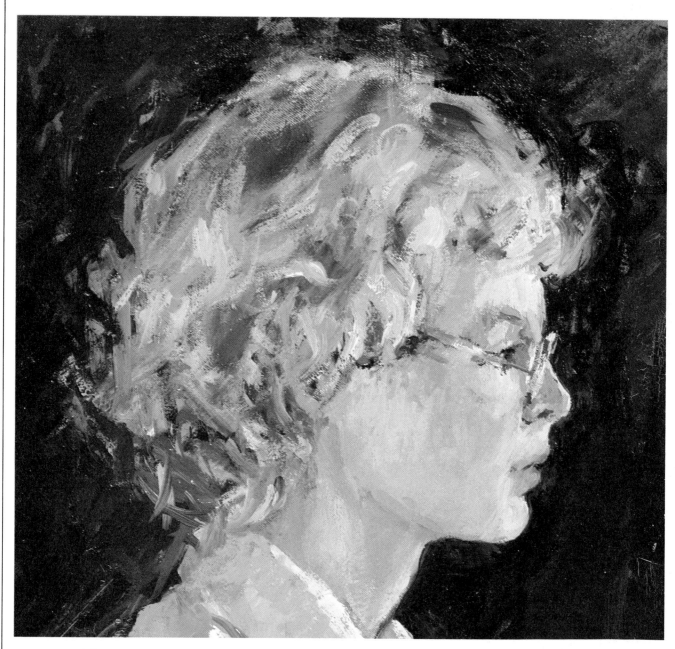

When painting portraits, there is more to consider than trying to obtain a likeness. The sitter's character and emotional makeup must be conveyed, and the setting, composition, and color scheme must be selected and arranged to describe the character and personality of the subject.

John, the son of a friend of the artist, was sensitive, intelligent, and shy. To emphasize the curves of his refined, gentle features, she placed him in profile against a stark series of rectangles, including the box he was seated on. She also selected a simple color scheme of deep umbers (composed of many colors), light blue clothing, and soft pink flesh tones.

The background was a light under-painting of cerulean blue, over which the artist worked a slightly darker rectangle of cobalt blue. Then she gradually covered this with layers of viridian, French ultramarine, cadmium red, and burnt sienna, letting these colors show through here and there for interest and depth.

The cool blue tones of the shirt made the complexion appear softer and warmer, and helped to express John's gentle reserve. The artist painted the face with various mixtures of yellow ochre, cadmium red, cobalt blue, viridian, and white, with bright blushes of rose madder on the cheeks and hands and dark accents of burnt sienna and blue on the nose, ear, and eye. His blond hair was a combination of yellow ochre, terre verte, and white, with cobalt blue added in the darker areas.

It's hard to describe character through a profile—the eye is constantly led to the edges of the form and the head tends to look flat. To counteract this, the artist painted bright spots of color near the cheekbones and defined the features, and the forms and planes of the head, more carefully than usual, to emphasize the three-dimensional quality of the head and describe John's expression. Note how the light left distinct (though subtle) edges at the junction of the front and side planes of the head.

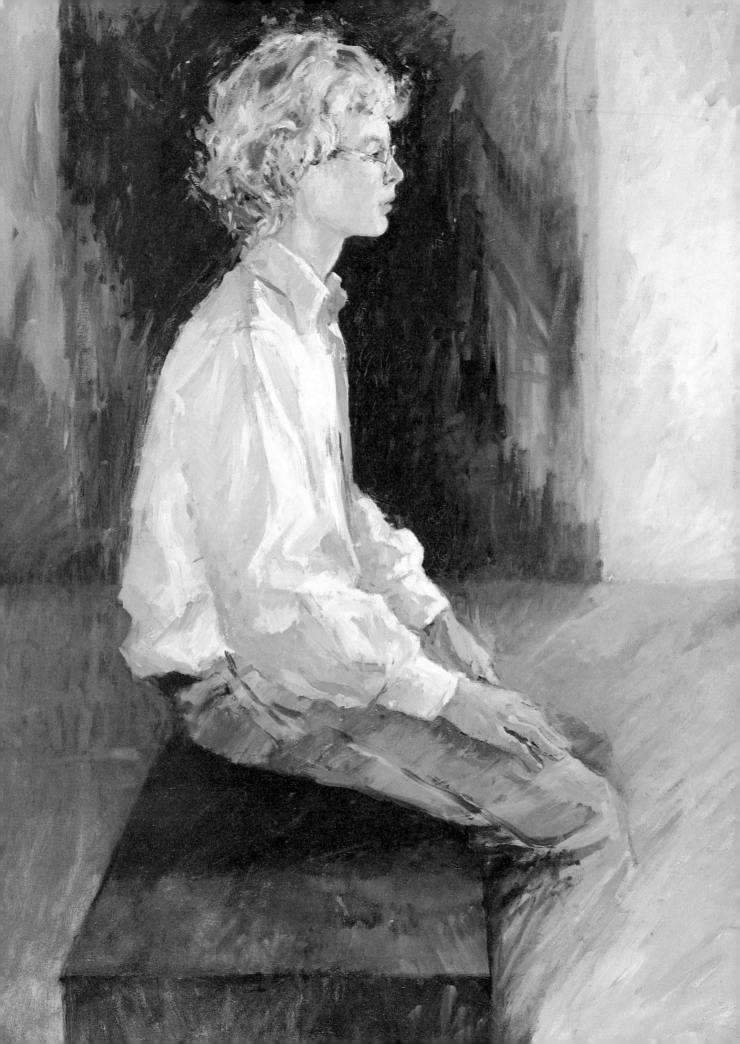

Warm Portraits

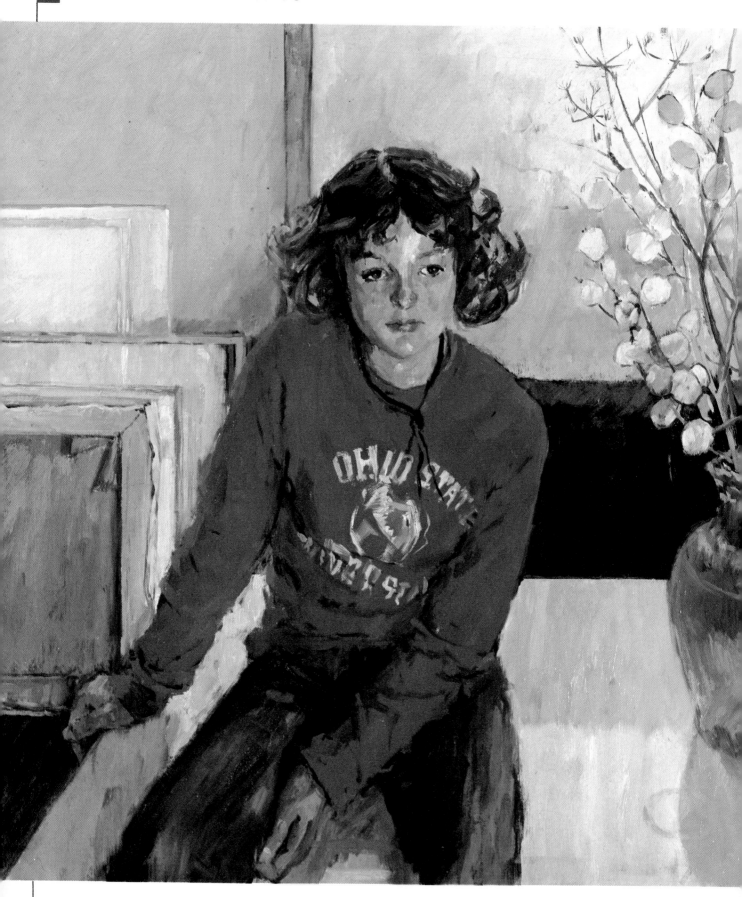

Kate (John's sister) was quite different from her brother. She was confident and active, and the frontal pose helped convey her straightforward manner.

There were two light sources for this portrait. In the foreground, firelight shone on Kate's face and the upper part of her body, giving it a warm glow that helped convey her personal warmth. On the other hand, the blue light from the window threw its contrasting cool tones on the table and background.

Ms. Corsellis arranged the composition carefully, letting the strong squares of the window, stacked canvases, and table intersect Kate's body in an interesting, abstract manner. She offset these angles with the curves of the earthenware jug, the circles of honesty, and the round shape of her head and emblem on her sweatshirt.

Kate's head was painted more loosely than

John's, in keeping with her extroverted, exuberant vitality. Her flesh was painted with mixtures of yellow ochre, burnt sienna, cadmium red, rose madder, and white, cooled and softened with touches of cobalt blue, French ultramarine, and viridian. The cool light of the window (painted with tones of cerulean blue, French ultramarine, viridian, and white) intensified the warm colors on her face. Her warm brown hair (burnt sienna, yellow ochre, and French ultramarine) framed her face and created a barrier against the cool background daylight. Note the way the artist brought the cool daylight into Kate's parted hair, linking the two areas. She painted the base of her hair a transparent burnt sienna and French ultramarine, adding opaque yellow ochre and white tones to it where it bounces upward and catches the light.

Painting a Nude in Cool Colors

Pencil Studies. The drawings on this page are preliminary studies Charles Pfahl did before beginning his oil painting. The upper one is merely a rough sketch he made to indicate the general placement of elements. In the lower one, the artist went a step further and worked out some of the values to obtain a preview of the picture's tonal relationships. (Note how little he varied from these sketches in the final painting, page 133.) He was fairly well satisfied with the way the concept appeared in pictorial terms at this point and confident enough to proceed further.

1. Working from his sketches, the artist quickly drew in the figure for placement on the silver-gray toned Masonite board. Although in the original concept the model's legs were uncovered, he decided that it would be better to cover most of them under the blanket. Mr. Pfahl made most of these decisions prior to proceeding to the board.

2. The artist's primary effort here was to resolve the basic value before proceeding further. He reinforced the drawing and placed some of the darker darks in the hair, the crotch, and the wall in the upper left-hand side of the painting. Some major folds in the blanket were blocked in and the patterns in the blanket were indicated more accurately. Now it was time to begin placing basic colors.

3. The artist roughly covered the entire board with hues that approximated the actual colors. The basic areas of the patterns in the blanket were laid in, and the light areas in the right forearm and breast were indicated. The artist could now visualize how the finished painting would emerge.

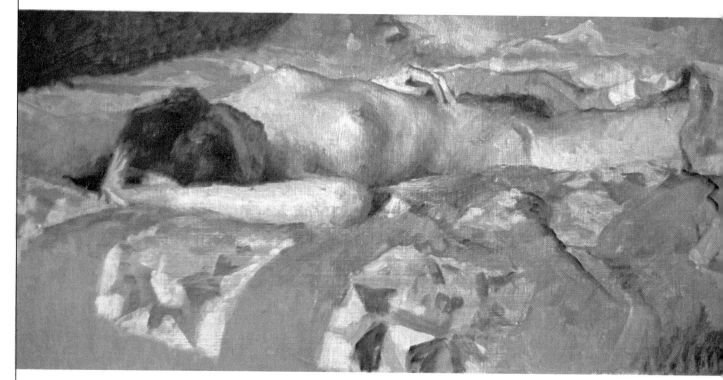

4. Here, the artist blocked in all the basic tones in the painting with the exact colors, exploiting the tone of the board as much as possible and pulling together the darks and lights to provide some feeling of unified form. He also laid the quilt in quickly, indicating the design of the pattern and trying to keep the colors, values, and shapes as accurate as possible.

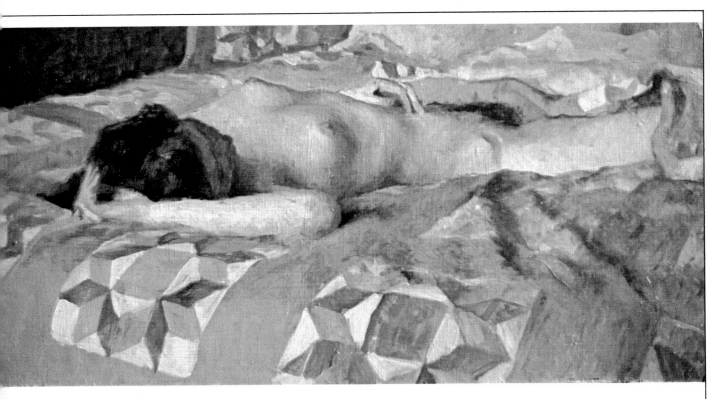

5. The artist worked out some of the basic shapes of the folds in the quilt, as well as the designs in its pattern, putting them down as flat areas of basic color without indicating any of the overlying textures. He was more concerned here with getting their correct dimensions than their exact hue.

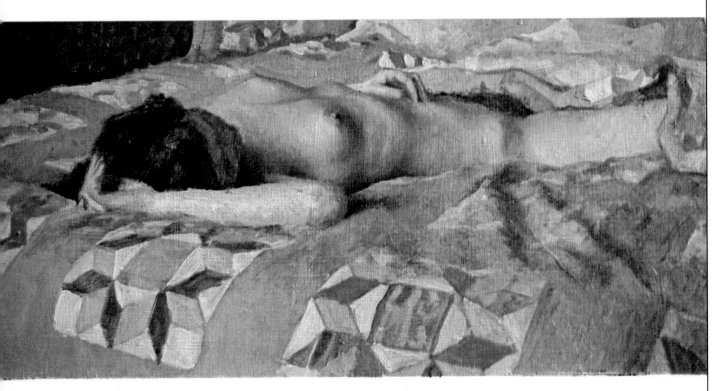

6. The artist painted the many cool grays and blues he found on the figure's chest and abdomen area. Much of this area was established by manipulating the underlying gray tone of the painting surface. The artist often tones his surfaces to exploit their value and color so that they represent halftone areas in the finished painting. Since he lays his paint in thinly, this device serves his technique admirably. He goes somewhat cooler all over the painting.

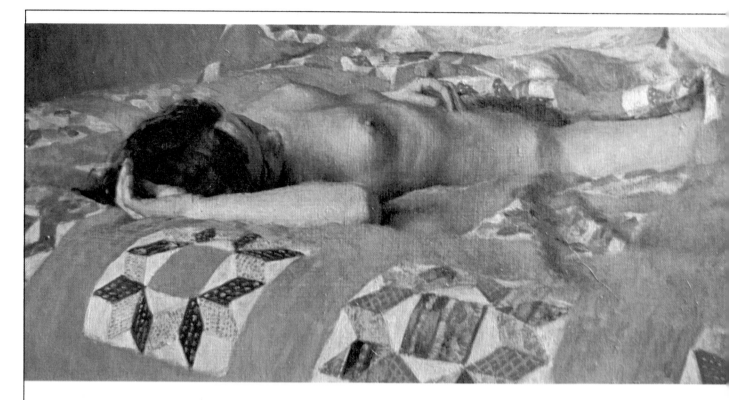

7. Here the artist again concentrated on the patterns in the foreground areas of the quilt and laid the paint in with accurate attention to the detail and color of the designs within these patterns. He added stronger color to the painting and warmed it considerably throughout. He corrected the chartreuse hue of the quilt and brought out its warm quality. By this stage, the entire head and the forearm had been repainted. The head was kept simple to foster the illusion that it blended with the shadow of the body.

7. (Detail below) This close-up view shows how the artist employed an almost pointillist technique to depict the design of the patterned squares in the quilt. Seen from a distance, the little spots of blue and red color seem to vibrate and provide the illusion of texture in the design. Actually, the drawing is loose, the color is simple, and no tight edges exist; but the general effect successfully conveys the impression of a busy, variegated pattern.

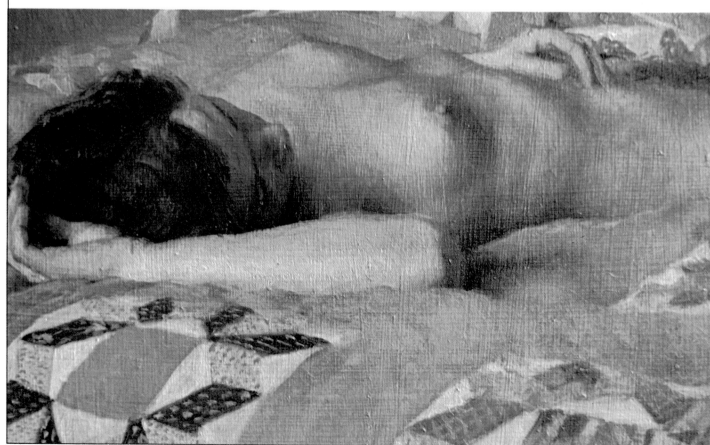

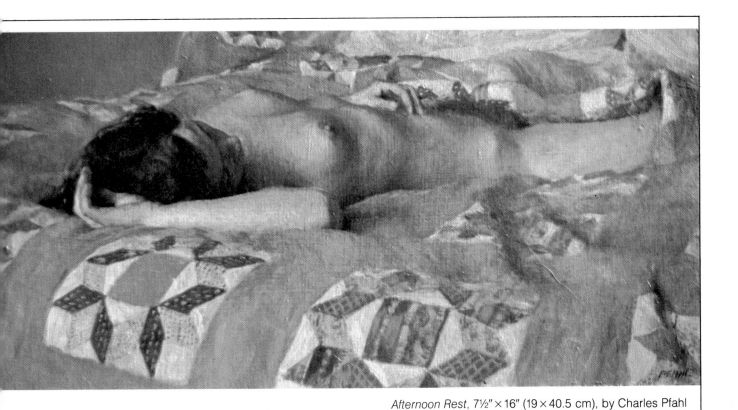

Afternoon Rest, 7½″ × 16″ (19 × 40.5 cm), by Charles Pfahl

8. Here the artist lightened the model's right breast and forearm. He finished the right leg, which represented the second lightest area in the painting. He kept it lighter in value than the rest of the torso but darker than the lightest area, the forearm. He carefully repainted the left hand resting on the abdomen. In the lower right-hand corner, he placed a fold through the partly visible square to break up the pattern, and lightened it to keep it from being too distracting.

8. (Detail below) Note the small light accents on the nose and the forehead. These highlights gave form and shape to the face, which remained basically a medium-dark tone. A cool bluish light brought the right breast forward. The edges were extremely soft throughout the body, as befits the true character of flesh, but the viewer gets a distinct impression of receding planes as the figure moves away from its most forward point—the forearm.

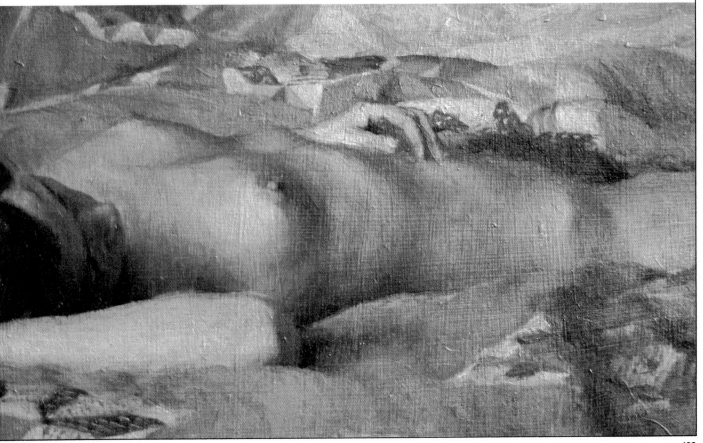

Figure and Surroundings

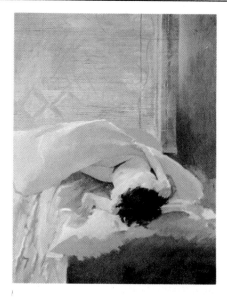

1. Ms. Corsellis likes to involve a figure with its surroundings, as you may be able to see even in the first stage of this painting. When the artist first saw this scene, the horizontal lines of the blind contrasted with the round shape of the bedclothes; the warm patches of sunlight on the model's body played against the cool shadows; the strong, dark column of the wall was solid against the light rectangle of the window; and the diamond pattern of the balcony trellis was echoed in the sharp angles of the bamboo leaves and the unusual bend of the model's body. To the artist, it was a perfect set of relationships.

She did a preliminary charcoal drawing that plotted the light and shade and worked out the painting's basic composition. She then started with a pale wash of cobalt blue and burnt sienna, laid in with a 1½-inch (4-cm) housepainter's brush. She worked progressively darker, leaving some areas white and blocking in the darkest tones with a mixture of French ultramarine blue and burnt sienna.

The artist always prefers working toward the darks rather than painting them immediately because it gives her paintings a greater sensitivity. Try this approach in your own paintings.

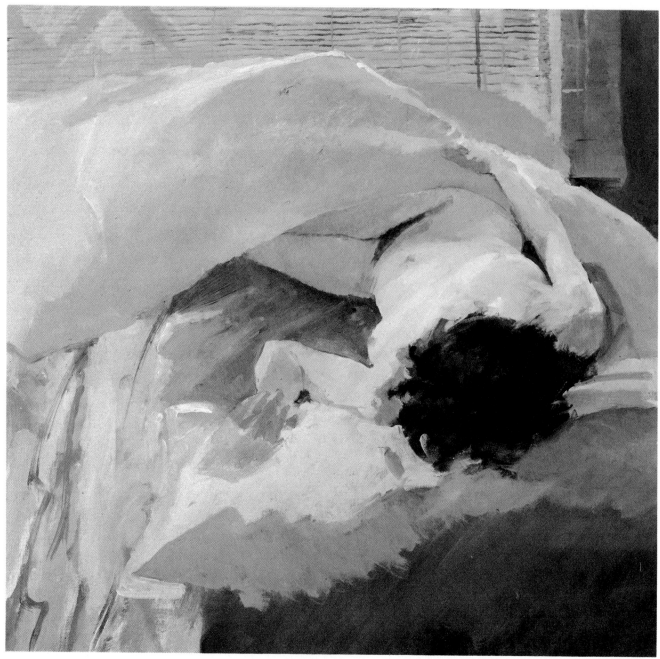

2. Early on in the painting, the artist had noticed that things were going wrong. The figure and the bedding were too pink and the shape of the bedding was awkward. The window area wasn't working well either. The reeds of the Japanese blinds were detailed too precisely, and, as a result, looked too linear and prominent. In fact, no area of the painting worked well except for the model. Even the blue underpainting was too dark, and the horizontal porch line was too hard.

The artist tried to correct the shape of the bedding by repainting the upper edge. She tried to weigh it down on the left by deepening the shadows there to a purple (French ultramarine blue and rose madder), but that made matters worse, accentuating the very pink tones she wanted to get rid of.

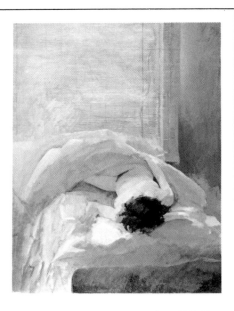

She tried breaking up the lines of the blind to soften their linear rigidity by scrubbing a warm, light beige (of cadmium orange, cerulean blue, and white) into it, and then lightened the background outdoor tones too. But in the process of doing that, she lost the diamond shape of the plant and trellis and destroyed the original feeling she'd captured in the charcoal drawing.

At this point, the artist lost her initial enthusiasm for the painting. She knew something was wrong, but couldn't determine what it was since none of the changes she'd made had helped. In fact, they had made matters worse. In despair, she finally turned the painting to the wall and tried to forget it, hoping a solution would present itself eventually. In a few weeks it did.

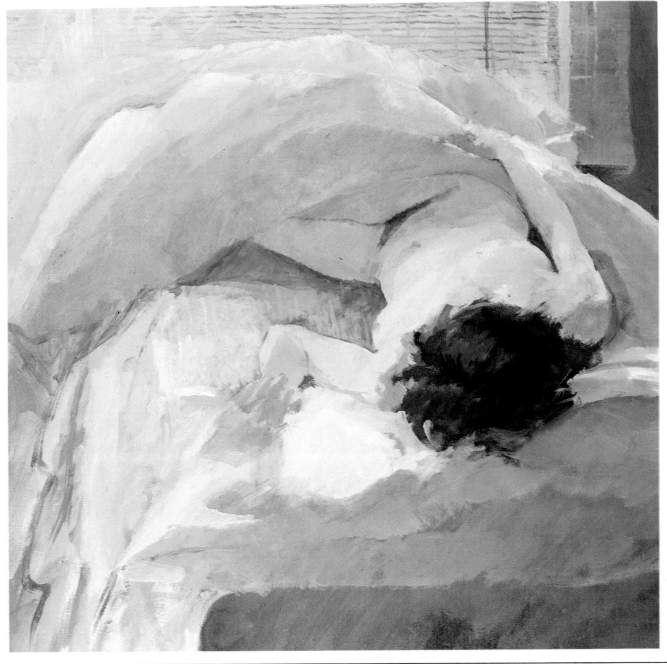

Oil Sketch. Ms. Corsellis worked out the painting problems on a small canvas to see where she had gone wrong. This time she worked quickly and decisively, carefully placing patches of warm color against cool. She painted a bit loosely, but it was far more alive and vigorous than the larger painting. She also referred to the charcoal drawing she'd done initially, and that early study revealed how she'd lost sight in the larger painting of the contrasts that had first caught her attention—the bright square of the window and windowsill. She had also forgotten about the diamond shapes of the trellis and plant leaves and the way they echoed the odd angles of the model's arms and hips.

In stage 2, the darks on the right were unbalanced and the painting was floating on the left. It needed to be anchored by continuing the horizontal of the windowsill and lower wall on the left. Also, the weight of the model's body had to be balanced by the strong colors and shapes of the plants and trellis. Because the room was brightly lit, it was filled with strong reflected lights—and the artist had made the foreground mattress area much too dark.

Finally, Ms. Corsellis realized that the fundamental problem was that she had ceased to see the painting as a whole and, by concentrating on isolated, unrelated sections, she had failed both to capture the feeling of the sun-filled atmosphere and had lost the compositional balance and geometrical interest of the painting.

Finished Painting. (Opposite page) When the model returned and posed again, all seemed to go right this time, though there were a lot of changes to be made from stage 2. The artist worked on it for many hours to get it just right.

The artist lightened the shadows at the base of the bed, under the coverlet, and on the legs by increasing the amount of reflected light there. She also deepened the color of the leg in shadow, making it pinker and brighter as the reflected light was strengthened, and she lightened the sunlight on the model's hair. In addition, she lightened the surface of the sheet and coverlet and where the sunlight struck them and changed the shape of the bedding to a more interesting and complicated series of angles and edges, especially on the right.

Ms. Corsellis worked on the pillow and mattress, improving their shapes, lines, and colors, and strengthened the intersecting horizontal of the windowsill, trellis, and stone wall beyond. She got rid of the blue tones on the wall on the right and deepened the burnt umber color there. She also eliminated the unattractive purple tones of the sheets on the lower left, massing the area instead into a series of light, subtle colors and shapes.

The artist enjoyed painting the pillow and coverlet, although the purple-blue shadow on the sheets and the cool (yet warm) tones of the model's legs were very difficult to paint because of the almost imperceptible changes of color and tone there. But despite this difficulty, the contrast of the coverlet against the creamy body color is successfully distinct without being harsh and is just slightly provocative.

Notice the way the bamboo leaves follow the line of the straight arm and complement the bent one, and the way the curve suggested by the climbing clematis plant on the balcony follows the curve of the model's body and yet is counteracted by the severity of the straight vertical of the string holding up the blind. But even though there is a lot going on in the upper half of the painting, it isn't *too* busy—the main subject is definitely the model. Your eyes are always drawn to the figure—by the line of the bamboo, the blind, and the trellis. Had the blind stayed as fussy and meticulous as it was when the artist first painted it, the model would have been merely an incidental image in a painting of a balcony and blind.

Asleep in the Sun, 45″ × 50″ (114 × 127 cm) by Jane Corsellis

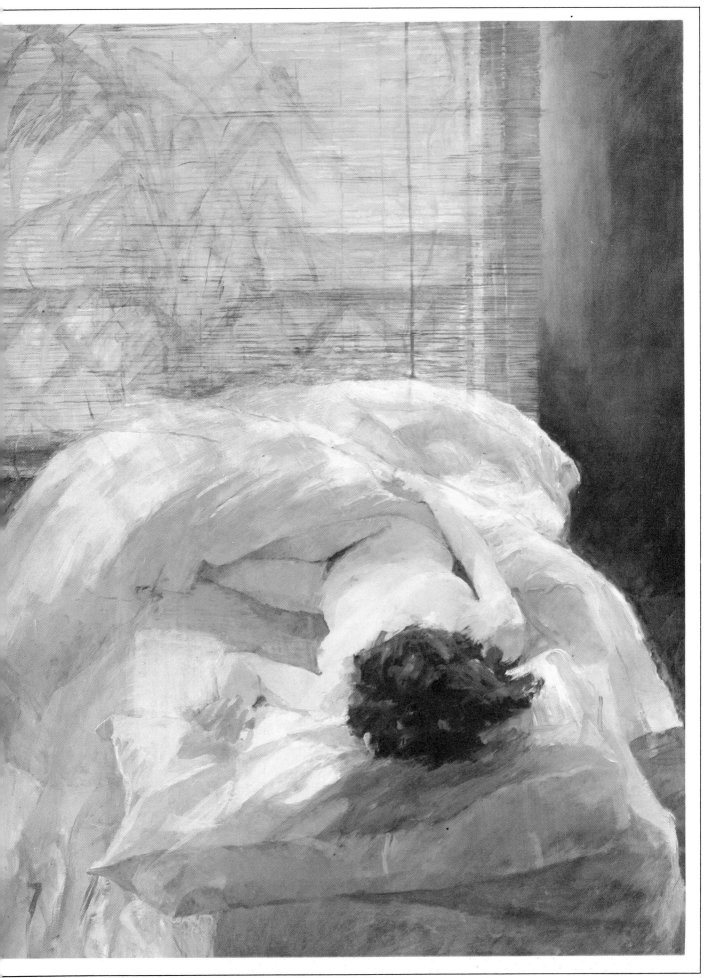

Painting a Figure in Morning Light

Artists get their painting ideas in varied, and often unusual, ways. Jane Corsellis began working out the composition for this piece before the idea of the painting even existed in her mind. On summer mornings, she would lie in bed watching the patterns and colors playing on the curtains and wall in her bedroom as the early sunshine filtered through. The artist began subconsciously filing away visual experiences, noticing how the warm sun shone quite pink on the transparent curtain, and how the bars of the window cast contrasting blue shadows there. She was also aware of the quality of the light; it was that hazy sunshine of early summer mornings that shines softly and warmly before the brightness of noon has a chance to bleach the colors. At midday, when the sun would have shone flat and square on the floor, the artist would have had an entirely different and exciting composition, but at that early hour, she was impressed by the dramatic directions of the shadows, their differing patterns and angles, and the subtle interplay of color temperatures.

As she continued working out the composition, she first pictured only a wall behind the model. She then decided that the flat space was boring and considered adding a closed door. Later (perhaps being influenced by Vermeer and other Dutch old masters the artist admires), she realized that a half-open door would create a sense of mystery and expectancy. (Ms. Corsellis often uses this theme in her compositions.) She discovered just the right door and angle of light she wanted at a friend's house, and did some drawings of it while there. Once she had studied the way the light struck and the colors reacted, she easily transferred the information to the painting. (At one point, she had even added the figure of a man in the room beyond, but took it out because it was too distracting.) She also made a detailed study of the net curtain in pencil and watercolor. Interesting patterns were created by the warm glow that reflected from the unseen brick wall in the garden, contrasting with the cool shadows that the window bars cast on the curtain. Since this effect lasted only about an hour, she had to be up early to catch it. When she had worked out the ideas for the painting in her mind, she started work on a large canvas, without preliminary drawings of the painting as a whole.

She roughed in the basic composition with a 1½-inch (4-cm) house-

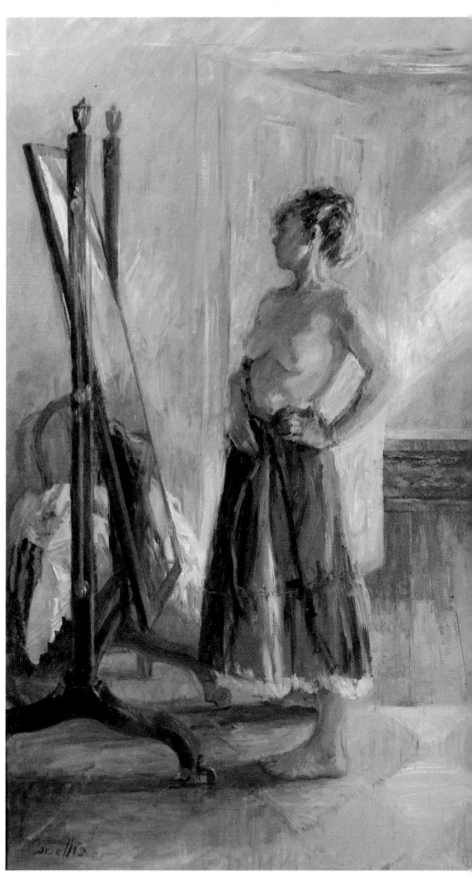

Morning, 50" × 60" (127 × 152 cm), by Jane Corsellis

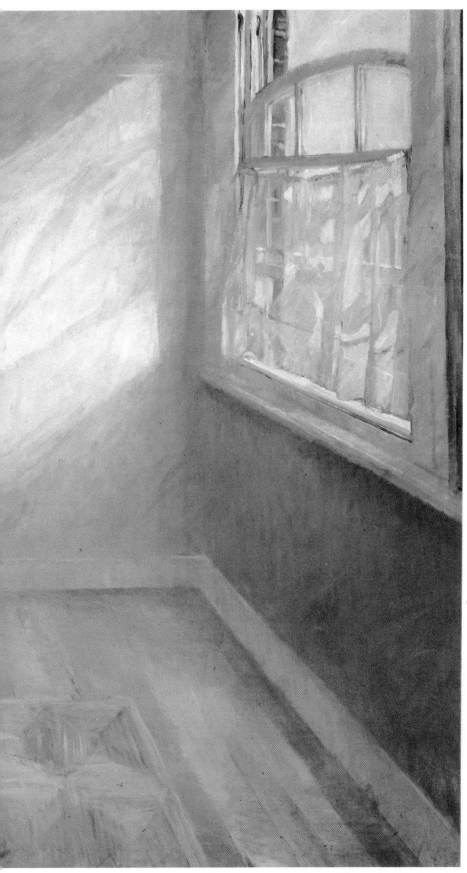

painter's brush and a diluted wash of raw umber. When it was dry, she scumbled layers of fairly dry paint onto the canvas, rubbing them in thinly, relating and contrasting the tones in various areas. She continued to scrub on thin glazes of paint until she achieved the right effect. Since few areas were completely cool, these layers of warm and cool glazes expressed the quality of the light and its complexity particularly well. The cool shadow areas, with their bright, warm reflections, were especially difficult to assess and paint.

The basic composition, values, and the light sources of the painting are analyzed in the small tracings on the next page, at the far right. Compare them carefully with the finished painting—you will see how the artist translated her thoughts into paint.

COMPOSITION

LIGHT SOURCES

VALUES

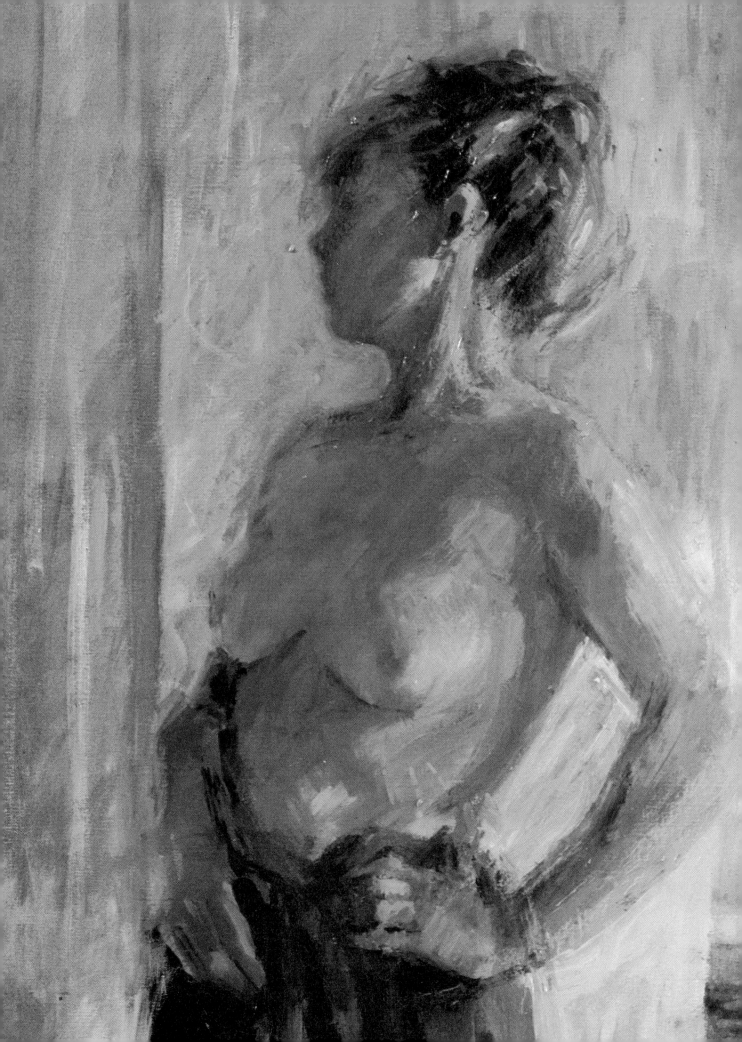

Ms. Corsellis painted the model's head turned away from the window at an angle, and her profile, which was mostly in shadow, was painted almost without changes of color. The colors there were further complicated by the warm light of the sun reflected from the mirror onto her body. But the artist scrutinized the scene intensely and did her best to paint what she saw.

The artist looked for both similarities and contrasts in the shadow patterns. For instance, she noticed that the wavy shadows on the curtains were repeated in the shadows on the model's body. She also tried to capture the lost-and-found, flickering quality of the light on various objects, particularly on the paneled door. The inner edge of the door near the head was quite sharp, while higher up, colors and tones merged. Ms. Corsellis suggested the panels on the lower part of the door with light tones, but, as the light changed on its highly polished surface, she used increasingly darker tones. For example, she painted the shadowed upper part of the door (see full painting) with cerulean blue and rose madder genuine, and expressed the warmer tones below it (shown here) with cerulean blue and burnt sienna, adding terre verte for the shadows and touches of cobalt blue for the highlights.

This area contains one of the most complex patterns of values and angles in the painting. The artist felt that leaving the top of the window slightly open made the painting much more interesting because the blue shadows waved in broken lines in contrast to the severe horizontal parallels of the window frames. The white edges of the window bars also played an important role in the composition, stopping the eye at the edge of the painting while directing attention and interest to the window area.

The white curtains also help to heighten the contrast between the light outside and the shadows in the room—an effect strengthened by the dark line of bricks outside the window. For a transparent effect, the artist rubbed burnt sienna (reflected by a brick wall from the garden outside) onto the canvas as a base, wiping away what would later be the blue pattern of the shadows. She then painted the shadows carefully, with sweeping strokes of thin cobalt blue. The whole painting was a combination of such seemingly casual areas of brush strokes and some very carefully placed details, such as those on the windowsill and lower edge of the curtain, and the barely noticeable bars behind it.

The bright sunlight brought out changes of color and tone in the white wall. The actual wall needed a coat of paint, and the effect of this scrubbed-on, whitewashed look, with its underlying changes of color, was what the artist was trying to achieve. She painted it with thin washes of burnt sienna and ochre and later scumbled on cerulean blue.

Index

Edited by Robin White Goode and Betty Vera
Designed by Jay Anning
Set in 9 pt. helvetica light